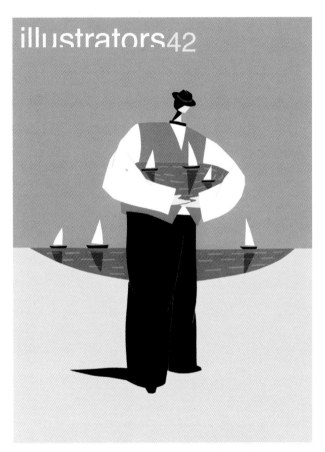

illustrators42

The Society
of Illustrators
42nd Annual
of American
Illustration

SI00

From the exhibition held in the galleries of the
Society of Illustrators Museum of American Illustration
128 East 63rd Street, New York City
February 12 - April 15, 2000

Society of Illustrators, Inc.
128 East 63rd Street, New York, NY 10021-7303
www.societyillustrators.org

ISBN 2-88046-592-3
Library of Congress Catalog Card Number 59-10849

A RotoVision Book
Published and distributed by RotoVision SA
Rue du Bugnon 7
CH-1299 Crans-Près-Céligny
Switzerland
Tel: +41 (22) 776 0511
Fax: +41 (22) 776 0889

RotoVision SA, Sales & Production Office
Sheridan House, 112/116A Western Road
Hove, East Sussex BN3 1DD, UK
Tel. + 44 (0) 1273 72 72 68
Fax + 44 (0) 1273 72 72 69

Distributed to the trade in the United States by:
Watson-Guptill Publications
770 Broadway, 8th Floor
New York, NY 10003
Tel: +1 (646) 654-5451
Fax: +1 (646) 654-5487

Jill Bossert, Editor
Jacket design and illustration by Craig Frazier
Interior design by Bernadette Evangelist

Production and separations in Singapore by ProVision Pte. Ltd.
Tel: +65 334 7720
Fax: +65 334 7721

Photo Credits: Jim de Barros by Michael Wong, Diane Dillon by Lee Dillon,
Gary Kelley by Murray Tinkelman,
Ethel Kessler by Max Hirshfeld, Mirko Ilić by Ina Saltz, Geoffrey Moss by Marc Rosenthal,
Judith Murello by Maryellen Murello, Rafal Olbinski by Susumo Sato,
Alice and Martin Provensen by Eric Lindbloom,
Ward Schumaker by Vivienne Flesher, Davor Vrankic by Eric Lassalle

illustrators42

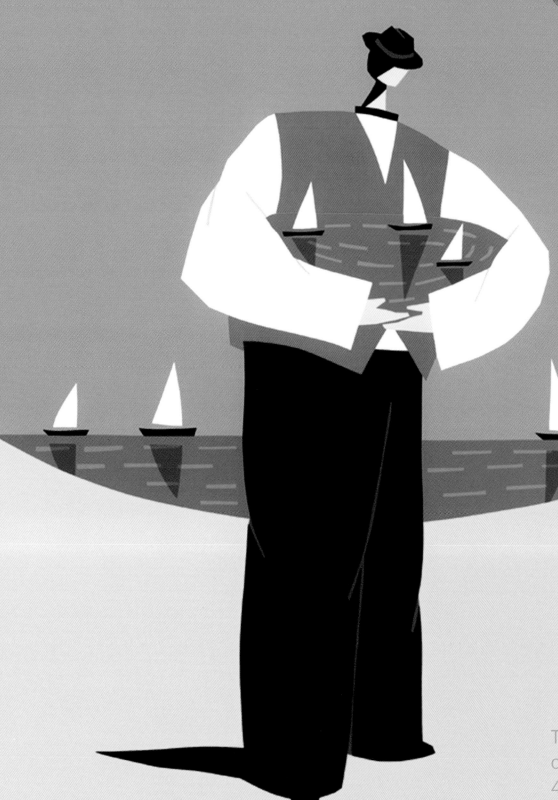

The Society
of Illustrators
42nd Annual
of American
Illustration

1/42 Published by
RotoVision S.A.

chairperson's message

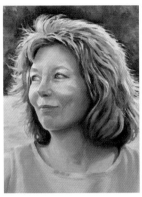

The 42nd Annual of American Illustration is the premier exhibition of original art by accomplished illustrators worldwide. Each year a jury of top illustrators and art directors selects what it considers the best of illustration from over 5,000 entries.

The level of excellence of each piece makes this show unique. The illustrator works under a deadline and must solve the communications needs of an art director, editor, publisher or client and sometimes all of the above. The picture must accommodate text and headlines, and it must look its best when reproduced. Despite these constraints—or perhaps because of them—illustrators create exquisite works of art that provoke thought, tell a story, decorate a product or interpret an idea.

It was an honor chairing this exhibition and having the opportunity to work with these talented artists and their amazing artwork. I would like to thank the Society, all the past chairs, and especially Vin Di Fate for inviting me to be part of the team.

It takes a team of dedicated, generous and talented people to produce a show of this magnitude and I extend my thanks to everyone who took part in this year-long project. Nancy Stahl, the Assistant Chair, helped me make every decision and sometimes stood in for me. She has become a good friend and I'm confident will do a splendid job on the 43rd Annual. Kinuko Craft created the mystical illustration in honor of the Millennium which adorned the stunning Call for Entries poster, graciously designed and produced by Irene Gallo. The 45 jurors had a vision that gives this show the cohesive rhythm you will see on these pages. The staff at the Society was friendly, supportive and welcoming to an out-of-towner. Finally, thanks to the exhibitors, whose fine art of picture making will impress, inspire and amaze the viewer.

Martha Vaughan

Martha Vaughan

*Chairperson,
42nd Annual Exhibition*

Painting by Bobbi Tull.

The Society of Illustrators
42nd Annual of American Illustration
Awards Presentation

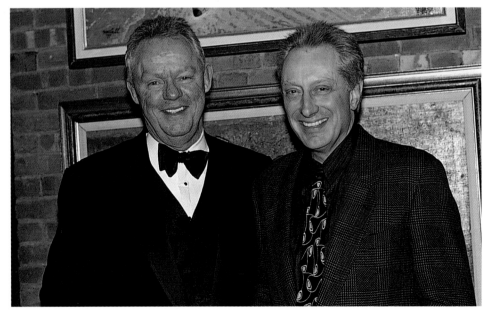

President Al Lorenz, *left*, with John Bergstrom of American Showcase which was once again the Exclusive Sponsor of the Annual Exhibition Awards Galas.

the illustrators hall of fame

Since 1958, the Society of Illustrators has elected to its Hall of Fame artists recognized for their "distinguished achievement in the art of illustration." The list of previous winners is truly a "Who's Who" of illlustation. Former presidents of the Society meet annually to elect those who will be so honored.

Hall of Fame Laureates 2000

James Bama
Alice and Martin Provensen
Nell Brinkley*
Charles Livingston Bull*
David Stone Martin*
J. Allen St. John*

Hall of Fame Committee 2000

Murray Tinkelman, *Chairman*

Willis Pyle, *Chairman Emeritus*

Former Presidents
Vincent Di Fate
Diane Dillon
Peter Fiore
Charles McVicker
Wendell Minor
Howard Munce
Alvin J. Pimsler
Warren Rogers
Eileen Hedy Schultz
Shannon Stirnweis
David K. Stone
Steve Stroud
John Witt

Hall of Fame Laureates 1958-1999

1958	Norman Rockwell
1959	Dean Cornwell
1959	Harold Von Schmidt
1960	Fred Cooper
1961	Floyd Davis
1962	Edward Wilson
1963	Walter Biggs
1964	Arthur William Brown
1965	Al Parker
1966	Al Dorne
1967	Robert Fawcett
1968	Peter Helck
1969	Austin Briggs
1970	Rube Goldberg
1971	Stevan Dohanos
1972	Ray Prohaska
1973	Jon Whitcomb
1974	Tom Lovell
1974	Charles Dana Gibson*
1974	N.C. Wyeth*
1975	Bernie Fuchs
1975	Maxfield Parrish*
1975	Howard Pyle*
1976	John Falter
1976	Winslow Homer*
1976	Harvey Dunn*
1977	Robert Peak
1977	Wallace Morgan*
1977	J.C. Leyendecker*
1978	Coby Whitmore
1978	Norman Price*
1978	Frederic Remington*
1979	Ben Stahl
1979	Edwin Austin Abbey*
1979	Lorraine Fox*
1980	Saul Tepper
1980	Howard Chandler Christy*
1980	James Montgomery Flagg*
1981	Stan Galli
1981	Frederic R. Gruger*
1981	John Gannam*
1982	John Clymer
1982	Henry P. Raleigh*
1982	Eric (Carl Erickson)*
1983	Mark English
1983	Noel Sickles*
1983	Franklin Booth*
1984	Neysa Moran McMein*
1984	John La Gatta*
1984	James Williamson*
1985	Charles Marion Russell*
1985	Arthur Burdett Frost*
1985	Robert Weaver
1986	Rockwell Kent*
1986	Al Hirschfeld
1987	Haddon Sundblom*
1987	Maurice Sendak
1988	René Bouché*
1988	Pruett Carter*
1988	Robert T. McCall
1989	Erté
1989	John Held Jr.*
1989	Arthur Ignatius Keller*
1990	Burt Silverman
1990	Robert Riggs*
1990	Morton Roberts*
1991	Donald Teague
1991	Jessie Willcox Smith*
1991	William A. Smith*
1992	Joe Bowler
1992	Edwin A. Georgi*
1992	Dorothy Hood*
1993	Robert McGinnis
1993	Thomas Nast*
1993	Coles Phillips*
1994	Harry Anderson
1994	Elizabeth Shippen Green*
1994	Ben Shahn*
1995	James Avati
1995	McClelland Barclay*
1995	Joseph Clement Coll*
1995	Frank E. Schoonover*
1996	Herb Tauss
1996	Anton Otto Fischer*
1996	Winsor McCay*
1996	Violet Oakley*
1996	Mead Schaeffer*
1997	Diane and Leo Dillon
1997	Frank McCarthy
1997	Chesley Bonestell*
1997	Joe DeMers*
1997	Maynard Dixon*
1997	Harrison Fisher*
1998	Robert M. Cunningham
1998	Frank Frazetta
1998	Boris Artzybasheff *
1998	Kerr Eby*
1998	Edward Penfield*
1998	Martha Sawyers*
1999	Stanley Meltzoff
1999	Andrew Loomis*
1999	Antonio Lopez*
1999	Thomas Moran*
1999	Rose O'Neill*
1999	Adolph Treidler*

Presented posthumously

JAMES BAMA
(b. 1926)

James Bama was born in 1926 in the Washington Heights section of New York City. He began drawing at a very young age, having been inspired by artwork in the comics. His childhood had its share of trauma: when he was thirteen his mother, Selma, suffered a stroke and his father died a year later from a heart attack. He graduated from the High School of Music and Art in 1944, and after serving in the Army Air Corps during World War II, began his studies at the Art Students League under the noted instructor Frank Reilly.

I arrived at the League to study with Reilly the year after Bama had left to begin freelancing. Within the year Bama had joined the prestigious Charles E. Cooper Studios, which was already representing such distinguished illustrators as Coby Whitmore, Joe Bowler, Lorraine Fox, Bernie D'Andrea, Jon Whitcomb and Joe DeMers, among many others. Bama polished his style in his early years at Cooper, and eventually shone among this talented group of illustrators. His career was off and running, a career which has not slowed down to this day.

Bama had a small apartment near Cooper Studios but was rarely there as most nights he slept on a small cot at the studio—his home away from home. Raised during the Depression, Bama learned the value of hard work early on and has been a workaholic all his life. His career in commercial art continued to expand and Cooper Studios afforded him the opportunity to let his realistic painting style mature. After only a few years he was considered by many to be one of the most successful realist illustrators working in the editorial and advertising markets at that time. In addition to his advertising clients, he did countless book jackets for Bantam Books and over 60 jackets for the famous "Doc Savage" series.

Bama's control of the edge of each dab of paint has always been unsurpassed. His undying devotion to the accurate depiction of the smallest detail of a costume and his dogged research for the perfect location are legend in the business. Always meticulous about using just the right props, he could, on occasion, be spotted heading up Madison Avenue for a photo shoot wearing a dark gray business suit with an old Montana A-fork saddle slung over his back and a buckskin-sheathed Winchester in his hand.

Bama met Lynne Klepfer in 1963, married her the following year and set up housekeeping in New York City. Lynne, having majored in Renaissance and Medieval art in college, was also a very creative person. She was an accomplished weaver and had a great interest in photography.

Though Bama was earning a very good living at commercial art, he found it stressful and felt it wasn't satisfying his need to be a serious artist. In 1966 Bama received an invitation to visit longtime-friend Robert Meyers, an artist who lived in Wyoming. Born and raised in Manhattan, Bama had never been West until this visit to Meyers' ranch where he discovered the visual power of the open sky, tall mountains, flowing rivers and, most of all, its wonderful people. The Bamas loved Wyoming and decided to make it their home.

The couple moved to a ranch in 1968 and Bama was overwhelmed with all the grandeur there was to see. The plan was for Bama to work on his illustrations part-time so that he could achieve his lifelong dream of painting subjects of his own choosing in his own way for a totally new market. He began at once, relegating his commercial work to the evening hours and by day painting the West as he saw it. He started recording his neighbors, local personalities, hunters and trappers, Native Americans, rodeo riders, empty ranches and deserted old buildings. Bama was truly inspired by his new surroundings and his art reflected it.

His first one-man exhibition was held in New York City in 1973 at the prestigious Hammer Galleries. Twenty-two of the 27 paintings quickly sold and a new way of life for the Bamas began. For the next 12 years Bama was represented by the Coe-Kerr Gallery in New York. In 1978, after the birth of their son Ben, the Bamas moved to a new home 20 miles west of Cody, Wyoming, where Bama's studio is today.

In the 27 years since his first show, Bama's great success as a fine artist has continued. His reputation as an exceptional painter of our time and of the people from around the world is in the truest tradition of Homer, Sargent, Remington or Russell. Bama ranks at the very top of any list of great American painters. His induction this year into the Society of Illustrators Hall of Fame is a long overdue honor for both the Society and for James Bama.

Gerald McConnell

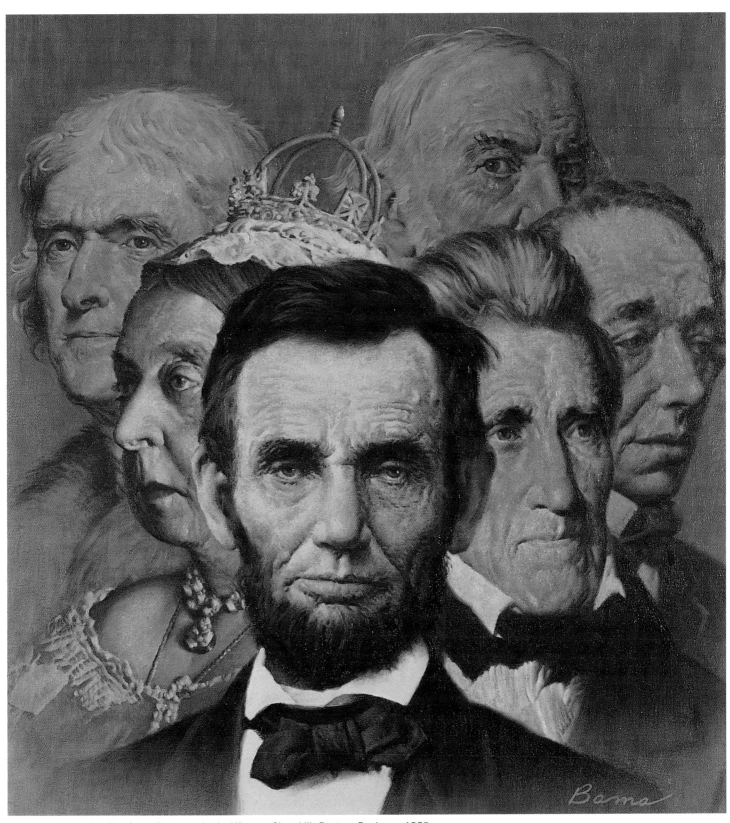

Cover illustration for *The Great Democracies* by Winston Churchill, Bantam Books, c. 1960s.

ALICE PROVENSEN (b. 1918)
MARTIN PROVENSEN (1916-1987)

Alice and Martin Provensen are a unique and talented team whose names are synonymous with the fine art of book illustration. Their collaboration as artists and husband and wife spans over forty years.

They were both born in Chicago and spent their early childhood there. Both received scholarships to the Art Institute of Chicago, though they never met there. Alice studied for a time at the Art Students League in New York and at the University of California. Martin attended Chouinard in California. Still, their paths did not cross.

In the early forties Martin served in the Navy and was sent to the Walter Lanz Studio to make training films. Alice was working there at the time as an animator and, as she states, "in walked a handsome sailor; it was love at first sight." It was also the beginning of a long and successful partnership.

As newlyweds they were stationed in Washington, D.C. They read an ad for a contest run by Domesday Press to illustrate a picture book. They entered the contest but Domesday was short lived. They took the samples they had done to New York, made the rounds of publishers and were given their first book to illustrate. *The Fireside Book of Folk Songs*, published in 1947, became a classic and is still in print. Unfortunately, it was commissioned as a flat fee.

After several books authored by others, the Provensens realized they could increase their income by writing their own stories or retelling work in public domain. *The Illiad and the Odyssesy* came out in 1957 and became another classic and inspiration to many aspiring art students.

Alice and Martin's work was ahead of its time in style and technique—a blend of design and texture. Their approach with each new manuscript was as varied as their subject matter. As a fine actor takes on the persona of each new role, the Provensens searched for the best way to express the feeling, the right line, tone, rhythm and spirit of the manuscript. Even with that diversity there is a unique signature, a look that is recognizable as theirs.

When the Provensens' daughter, Karen, was born, she became inspiration for several books in the early sixties. Their farm north of New York City provided them with tales of animal and country life, and their travels around the world provided them with rich subject matter. Voluminous sketches would later be used as research for their projects. "The act of drawing the object seen, for us, imposes a discipline and design on it that an amateur's camera cannot do."

History is a recurrent theme in their work. A Visit to William Blake's Inn won them a Caldecott Honor in 1981 and *The Glorious Flight* brought them the coveted Caldecott Medal for Best Illustrated Book of the Year in 1984. They received numerous awards including the Society of Illustrators Gold Medal in 1960 and several *New York Times* Best Illustrated Book Awards, among others.

The Provensens thrived on a challenge. When writing a book on Leonardo DaVinci, they proposed it as a pop-up book. They collected several pop-up books, studied the mechanisms and applied them to DaVinci's designs. The result was a book that would be the envy of the best paper engineers.

Working together provided its own unique challenges; there was a process of trial and error, setting aside of two separate egos, and blending individual drawing and painting styles. During a difficult stage of the creative process, there is often a need for privacy from critical eyes, so the Provensens devised a curtain down the center of their studio. When the curtain was drawn, the message was clear. One advantage of working together was that when one person had been working on a piece to the point of frustration and it still was not right, the other could take it and, with a fresh eye, finish it to perfection.

They would begin a book by working out the format, size, type design and layout. Although they might have started with separate ideas, they made style and technique decisions that resulted in a vision best suited for the subject matter and age group. They both made rough sketches and chose which ones they would pursue. Some work was done separately, some passed back and forth between them. It was often difficult for them to remember exactly who did what. They worked toward the same goal: a beautiful book. It was not a competition. This kind of respect, understanding and common goal was what made their partnership so successful, if not magical.

Sadly, Martin Provensen passed away in 1987. Alice continues to write and illustrate picture books. Her first solo book, *The Buck Stops Here*, published in 1990, was about American presidents. She is currently working on a book of Chinese folk tales. The collaboration continues, as Alice explains: "Martin's spirit is still here. I feel him over my shoulder telling me when the work is not right yet, or when to leave it." Truly, their shared love of the art of book illumination will enrich generations to come.

Leo and Diane Dillon

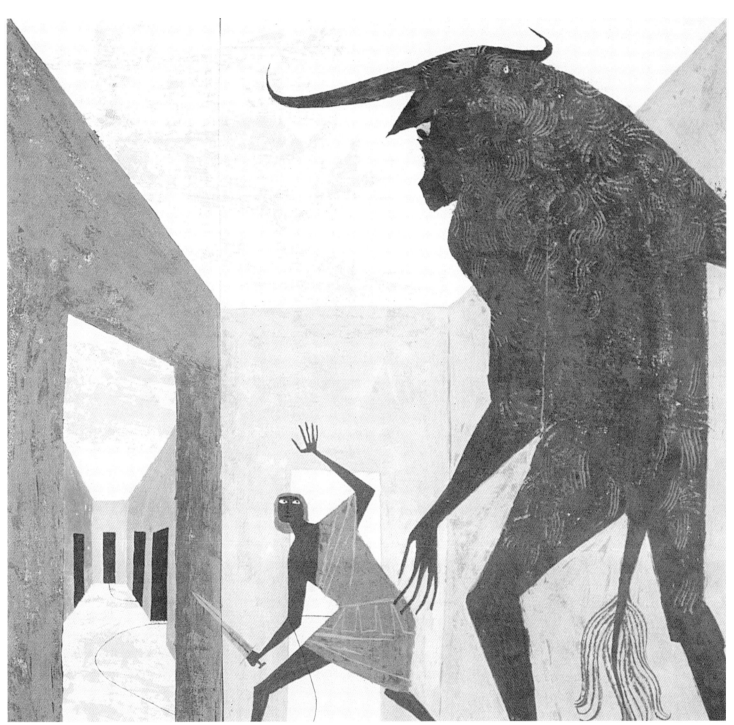

"Theseus and the Minotaur," from *The Golden Treasury of Myths and Legends*, adapted from the classics by Anne Terry White, Golden Press, New York, 1959.

NELL BRINKLEY
(1886-1944)

It took publishers of newspapers a long time to learn that they also had female readers. But by the time of the circulation wars of Joseph Pulitzer of the *World* and William Randolph Hearst of the *Journal* at the turn of the last century, it was discovered that more women subscribers could be successfully wooed by adding a special page featuring menus, style and dress patterns, home furnishings, rules of etiquette and advice for child care.

Newspapers had long focused on political editorials and cartoons, but one of the most innovative and successful new features was the cartoon for women created by Nell Brinkley.

Discovered at the age of 17 by Hearst's editor, Arthur Brisbane, Nell Brinkley had begun as a $7 a week newspaper artist in Denver, Colorado. Brisbane installed her on the *New York Evening Journal* and her career quickly flourished under his encouragement.

Miss Brinkley's cartoon illustration was given a large space at the top half of a page, with a special byline, and she quickly gained a huge following. Her style, in pen-and-ink, was florid but elegant with a lot of flourishes and curlicues. (She was a demon with curls!) Her women had cupid-bow lips and Mary Pickford-style hairdos; her men were movie star handsome with pomaded hair à la Rudolph Valentino. She usually had a sequential theme or story but sometimes the panels were independent tableaux. And, if the men were usually portrayed as matinee idols, she could also cut them down to size if need be.

Eventually she took over the whole Sunday front page, her pen-and-ink surprinted with color, in which she narrated such continued episodes as "Golden-Eyes and her Hero Bill over there" during World War I, or "How Kathleen Foiled the Wicked Plot against Her Sweetheart."

Miss Brinkley's avid audience was almost entirely limited to women but they idolized her, relied on her for the latest styles in dress and hair-dos and, most important, bought the newspapers to see her creations. She worked hard, not only creating a full-page Sunday feature, but she also had a daily cartoon and an additional illustrated feature in the *American Sunday Monthly* magazine section. Her "Brinkley Girl" became a twenties rival to the "Gibson Girl" and was celebrated in popular songs, a feature movie, and headline acts in the Ziegfield Follies.

As an artist, Miss Brinkley drew very well and despite the tendency to over-embellish dresses and hair-dos, her figures were anatomically sound and her pen line was expert, well adapted to newsprint reproduction. It is a question whether she accurately recorded the prevailing sensibilities of the teens and twenties—or perhaps was the female Norman Rockwell equivalent, who idealized women's roles. She certainly idealized their looks and perhaps their tacit acceptance of the romantic subservience to men that is a recurring theme in her pictures and text. If so, we've come a long way and we can thank her for providing that reminder of how far the Feminist movement has progressed by the year 2000.

We can also appreciate the charm, the coquetry and humor of her pen-and-ink creations. She obviously believed in what she did—and millions of women of her audience did, too.

Unfortunately, Miss Brinkley's work was not published in a more permanent form; the newspaper being one of the most ephemeral of mediums. Few of the newsprint reproductions are to be found and her original pen-and-ink drawings are very scarce. It is fitting, therefore, that she now be given a more permanent recognition by her inclusion in the Society of Illustrators Hall of Fame.

Walt Reed
Illustration House

Photo of the artist, circa 1932. Courtesy of Trina Robbins.

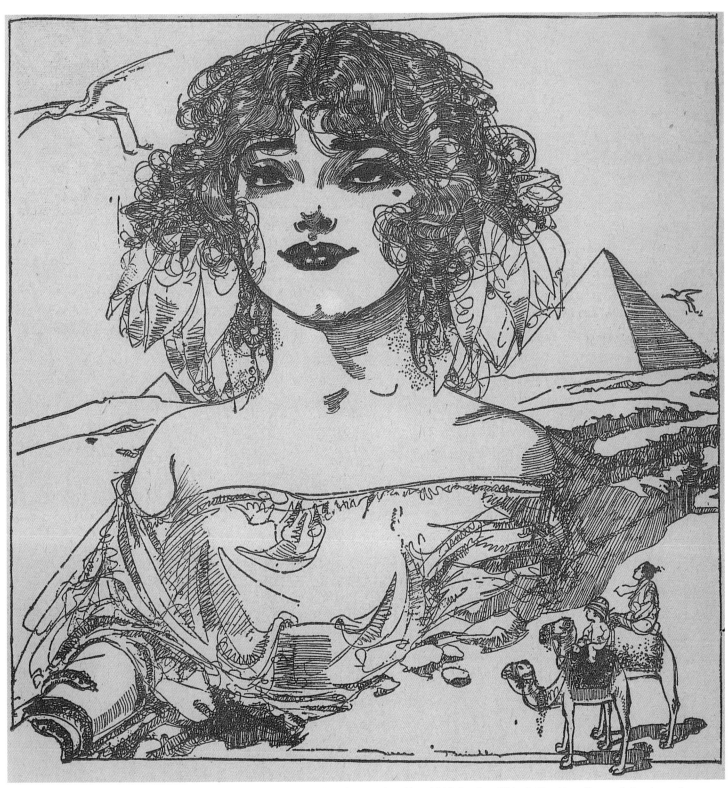

As a tribute to Miss Brinkley after her death, the *New York Journal American* reprinted her 1912 drawing, "This Sphinx Lives Forever." Courtesy of Illustration House, Inc.

CHARLES LIVINGSTON BULL
(1874-1932)

Charles Livingston Bull was considered the premier wildlife artist in America in his time. His 30-year career produced illustrations for no less than 125 books and numerous magazines, including *Outing*, *Century* and *McClure's*. He created the famous "leaping tiger" poster for Ringling Brothers and Barnum & Bailey Circus. Along with Philip R. Goodwin, Bull was the co-illustrator of the first edition of Jack London's *Call of the Wild*, published in 1903. Bull authored and illustrated the book *Under The Roof of The Jungle*, an account of his travels in the wilds of Guyana.

Charles Livingston Bull was born May 25, 1874, in West Walworth, New York. His family moved a few years later to Rochester. There, young Bull went to work at Ward's Museum where he studied the art of taxidermy. While at Ward's, Bull also attended the Mechanic's Institute where he studied drawing in 1889.

Bull's work on the Guatemalan exhibit for the 1893 Chicago World's Fair brought him to the attention of the National Museum in Washington, D.C., where he was appointed to the position of chief taxidermist. He became an expert on animal anatomy, sketched at the Washington Zoo, and attended night classes at the Corcoran Art Gallery for most of his seven years at the National Museum.

In 1901, Bull felt he was ready to try his luck as an illustrator in New York City. *Century Magazine* immediately purchased four drawings from his portfolio and gave him his first illustration assignment. He also got work from *McClure's* and *Outing*. The aspiring young illustrator was on his way.

In the age of Teddy Roosevelt's call to the "Great Outdoors," adventure and animal stories were very popular in all manner of books and magazine articles. Bull was certainly at the right place at the right time.

Bull's work soon achieved wide recognition with the publication of his drawings for Jack London's *Call of the Wild* which first appeared in the *Saturday Evening Post* in 1902. This, of course, preceded the publication of London's now famous book the following year, and marked the beginning of Bull's brilliant career as a full-fledged illustrator.

Bull settled in Oradell, New Jersey, with his wife, Fannie, in 1910. Their only daughter, Dorothy Charlotte, died in infancy. For the rest of his working life, Bull spent most of his time in seclusion on his wooded two acres, surrounded by the many birds and animals he so loved.

Today, out of the more than 2,000 illustrations produced in Bull's short life, only a small number of original pieces survive. The Hiram Blauvelt Art Museum in Oradell mounted a retrospective of Bull's work in 1994, and some of his pieces are in the permanent collection there.

Bull's art—with its beautiful sense of oriental design, clarity of form, and atmospheric drama—has been the inspiration of many wildlife artists working in the past half-century. May his legacy continue.

Wendell Minor

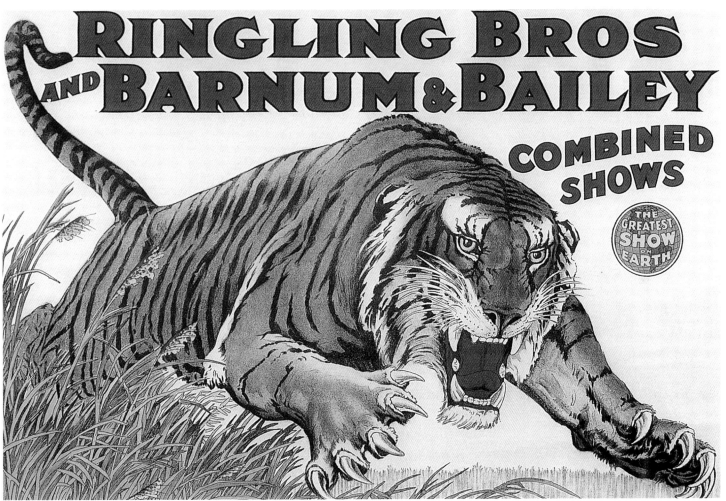

"Leaping Tiger," poster for Ringling Bros and Barnum & Bailey. Collection of Mr. and Mrs. Al Bolter. Courtesy of the Hiram Blauvelt Art Museum.

DAVID STONE MARTIN
(1913-1992)

David Stone Martin's work was a central catalyst in the push by the illustrators of the 1950s to move out of the painterly rectangle of the "Golden Era" into the white space of the more graphic, less bookish, modern magazine. He was also at the forefront of the group of artists who, having turned away from the sweet fashionableness of much boy-girl illustration of that time, infused their work with a darker psychology. It was a mood more inspired by German Expressionist artists like Max Beckmann and the theater of Kurt Weill than it was by the benign impressionism of American artists such as William Merritt Chase or Childe Hassam.

Like Andy Warhol in his I. Miller shoe ads of the late 1950s, David Stone Martin's style was created out of a self-consciously textured black line. Unlike Warhol's staccato blotted line, however, Martin's line swirled rhythmically from spidery whorls to sudden fat slices and lozenges of black as though the ink bottle had tipped over and had magically hit all the right places.

David Stone Martin had come to this dramatically modern drawing style after an apprenticeship in the 1930s and 1940s painting murals in a more traditional way for the Federal Artists Project and the Tennessee Valley Authority. It was a fully rounded, non-linear style that he would sometimes return to in his illustration for Lucky Strike advertisements or the occasional fiction piece in a magazine. But it was in the next period of his life, during his art directorship of the Office of Strategic Services, that he developed the style for which he became famous and for which we celebrate him. During this time, and in his role as art director, he worked closely with a number of artists including Ben Shahn, Henry Koerner, Bernard Perlin and William Golden. Undoubtedly they stimulated his thinking about a more linear approach to his art. In fact, it is impossible not to speculate that Ben Shahn had a particularly powerful effect on the young David Stone Martin, the affinities being so strong between Shahn's incisive drawing style and Martin's own etching-like line. Whatever David Stone Martin got from Ben Shahn, he eventually moved away from the older artist's austerity to express a more rambunctious vision of his own.

It is this underlying exuberance of David Stone Martin's art that must have first attracted clients like Asch and Cleff Records and led them to offer him work doing their jazz record jackets. In whatever way these first jobs came about, they obviously opened up for Martin an opportunity to explore a particular gamut of textural effects and to develop the innate musicality of his style. As we look at examples of these jazz jackets now, the dramatic, almost percussive use of black accents can easily suggest the changing rhythm of a drummer and sweeping, crisscrossing transparency of his fluent curves bring to mind the interweaving of theme and variation. Even the soft, furry watercolor washes that he often dropped into his web of lines seem to echo the background thrum of the bass. Beyond this textural affinity to the ebb and flow of jazz, David Stone Martin plays a hide-and-seek game with the information in his images which is very like the hide-and-seek game that jazz musicians play with their themes. When Martin camouflages the saxophonist's hand in the florid decoration of his instrument, it is a little like John Coltrane having so much fun playing around with the notes of "Night and Day"—the tune slides in and out of recognition. For people of a certain generation, David Stone Martin's style represents the whole idea of jazz. Jazz is the black circle sitting in the nest of elegant lines in his drawing of a trumpet, or the helmet of black hair atop the filigree of lines in his portrait of Charlie Parker. Martin has somehow forged a bond between a certain kind of visual texture and a style of music that is so powerful we sometimes seem to be hearing his drawing.

We are celebrating David Stone Martin's art not only for its high level of draftsmanship and its innate grace, but also because it was expressive enough to uniquely represent an era of music and the particular mood of a time in the history of illustration. The sense of art changing in the 1950s, of those illustrators being on the brink of a new esthetic, is nowhere more powerfully embodied than in the innocent high spirits of David Stone Martin's art. When we sense his pen line exploring the unbordered field of the white paper, it is more than just the graphic jolt he achieves with the magic of his hand: it is like seeing a kid skating figure eights in the virgin ice of a newly discovered pond.

James McMullan

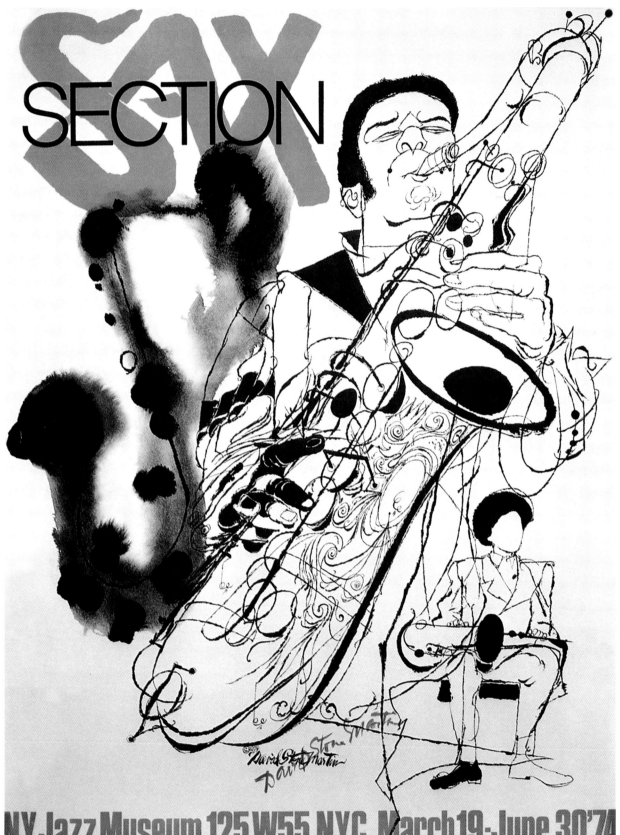

"Sax Section," poster for the New York Jazz Museum exhibition, 1974.

J. ALLEN ST. JOHN
(1872-1957)

J(ames) Allen St. John was one of the premier illustrators of Chicago's book publishing industry in the early decades of the twentieth century and was a star of the pulp magazines. Now largely unremembered and greatly overshadowed by the fame of artists such as Frank Frazetta and Boris Vallejo, St. John was important for having formulated the look of heroic fantasy art and for having defined and elutriated its iconography in more than a thousand published works. His art was enormously influential during a particularly formative time for American fiction–a time when readers were in love with a good story, and good fiction was everywhere.

A facile draftsman, St. John was proficient in a broad range of media and was adept at watercolors, oils, gouache and pen-and-ink. His vigorous color paintings and strikingly fluid pen-and-ink drawings for the stories of Edgar Rice Burroughs helped to popularize and give indelible vision to the adventures of such fictional heroes as John Carter, Carson Napier and—most famous of all of Burroughs's creations—the indomitable Tarzan. Based in part on the style of the sixteenth-century Flemish painter Peter Paul Rubens, St. John's art captured all of the essential vitality of that Renaissance master's work, while reducing its complex, helical compositions to simple arcs that dazzled the viewer with their robust flourish. Even in his line art one can see St. John's effect on such major adventure artists as Hal Foster, the creator of the comic strip *Prince Valiant*, and Alex Raymond, the originator of *Flash Gordon.*

Grandson to the noted nineteenth-century painter Hilliard Hely, St. John was born in Chicago and traveled abroad at an early age with his mother, Hely's daughter, who aspired to be a painter herself. While in Europe, the young St. John studied with Jean-Paul Laurens in Paris and with Henri Vierin in Belgium. On returning to the United States he traveled the American West, befriending and painting alongside Western artist Eugene Torrey. He eventually made his way to New York where he attended the Art Students League and studied with such illustration notables as William Merritt Chase and F.V. DuMond. Despite the extent of his art education, however, St. John considered himself to have been largely self-taught.

He began his illustration career while in New York and achieved early success there as a portraitist before moving back to Chicago. He remained in Chicago for the rest of his life and for nearly five decades he produced hundreds of illustrations for that city's book and magazine markets. A prolific artist by any standard, St. John still found time to teach at the Art Institute of Chicago and later at the American Academy of Art. Among the scores of artists who studied with him was Harold W. McCauley, also destined to become a stalwart of the Chicago-based pulp magazines.

St. John's first book assignment was done in 1904 for the A.C. McClurg Book Company, for which he would eventually illustrate many of the adventure novels of Edgar Rice Burroughs. The first of these, *The Beasts of Tarzan*, was published in 1916 and was quickly followed by others, including novels in Burroughs' Mars and Pelucidar series. St. John's art became almost immediately synonymous with the writings of Burroughs, who, in his own time, was among the most popular and successful writers in America. Their association through the McClurg Company lasted for nearly twenty years until Burroughs formed his own publishing firm in 1936.

In addition to his book illustrations, St. John was a prolific contributor to the pulp magazines, so called because of the inexpensive pulp paper on which they were printed. The American pulp magazines grew out of the penny dreadfuls of England and the U.S. and from the story papers, tabloid-size publications that usually centered on the exploits of a single, continuing character. They came into being with the invention of the pulp paper process in Germany in the 1880s and disappeared, almost overnight, in 1955, due to a number of factors (not the least of which was the entrenchment of television). St. John lived through the best days of that market and his magazine clients included *Bluebook*, *Weird Tales*, *Magic Carpet*, *Amazing Stories*, *Fantastic Adventures*, *Science Stories*, *Fate* and *Other Worlds.*

St. John's romantic flair and vigorous painting style were the perfect accessory to the adventure-driven stories of an earlier era when pulp fiction was the predominant reading matter of adolescent males. His art set the spirit and rhythm for heroic fantasy illustration that today survives through the great narrative paintings of Frank Frazetta and countless others who revel in the daring exploits of brawny heroes, fair damsels in need of rescue, and in the thousand fearsome beasts and monsters of our wildest imaginings.

Vincent Di Fate

Photo of the artist courtesy of Darrell C. Richardson.

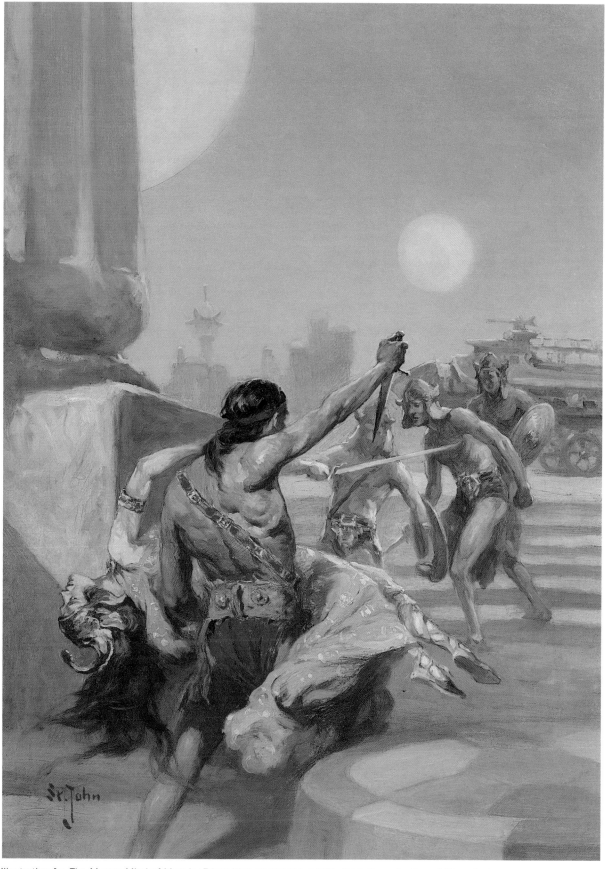

Illustration for *The Master Mind of Mars* by Edgar Rice Burroughs, 1928. From the collection of Glynn Crain.

MARK SUMMERS
(b. 1951)

The Hamilton King Award, created by Mrs. Hamilton King in memory of her husband through a bequest, is presented annually for the best illustration of the year by a member of the Society. The selection is made by former recipients of this award and may be won only once.

Hamilton King Award 1965-2000

1965	Paul Calle
1966	Bernie Fuchs
1967	Mark English
1968	Robert Peak
1969	Alan E. Cober
1970	Ray Ameijide
1971	Miriam Schottland
1972	Charles Santore
1973	Dave Blossom
1974	Fred Otnes
1975	Carol Anthony
1976	Judith Jampel
1977	Leo & Diane Dillon
1978	Daniel Schwartz
1979	William Teason
1980	Wilson McLean
1981	Gerald McConnell
1982	Robert Heindel
1983	Robert M. Cunningham
1984	Braldt Bralds
1985	Attila Hejja
1986	Doug Johnson
1987	Kinuko Y. Craft
1988	James McMullan
1989	Guy Billout
1990	Edward Sorel
1991	Brad Holland
1992	Gary Kelley
1993	Jerry Pinkney
1994	John Collier
1995	C.F. Payne
1996	Etienne Delessert
1997	Marshall Arisman
1998	Jack Unruh
1999	Gregory Manchess
2000	Mark Summers

In these days of high tech infatuation with high tech buy-outs and high tech print-outs, it seems somewhat ironic, yet delightfully appropriate to find Mark Summers this year's Hamilton King Award winner. It is also ironic that Mark Summers should receive this prestigious award for his portrait of Leonardo DiCaprio at a time when we are more familiar with Mark's portraits of such notables as Winston Churchill, Emily Dickinson and Ludwig van Beethoven. This, of course, is more of a reflection on us rather than on Mark. But in telling Mark Summers's story, it is fitting that the Society of Illustrators has chosen this piece and this time to give him the Hamilton King Award.

Over the past ten years I have known Mark Summers and have come to realize that the best way to describe him is found in the filters by which he allows us to see his world. Mark's art has a timeless quality. The intelligence, care and grace found in all of his work is a reflection of the qualities he brings to his everyday life. Each piece of art is done on scratchboard with repeating parallel lines that reveal to us the form and structure of his pictures by the variation of thickness and thinness. One can also note the many parallels found in Mark himself that reveal to us the artist we have come to know and admire.

It was 1965 in Burlington, Ontario, not five minutes from where Mark now resides, that two major events took place that changed his life forever. The Society of Illustrators awarded Paul Calle its very first Hamilton King Award and Mark met the love of his life, Shawn. At a time when many boys in Canada were dreaming of Maurice the Rocket and Lord Stanley's Cup, Mark was reading literature and learning about Norman Rockwell's world of illustration. This set the course for Mark's artistic life.

As Mark tells it, literature was a huge part of the Summers' household, and if you wanted to be part of the conversation at the dinner table, you had better have read something. After high school Mark studied illustration at the Ontario College of Art. Like many young illustrators, the next few years were tough, but through Shawn's persistence, Mark sent his work to Steven Heller at the *New York Times Book Review*. At a moment when Mark's career hung in the balance, the call came from the *Times* for a portrait of General Douglas MacArthur. Mark performed beautifully and was rewarded by one assignment per week for the next six months. Once again, a beautiful parallel line was found, a perfect union was made to complete the picture of the illustrator I am proud to call my friend and pleased to see honored by this year's Hamilton King Award.

C.F. Payne

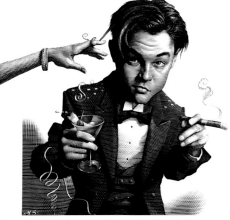

"Party Animal." Portrait of Leonardo DiCaprio for *Entertainment Weekly*.

editorial

Diane Dillon, Chair
Illustrator

Phil Boatwright
Illustrator

Jody Hewgill
Illustrator

Ethel Kessler
*President, Kessler Design
Group*

Nancy R. Leo-Kelly
*Associate Art Director,
Dial Books for Young Readers,
Penguin Putnam Inc.*

William Low
Illustrator

Stanley Martucci
*Illustrator in collaboration with
Cheryl Griesbach*

Judith Murello
*Senior Art Director,
Berkley Publishing Group,
Penguin Putnam Inc.*

Dennis Ziemienski
Illustrator

Jury

1 Gold Medal

Artist: **Hervé Blondon**

Art Director: Nicki Kalish

Client: The New York Times/Sophisticated
Traveler Magazine

Medium: Pastel on paper

Size: 15" x 10"

"Like everyone else, the illustrator forms mental images as
he reads a text, so, ultimately, the illustration represents the under-
standing of a single person—himself. But more than
simply imposing his vision on the viewer, the good illustrator also
attempts to seize upon and preserve what the viewer is most likely to
have perceived in the text, rendering the work more 'commercial' than
a purely original work of art. Still, the finished product retains the
dynamics of original art in that the illustrator is the sole author of it
and the illustration remains free of anyone else's pre-established
notions. Is it art? You tell me."

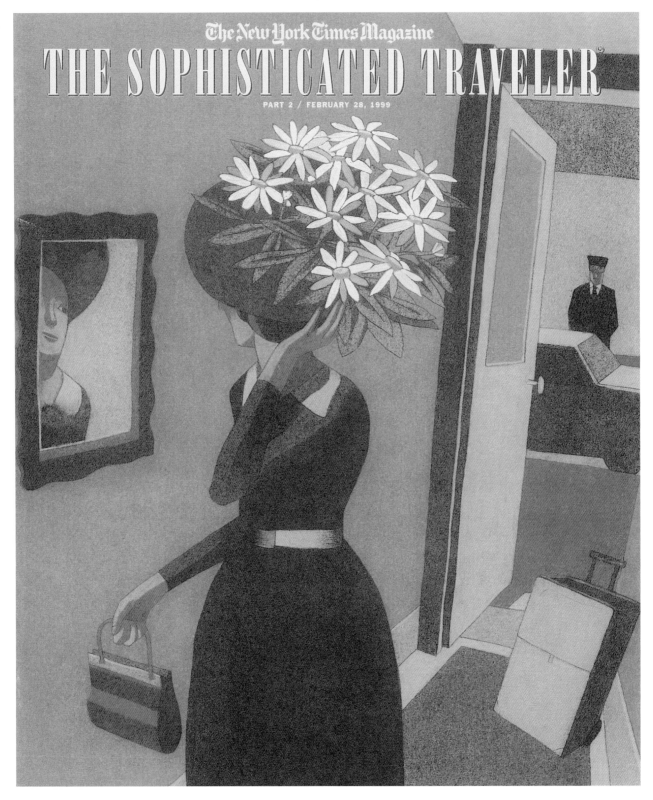

2 Gold Medal

Artist: **Kinuko Y. Craft**

Art Director: Larry Laukhuf

Client: Angels On Earth

Medium: Oil

Angels on Earth, a publication of *Guideposts*, had an article coming up about smuggling bibles into China. It was one of their "stories of humans who have played angelic roles in daily life." In reality, Craft wasn't thrilled with the synopsis, nor with art director Larry Laukhauf's concept, and she was unclear on how a Chinese angel might look. Nonetheless, she found a solution. She claims to thrive on such assignments, but is glad when the job is done. "My mind is not there when the printed piece comes out."

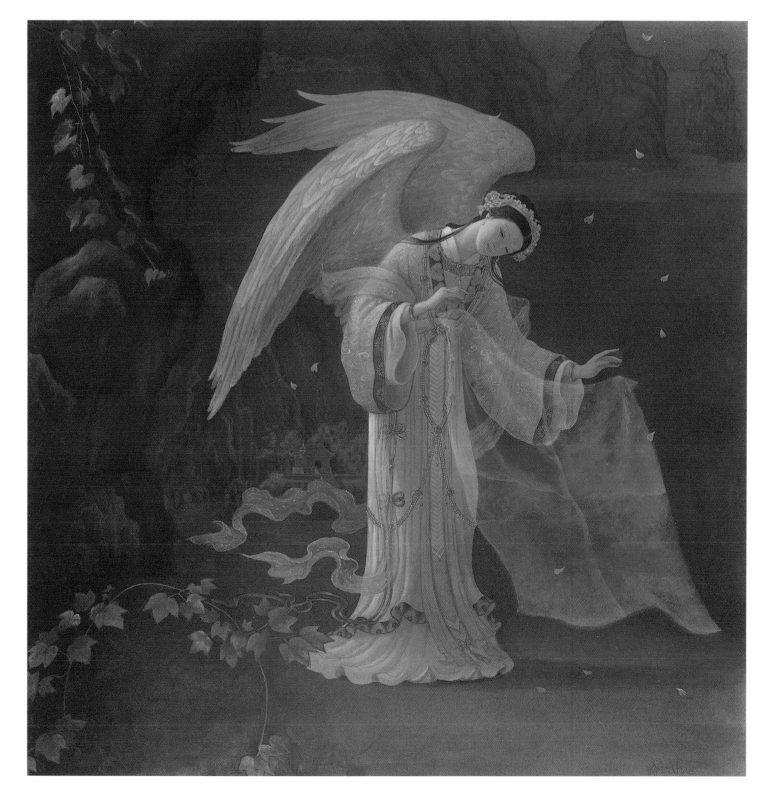

3 Gold Medal

Artist: **John Jude Palencar**

Art Director: Shauna Wolf Narcisco

Client: Amazing Stories Magazine

Medium: Acrylic on ragboard

Size: 18" x 30"

A past medal winner in the editorial category, Palencar's work has appeared on hundreds of book covers, in magazines and for select advertising clients. He has been an artist-in-residence in Ireland and his work was included in a special exhibit, "Images of Ireland," held at the National Museum in Dublin. His award-winning work has appeared on book covers for such authors as H.P. Lovecraft, Ursula LeGuin, Marion Zimmer Bradley, Octavia Butler and Stephen King, as well as for his work for National Geographic Television and *Smithsonian* magazine.

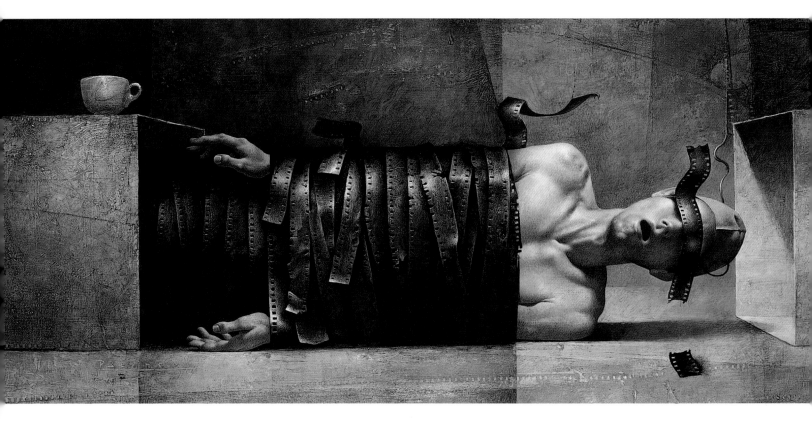

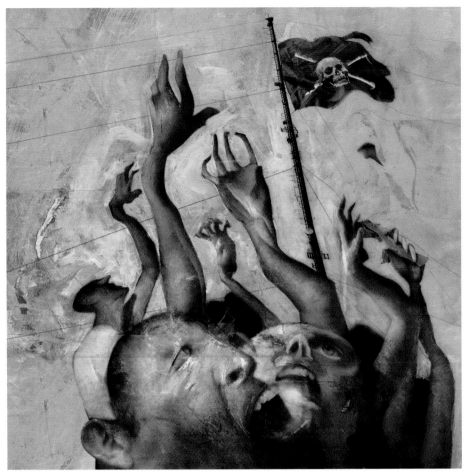

4 Silver Medal

Artist: **Dave McKean**

Art Director: Nicholas E. Torello

Client: Penthouse

An illustrator in England since 1986, David McKean has illustrated several comics including *Arkham Asylum, Signal to Noise, Mr. Punch* and the self-penned *Cages.* Some of his 120 CDs are recent releases by Michael Nyman, Counting Crows, Dream Theatre and Bill Bruford. He also runs a small jazz label called Feral, is doing film work for Channel 4, and is working on a second children's book—his first, *The Day I Swapped My Dad for Two Goldfish,* is being developed for an animated TV show. He says, "*Penthouse* was great to work with. This is a Photoshop comp, mixing a painted piece with photographic details. I submitted eight roughs of varying obscurity. This, the most straightforward, seemed to be the favorite."

5 Silver Medal

Artist: **C.F. Payne**

Art Director: Steven Heller

Client: The New York Times Book Review

Medium: Mixed on board

Size: 15" x 12"

C.F. Payne was given an option by *New York Times Book Review* editor Steven Heller: Roosevelt or Hemingway. The decision was easy, and not because he had already done the bearded author. It was the interesting quality of the First Lady's face that captured his imagination. However, in all his reference, there was little that he found suitable. He sent off two imaginative sketches to New York, but worked up one to a finish while waiting for approval. Naturally, Heller chose the other, so Payne had to use his powers of persuasion to reconsider his choice. Amazingly, it worked.

6 Silver Medal

Artist: **Chris Sheban**

Art Director: Paul Carstensen

Client: US Airways/Attaché

Medium: Watercolor on paper

Size: 13" x 14"

In this story about rowing, the tone for the illustration is set in the first paragraph: "From beneath the bridge, we row into splendor, as the setting sun fires the river with magenta and flames of gold. Tall smokestacks rise from the powerhouse and waft plumes of smoke into the sky, the epitaph of fuel burned into power."

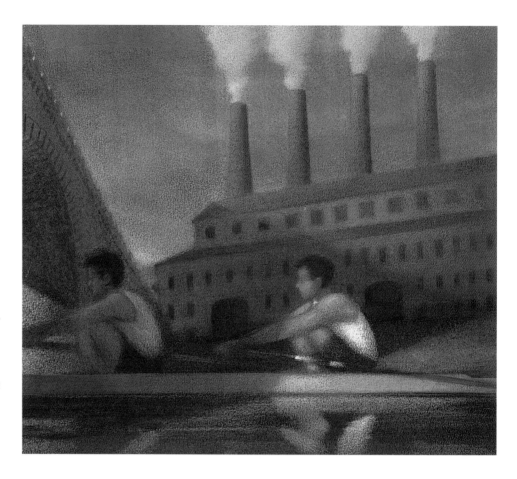

7

Artist: **Greg Swearingen**

Art Director: Gary Sluzewski

Client: Cleveland Magazine

Medium: Mixed on board

Size: 20" x 16"

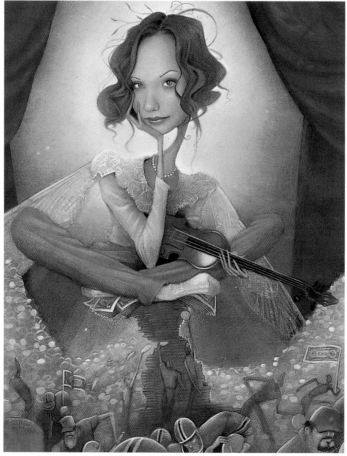

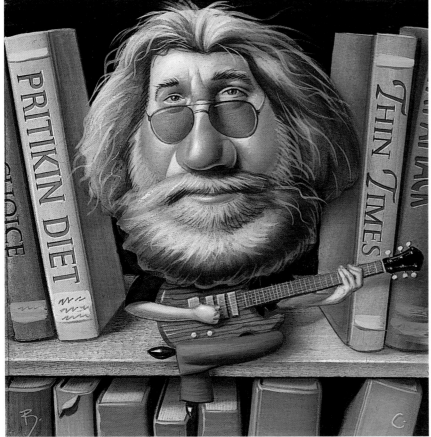

8

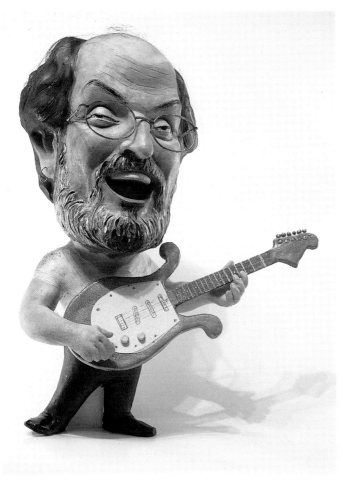

9

8

Artist: **Bill Cigliano**

Art Director: Steven Heller

Client: The New York Times Book Review

Medium: Oil on gessoed board

Size: 9" x 9"

9

Artist: **Bruce Strachan**

Art Director: Steven Heller

Client: The New York Times Book Review

Medium: Clay

Size: 14" x 10"

10

Artist: **C.F. Payne**

Art Director: Dorothy O'Connor-Jones

Client: Dow Jones Investment Advisor

Medium: Mixed on board

Size: 20" x 16"

11

Artist: **C.F. Payne**

Art Director: Steven Heller

Client: The New York Times Book Review

Medium: Mixed on board

Size: 15" x 13"

12

Artist: **Sebastian Kruger**

Art Director: Nicholas E. Torello

Client: Penthouse

13

Artist: **Steve Brodner**

Art Director: Janet Froelich

Client: The New York Times Magazine

Medium: Watercolor on watercolor paper

Size: 20" x 15"

14

Artist: **Matt Mahurin**

Art Director: Fred Woodward

Client: Rolling Stone

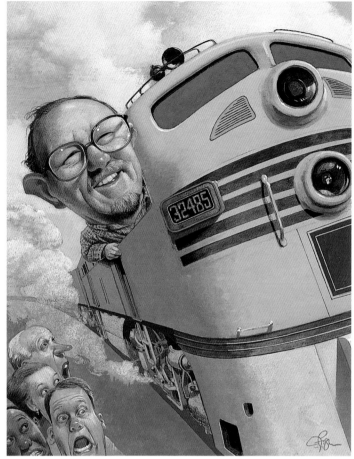

10

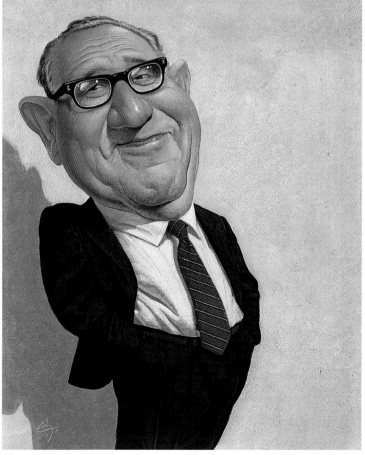

11

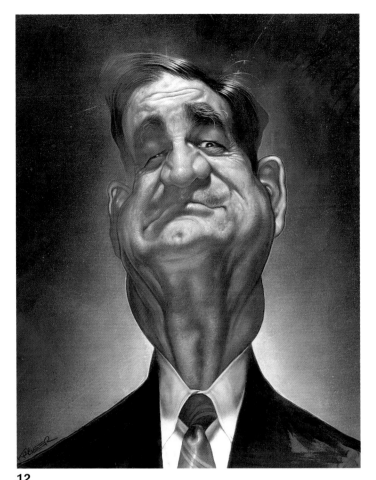

12

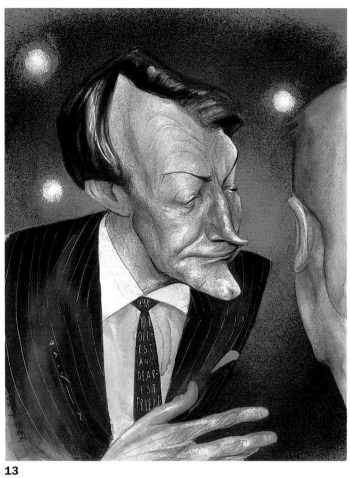

13

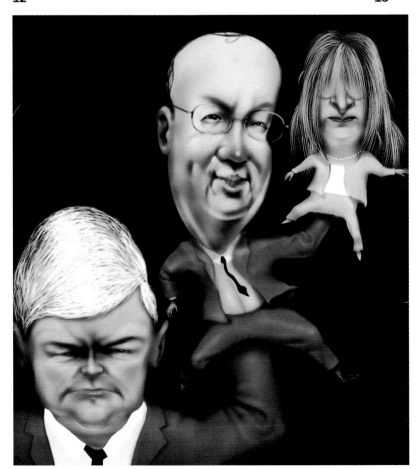

14

15

Artist: **James Bennett**

Art Director: Malcolm Frouman

Client: Business Week

Medium: Oil on board

Size: 17" x 14"

16

Artist: **Roberto Parada**

Art Director: Michael Walsh

Client: Sports Illustrated

Medium: Oil on board

Size: 18" x 24"

17

Artist: **Roberto Parada**

Art Director: Rockwell Harwood

Client: Esquire

Medium: Oil on canvas

Size: 18" x 24"

18

Artist: **Mark Stutzman**

Art Director: Geraldine Hesler

Client: Entertainment Weekly

Medium: Watercolor, airbrush on board

Size: 22" x 18"

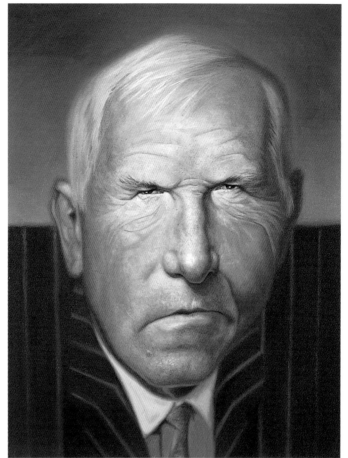

15

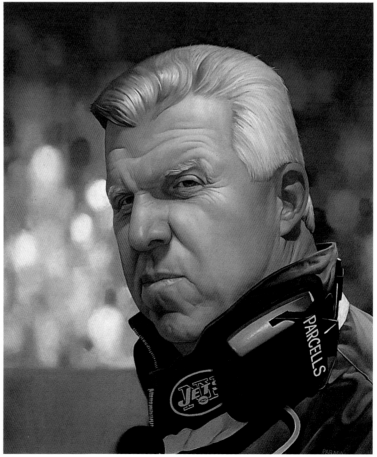

16

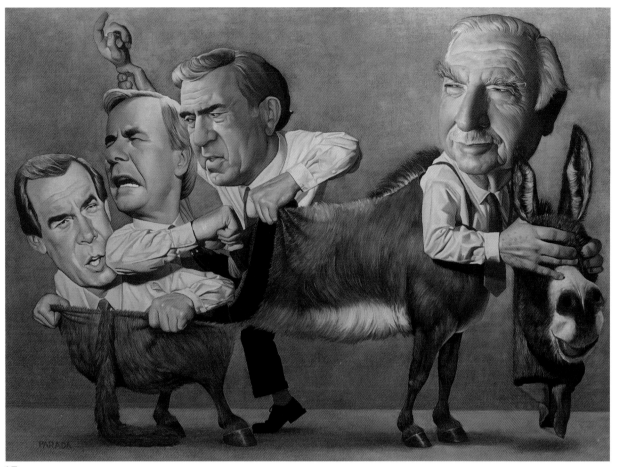

17

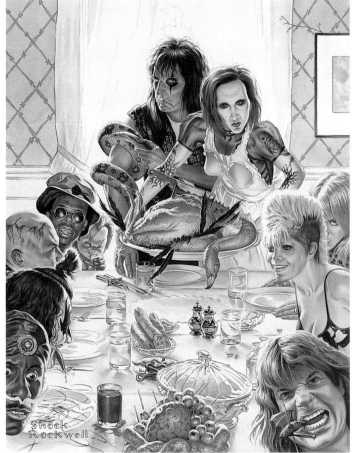

18

19

Artist: **James Bennett**

Art Director: Dorothy O'Connor-Jones

Client: Dow Jones Investment Advisor

Medium: Oil on board

Size: 16" x 12"

20

Artist: **Steve Brodner**

Art Director: Kelly Doe

Client: Washington Post

Medium: Watercolor on watercolor paper

Size: 20" x 15"

21

Artist: **David O'Keefe**

Art Director: Kenneth Smith

Client: TIME

Medium: Clay sculpture

Size: 6" x 6"

22

Artist: **James Bennett**

Art Directors: Alana Andrews
 Paul Carstensen

Client: US Airways/Attaché

Medium: Oil on board

Size: 17" x 14"

23

Artist: **Scott Laumann**

Art Director: Brandon Kauulla

Client: Vib

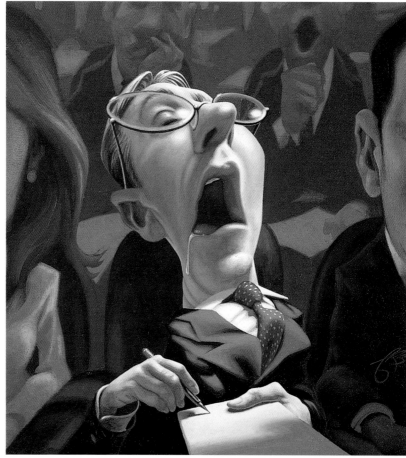

19

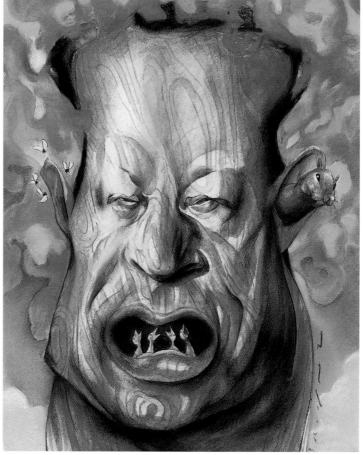

20

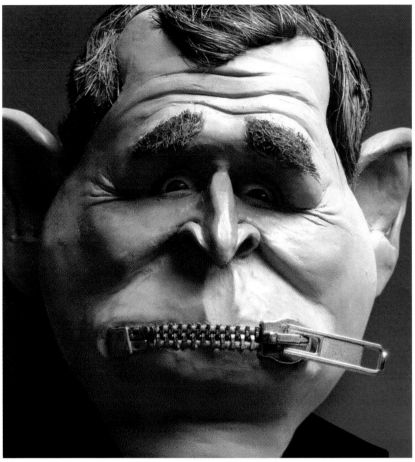

21

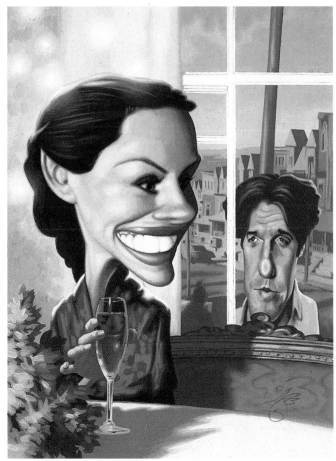

22

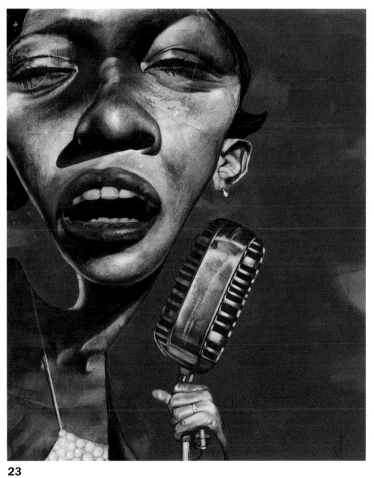

23

24

Artist: **Anita Kunz**

Art Director: Tom Miller

Client: TIME

Medium: Watercolor board

Size: 9" x 10"

25

Artist: **Daniel Adel**

Art Director: Nicholas E. Torello

Client: Penthouse

Medium: Oil on canvas

26

Artist: **Anita Kunz**

Art Director: Joe Kimberling

Client: Entertainment Weekly

Medium: Watercolor on board

Size: 10" x 7"

27

Artist: **Anita Kunz**

Art Director: Chalkley Calderwood Pratt

Client: Premiere

Medium: Watercolor on board

Size: 10" x 7"

28

Artist: **Roberto Parada**

Art Director: Liliane Vilmenay

Client: Entertainment Weekly

Medium: Oil on canvas

Size: 14" x 14"

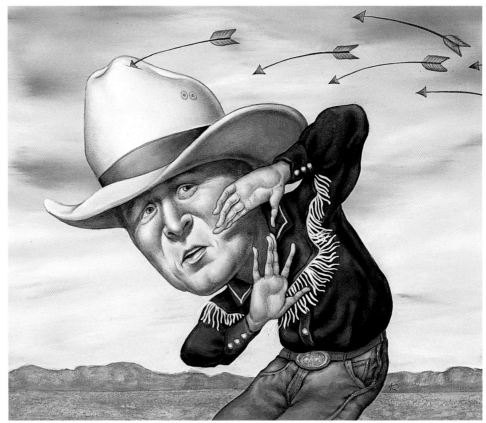

24

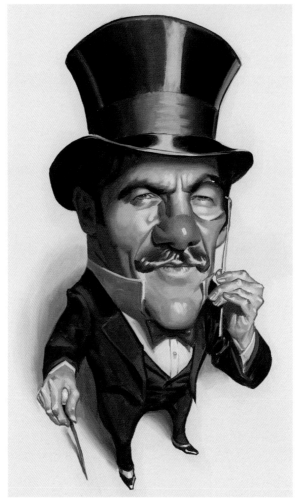

25

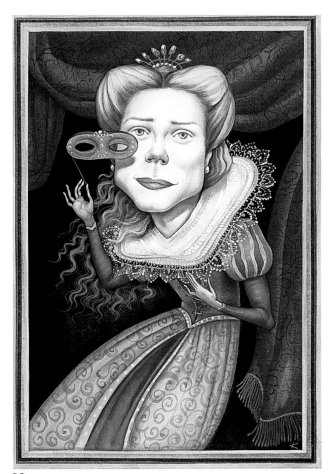

26

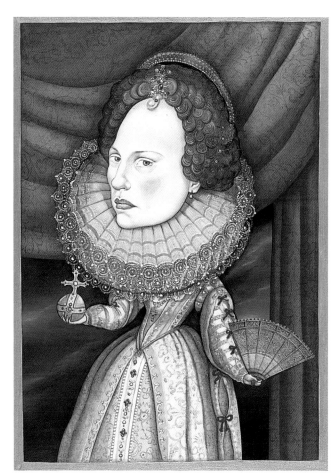

27

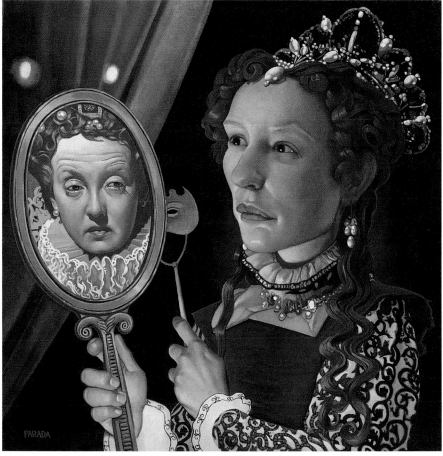

28

29

Artist: **David G. Klein**

Client: INX./United Features

Medium: Linocut on paper

Size: 10" x 7"

30

Artist: **Joe Ciardiello**

Art Director: Tamotsu Ejima

Client: Playboy Japan

Medium: Pen & ink on paper

Size: 12" x 9"

31

Artist: **Mark Summers**

Art Directors: Robin Gilmore-Barnes
 Betsy Urrico

Client: The Atlantic Monthly

Medium: Scratchboard, ink

Size: 8" x 6"

32

Artist: **Mark Summers**

Art Director: Joe Kimberling

Client: Entertainment Weekly

Medium: Scratchboard

Size: 12" x 10"

33

Artist: **Mark Summers**

Art Director: Steven Heller

Client: The New York Times Book Review

Medium: Scratchboard, watercolor

Size: 12" x 10"

34

Artist: **Joseph Salina**

Art Director: Marti Golon

Client: TIME

Medium: Acrylic, airbrush on board

29

30

31

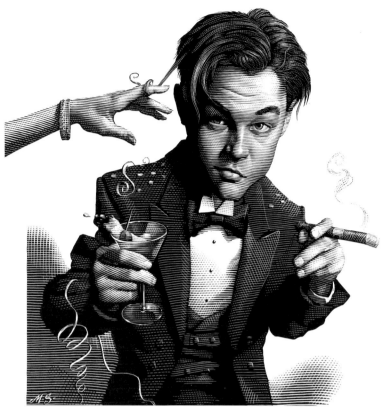

32

33

34

35

Artist: **Peter de Sève**

Art Director: Ellene Wundrok

Client: Entertainment Weekly

Medium: Watercolor on watercolor paper

Size: 12" x 8"

36

Artist: **Nick Galifianakis**

Art Director: Carolyn Hax

Client: Washington Post

Medium: Pen & ink on Bristol

Size: 9" x 9"

37

Artist: **Peter de Sève**

Art Director: Francoise Mouly

Client: The New Yorker

Medium: Watercolor, ink on
 watercolor paper

Size: 14" x 10"

38

Artist: **Franklin McMahon**

Art Director: Tom Wright

Client: U.S. Catholic Magazine

Medium: Watercolor on Arches 140 lb.

Size: 30" x 22"

39

Artist: **Morgan Carver**

Art Directors: Jane Martin
 Catherine Aldrich

Client: The Boston Globe

Medium: Acrylic on Birch panel

Size: 22" x 22"

35

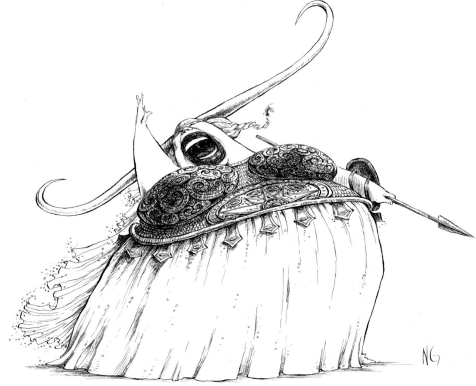

36

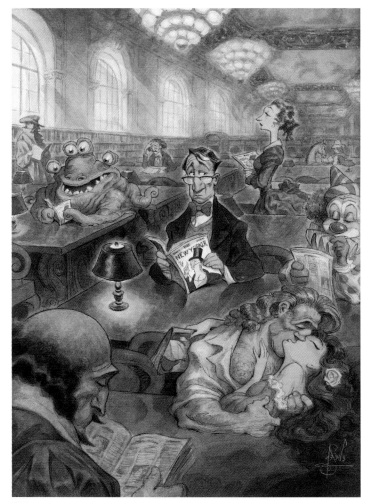

37

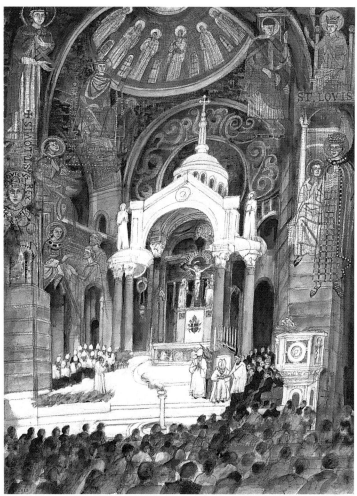

38

39

40

Artist: **Steve McAfee**

Art Director: Wes Bausmith

Client: Los Angeles Times

Medium: Digital

Size: 9" x 7"

41

Artist: **Wilson McLean**

Art Director: Frank DeVino

Client: Penthouse

Medium: Oil on canvas

Size: 20" x 20"

42

Artist: **Rob Day**

Art Director: Fred Woodward

Client: Rolling Stone

Medium: Oil on paper

43

Artist: **Gary Aagaard**

Art Director: Minh Uong

Client: The Village Voice

Medium: Oil on canvas

Size: 17" x 12"

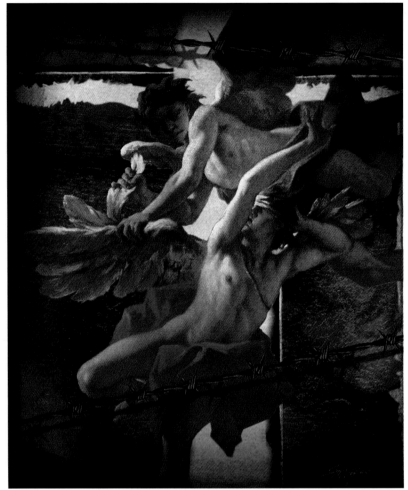

40

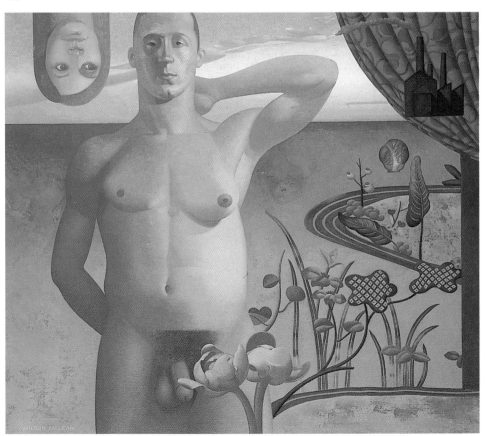

41

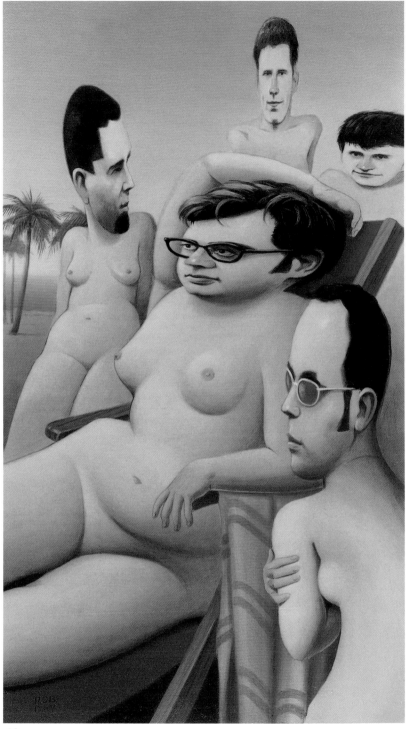

42

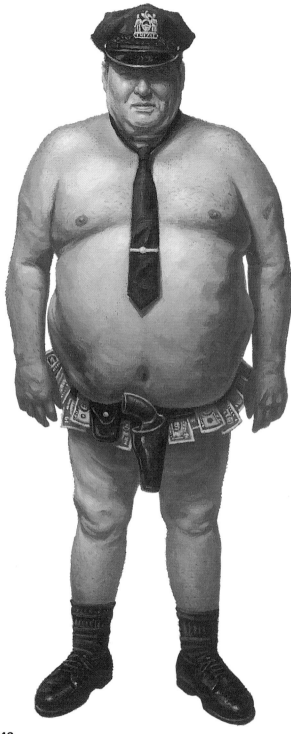

43

44

Artist: **Greg Spalenka**

Art Director: Susan Levin

Client: The Boston Globe

Medium: Digital, paint, collage

Size: 14" x 11"

45

Artist: **David Ho**

Art Director: Shauna Wolf Narciso

Client: Amazing Stories

Medium: Digital

Size: 20" x 18"

46

Artist: **John Jude Palencar**

Art Director: Ed Rich

Client: Smithsonian Magazine

Medium: Acrylic on ragboard

Size: 30" x 37"

47

Artist: **Sterling Hundley**

Art Director: June Gunawan

Client: Christianity Today

Medium: Pastel on Stonehenge

Size: 22" x 17"

48

Artist: **Cynthia von Buhler**

Art Director: Sharon Okamoto

Client: Civilization/The Library of Congress

Medium: Gouache on canvas, mixed media

Size: 38" x 25"

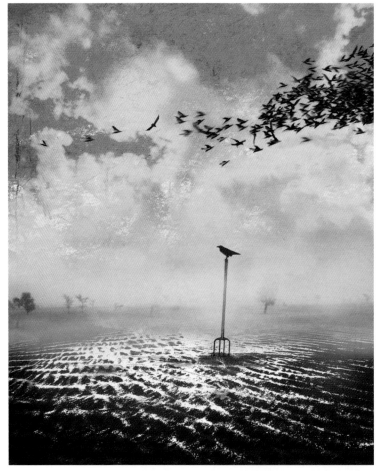

44

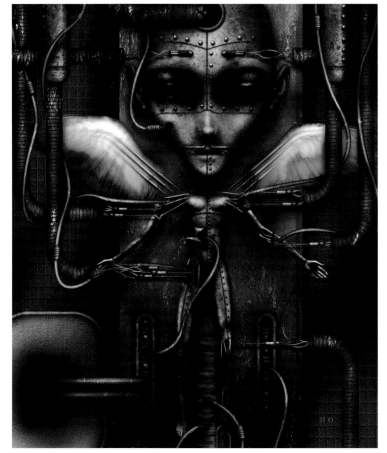

45

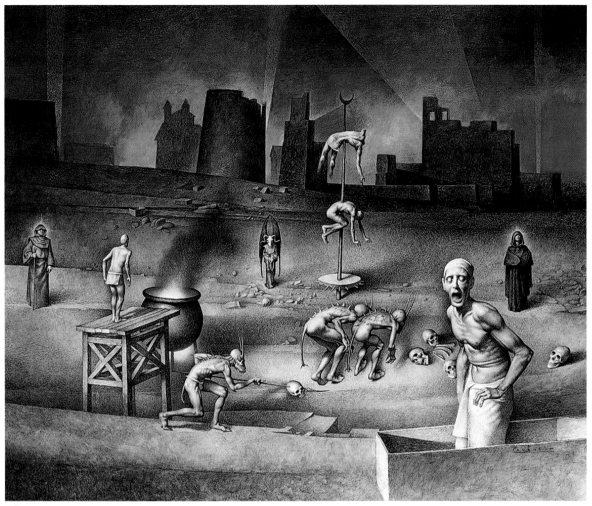

46

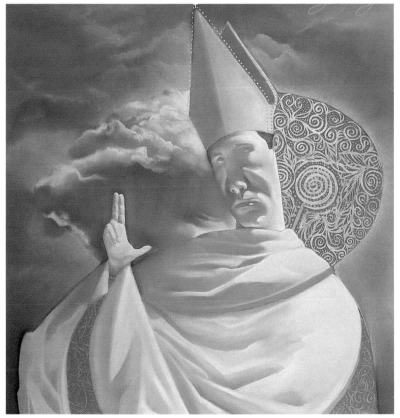

47

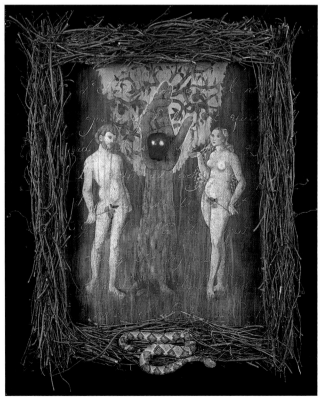

48

49

Artist: **Raymond Verdaguer**

Art Director: Frank DeVino

Client: Penthouse

Medium: Multicolored Linoleum Cut on fine Japanese Rice paper

Size: 16" x 11"

50

Artist: **Jack Unruh**

Art Director: Richard M. Baron

Client: Road & Track

Medium: Ink, watercolor on board

Size: 20" x 16"

51

Artist: **Jack Unruh**

Art Director: Fred Woodward

Client: Rolling Stone

Medium: Ink, watercolor on board

52

Artist: **Ralph Steadman**

Art Director: Michael Lawton

Client: Men's Journal

Medium: Mixed

53

Artist: **Boris Kulikov**

Art Director: Pamela Dunlop-Shohl

Client: We Alaskans

Medium: Mixed on paper

Size: 12" x 10"

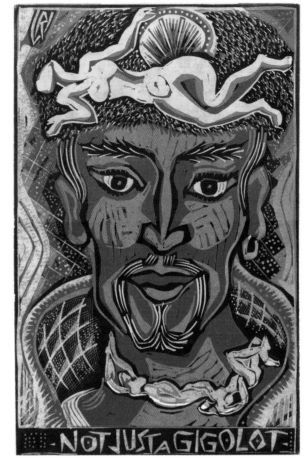

49

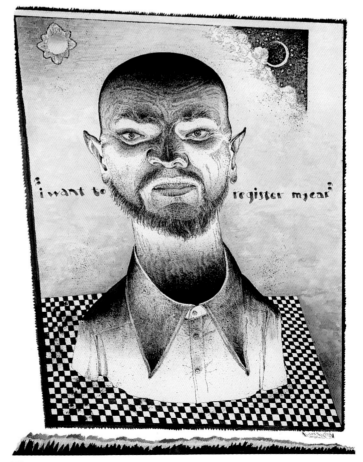

50

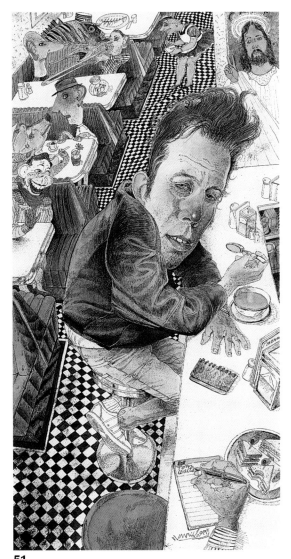

51

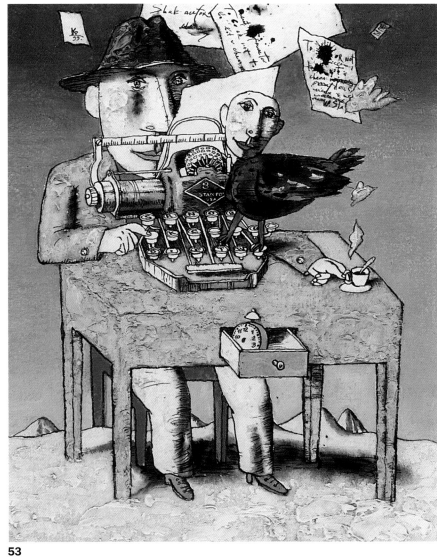

53

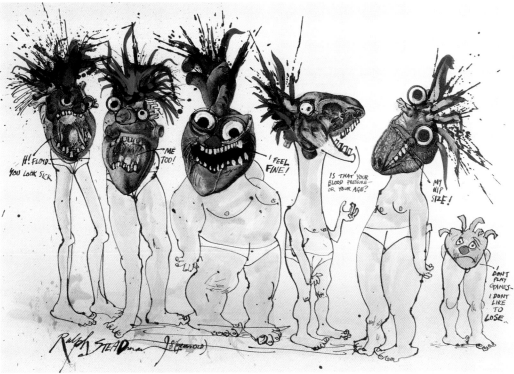

52

54

Artist: **Josef Gast**

Art Director: Cathy Orr Gontarek

Client: The Pennsylvania Gazette

Medium: Gouache on Typar

Size: 11" x 13"

55

Artist: **Greg Tucker**

Art Director: Cynthia L. Currie

Client: Kiplinger's Personal Finance
Magazine

Medium: Pastel (Carbothello pencils)
on paper

Size: 13" x 10"

56

Artist: **Gerard Dubois**

Art Directors: Alissa Levin
Donald Partyka

Client: Internal Auditor Magazine

Medium: Acrylic on paper

57

Artist: **Tom Curry**

Art Director: Traci Churchill

Client: Your Company

Medium: Mixed

Size: 20" x 15"

58

Artist: **Christian Northeast**

Art Director: Tom Staebler

Client: Playboy

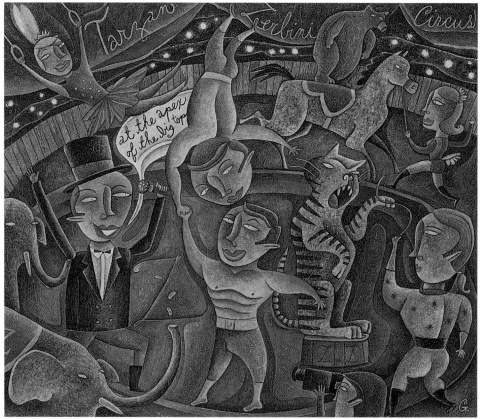

54

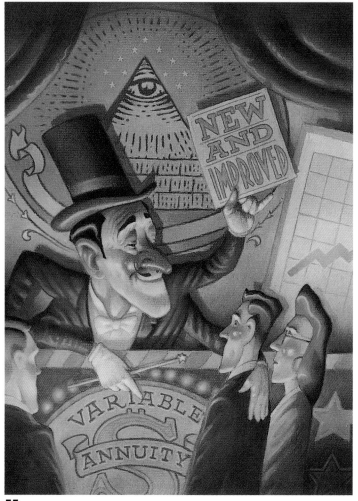

55

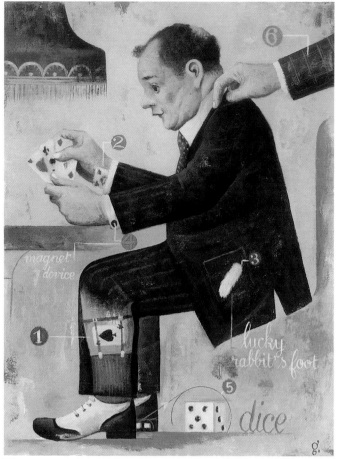

56

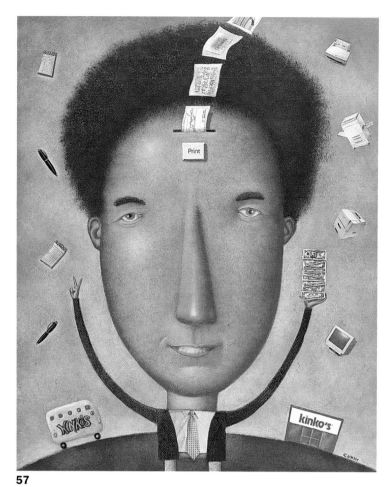

57

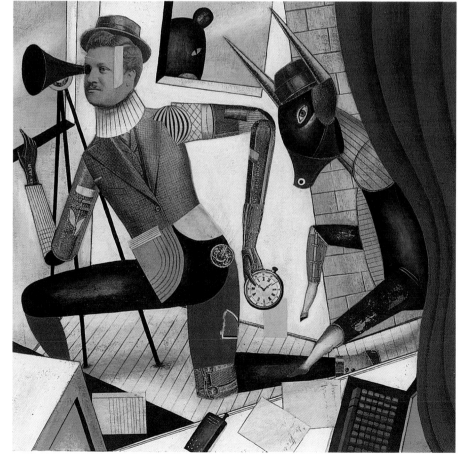

58

59

Artist: **Cathleen Toelke**

Art Director: Barbara Koster

Client: University of Minnesota Alumni
Association

Medium: Pastel on paper

Size: 15" x 9"

60

Artist: **Jonathan Barkat**

Art Directors: Louise Kollenbaum
Natacha Gonzalez

Client: California Lawyer

Medium: Mixed

61

Artist: **Gerard Dubois**

Art Director: Robin Gilmore-Barnes

Client: The Atlantic Monthly

Medium: Acrylic on paper

Size: 10" x 9"

62

Artist: **Etienne Delessert**

Client: Le Monde

Medium: Watercolor on paper

63

Artist: **Etienne Delessert**

Art Director: Dominique Roynette

Client: Le Monde

Medium: Watercolor on paper

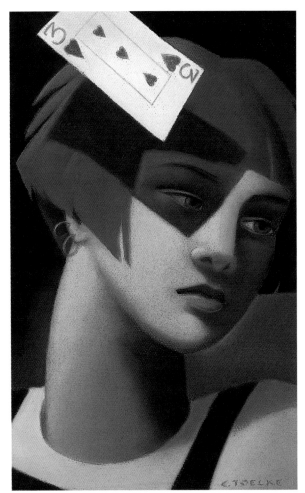

59

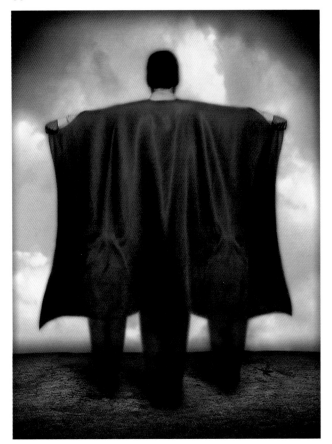

60

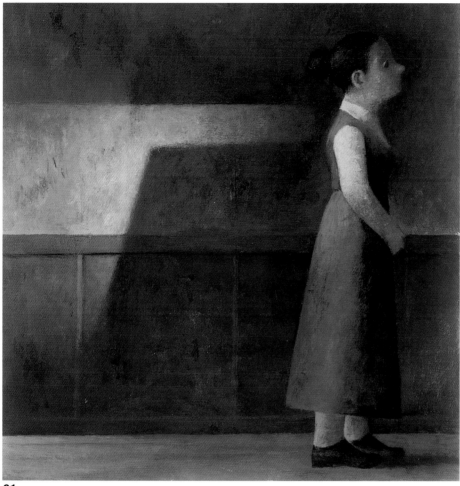

61

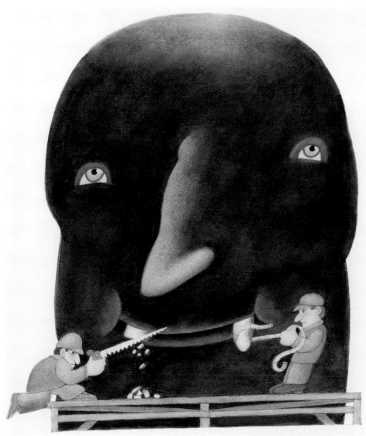

62

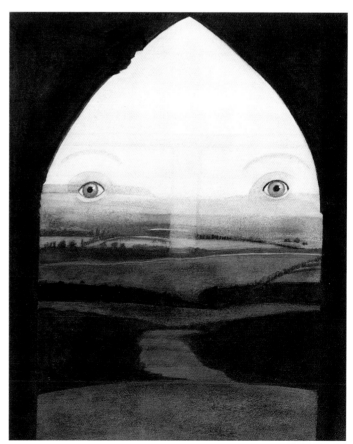

63

64

Artist: **Marshall Arisman**

Art Director: Francesca Messina

Client: Business Week Magazine

Medium: Oil on paper

65

Artist: **Andrea Ventura**

Art Director: Linda Warren

Client: USC Health

Medium: Acrylic, pastel on paper

Size: 18" x 16"

66

Artist: **David Hollenbach**

Art Director: Cathy Orr Gontarek

Client: The Pennsylvania Gazette

Medium: Mixed on paper

Size: 12" x 9"

67

Artist: **Gregory Manchess**

Art Director: Arem Duplessis

Client: Blaze Magazine

Medium: Oil on gessoed board

Size: 12" x 9"

68

Artist: **Jonathan Barkat**

Art Director: Steven Taylor

Client: Business Week Magazine

Medium: Mixed

69

Artist: **Brad Holland**

Art Director: Shaul Tsemach

Client: Johns Hopkins Magazine

Medium: Acrylic on board

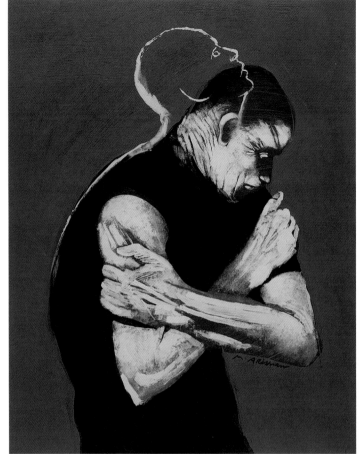

64

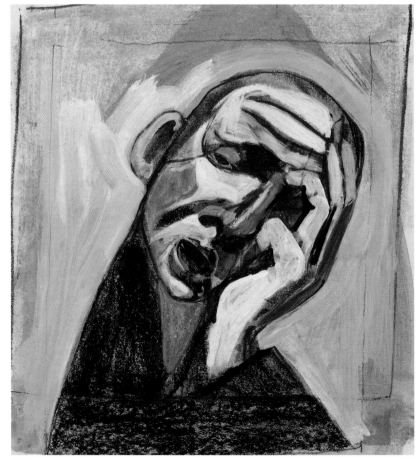

65

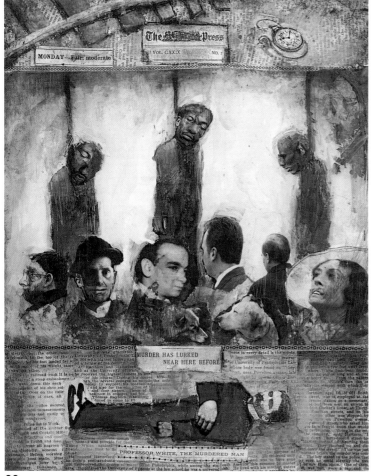

66

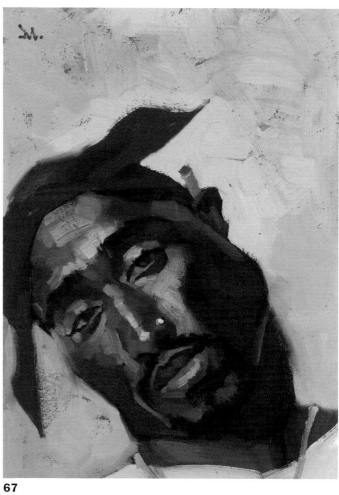

67

68

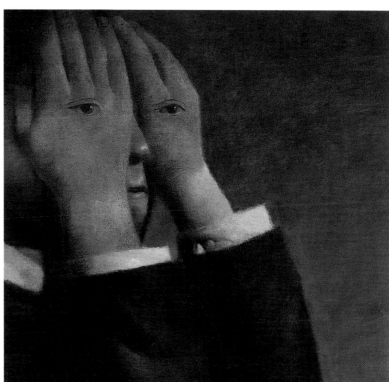

69

70

Artist: **Brad Holland**

Art Director: Sarah Vinas

Client: Global

Medium: Acrylic on board

71

Artist: **Tim Borgert**

Art Director: Ted Pitts

Client: Dayton Daily News

Medium: Mixed on watercolor board

Size: 8" x 12"

72

Artist: **Joe Sorren**

Art Director: Laura Zavetz

Client: Bloomberg Wealth Manager

Medium: Acrylic on canvas

73

Artist: **Joe Sorren**

Art Director: Laura Zavetz

Client: Bloomberg Wealth Manager

Medium: Acrylic on canvas

74

Artist: **Yishai Minkin**

Art Director: Afarin Majidi

Client: Shout Magazine

Medium: Oil on board

Size: 11" x 5"

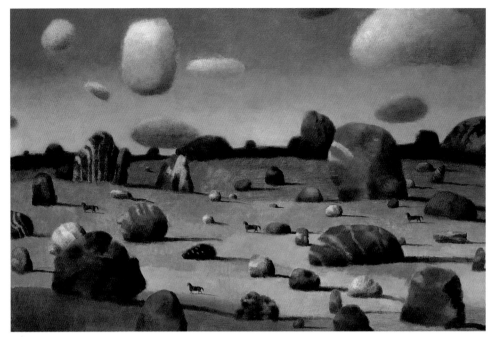

70

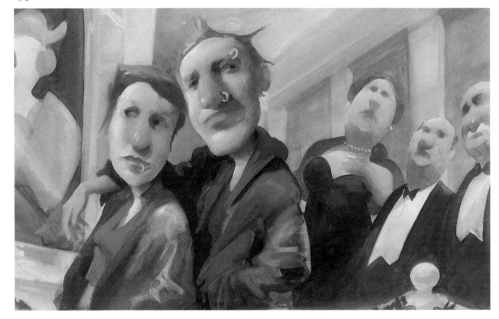

71

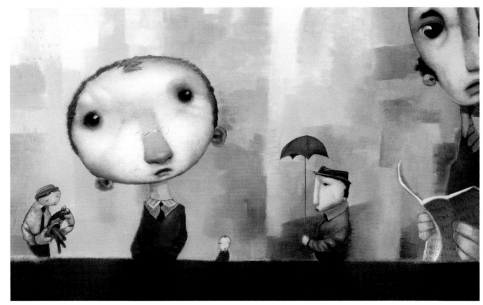

72

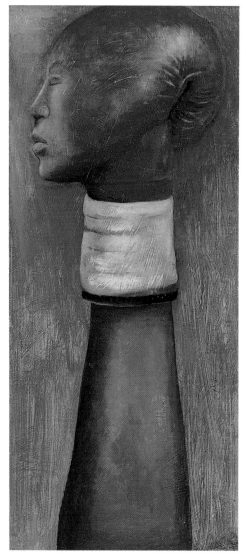

74

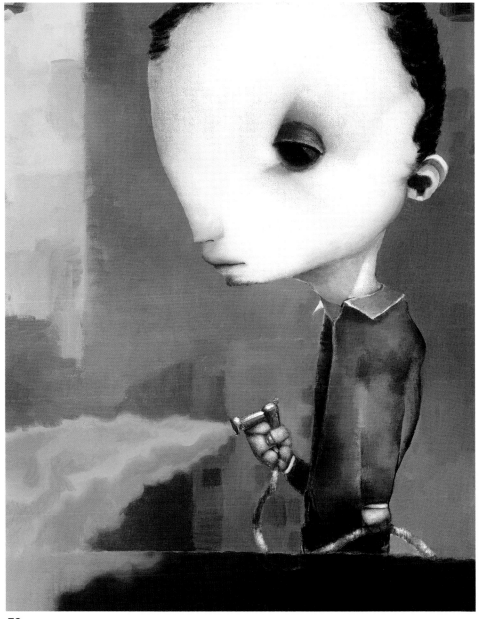

73

75

Artist: **Bill Mayer**

Art Director: Robert Lesser

Client: CFO Magazine

Medium: Gouache on hot press Strathmore

Size: 15" x 20"

76

Artist: **Bill Mayer**

Art Director: Amanda Laine White

Client: Baltimore Magazine

Medium: Dye, gouache on hot press board

Size: 10" x 12"

77

Artist: **Mitch Greenblatt**

Art Director: Evan Gubernick

Client: Revolver

Medium: Mixed

Size: 14" x 20" x 4"

78

Artist: **Daniel Zakroczemski**

Art Director: John Davis

Client: The Buffalo News

Medium: Nupastel on Stonehedge
 (printing) paper

Size: 19" x 12"

79

Artist: Bill Thomson

Art Director: Ann Sack

Client: Institute of Living

Medium: Watercolor on watercolor board

Size: 16" x 12"

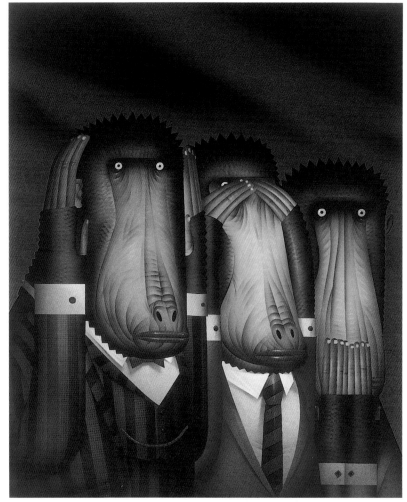

75

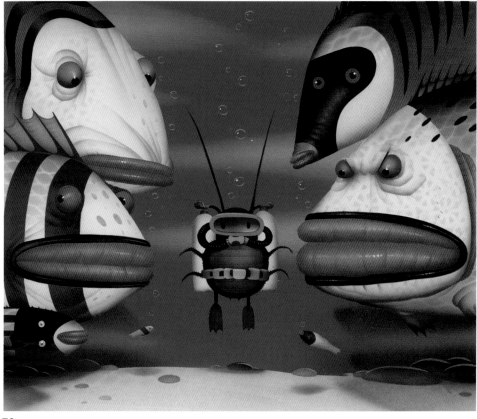

76

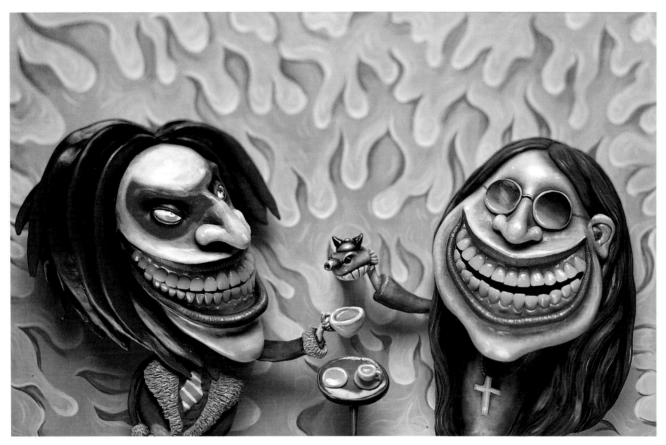

77

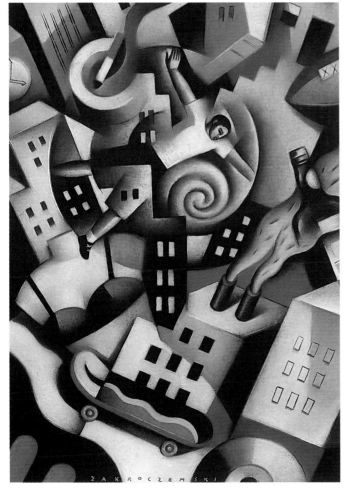

78

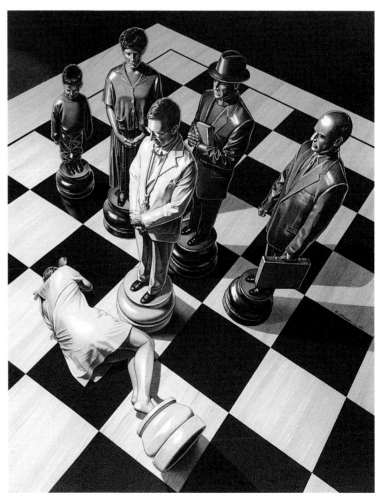

79

80

Artist: **Joseph Daniel Fiedler**

Art Director: Richard Mantel

Client: World Press Review

Medium: Mixed on Strathmore Bristol

Size: 14" x 11"

81

Artist: **Dave Cutler**

Art Director: Seval Newton

Client: AMA Management Review

Medium: Digital

Size: 5" x 7"

82

Artist: **Dave Cutler**

Art Director: Lissa Cornin

Client: American Journalism Review

Medium: Digital

Size: 12" x 9"

83

Artist: **Craig Frazier**

Art Director: Lance Hidy

Client: Harvard Business Review

Medium: Cut/Digital

Size: 16" x 12"

84

Artist: **Yucel**

Art Director: Minoru Morita

Client: Troika

Medium: Digital

Size: 9" x 11"

80

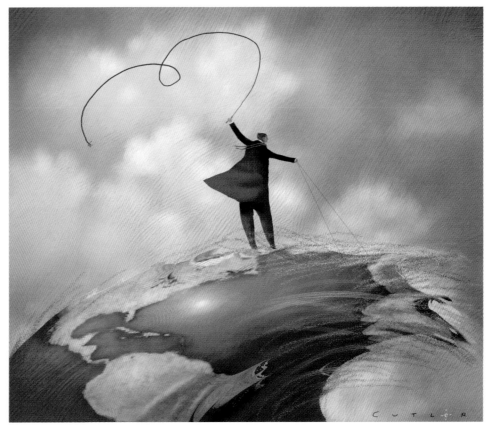

81

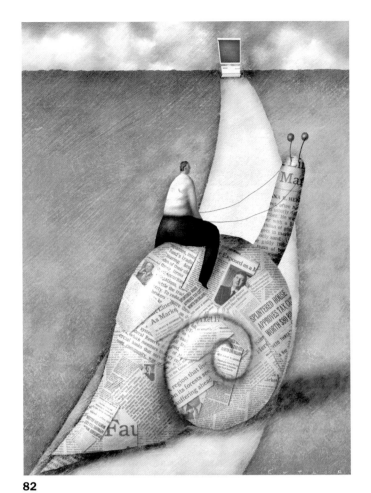

82

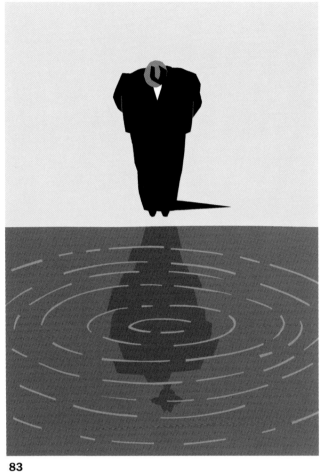

83

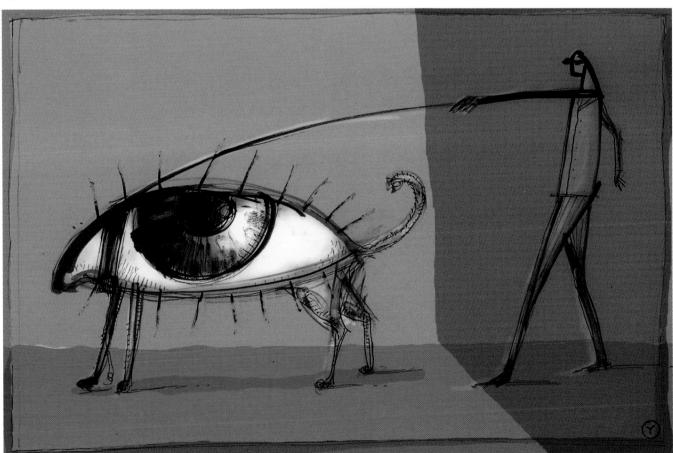

84

85

Artist: **Curtis Parker**

Art Director: Lance Hidy

Client: Harvard Business Review

Medium: Acrylic on linen

Size: 16" x 13"

86

Artist: **Amy Ning**

Art Director: Craig Arive

Client: Indianapolis Monthly

Medium: Acrylic, airbrush on paper

Size: 14" x 11"

87

Artist: **Amy Ning**

Art Director: Judi Havland

Client: Harvard Business Review

Medium: Acrylic, airbrush on paper

Size: 14" x 11"

88

Artist: **Sarah Wilkins**

Art Director: Saralynne Lowrey

Client: American Spa Magazine

Medium: Gouache on paper

89

Artist: **Laurie Luczak**

Art Director: Peter Lukic

Client: Women In Touch

Medium: Acrylic, collage on ragboard

Size: 20" x 24"

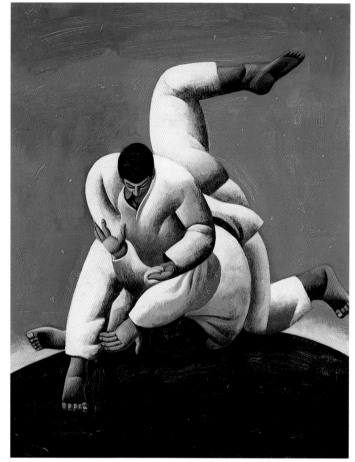

85

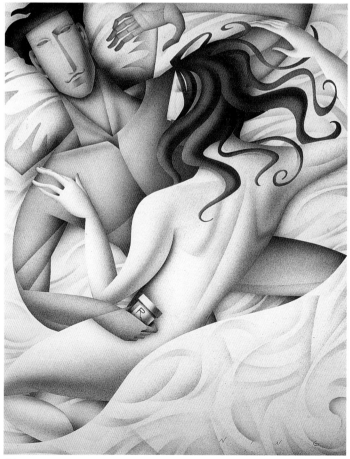

86

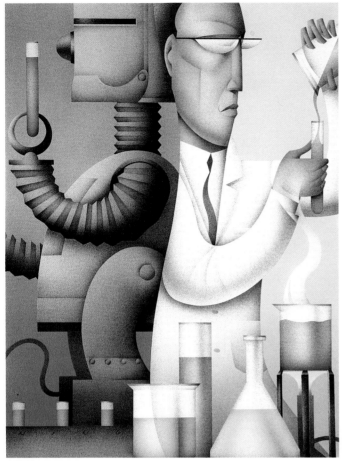

87

88

89

90

Artist: **Gary Clement**

Art Director: Lucy Bartholomay

Client: The Boston Globe

Medium: Gouache, pen & ink,
collage on paper

Size: 12" x 9"

91

Artist: **Ingo Fast**

Art Director: Stacie Reisstetter

Client: Washington Post

Medium: Pen & ink, watercolor on
watercolor paper

Size: 13" x 11"

92

Artist: **Juliette Borda**

Art Director: Stephanie Birdsong

Client: Fit Pregnancy

Medium: Gouache on paper

Size: 11" x 9"

93

Artist: **Mike Hodges**

Art Director: Francoise Mouly

Client: The New Yorker

Medium: Alkyd on gessoed paper

Size: 16" x 12"

94

Artist: **Ilene Winn-Lederer**

Art Director: Robyn Katz

Client: Baltimore Jewish Times

Medium: Gouache on watercolor paper

Size: 10" x 7"

90

91

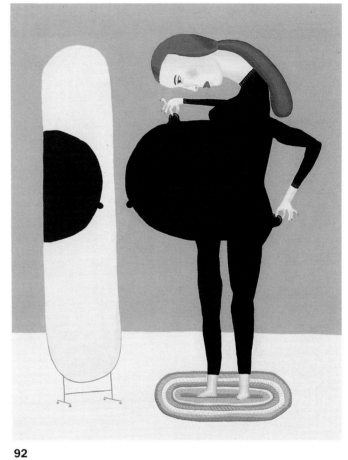

92

93

94

95

Artist: **Francis Livingston**

Art Director: Jody Mustain

Client: Hemispheres Inflight Magazine

Medium: Oil on paper

Size: 18" x 24"

96

Artist: **Francis Livingston**

Art Director: Jody Mustain

Client: Hemispheres Inflight Magazine

Medium: Oil on board

Size: 24" x 30"

97

Artist: **Francis Livingston**

Art Director: Jody Mustain

Client: Hemispheres Inflight Magazine

Medium: Oil on board

Size: 12" x 8"

98

Artist: **James McMullan**

Art director: Tony Lane

Client: Forbes ASAP Magazine

Medium: Watercolor, gouache on
 Whatman paper

Size: 10" x 7"

99

Artist: **James McMullan**

Art director: Leanne Shapton

Client: National Post Newspaper Canada

Medium: Watercolor, gouache on
 Rivs paper

Size: 9" x 12"

95

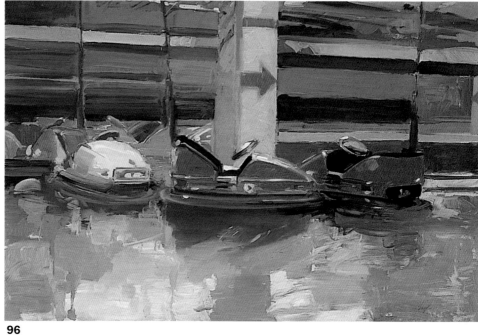

96

97

98

99

100

Artist: **Gary Kelley**

Art Director: Robin Gilmore-Barnes

Client: The Atlantic Monthly

Medium: Pastel on paper

101

Artist: **Gregory Manchess**

Art Director: Nicholas E. Torello

Client: Penthouse

Medium: Oil on gessoed board

102

Artist: **Joel Peter Johnson**

Art Director: Samantha Hand

Client: Wake Forest

Medium: Mixed on board

Size: 8" x 8"

103

Artist: **Gregory Manchess**

Art Director: Ed Rich

Client: Smithsonian Magazine

Medium: Oil on gessoed board

Size: 11" x 7"

104

Artist: **Charles S. Pyle**

Art Director: Janet Michaud

Client: The Boston Globe

Medium: Oil on board

Size: 12" x 16"

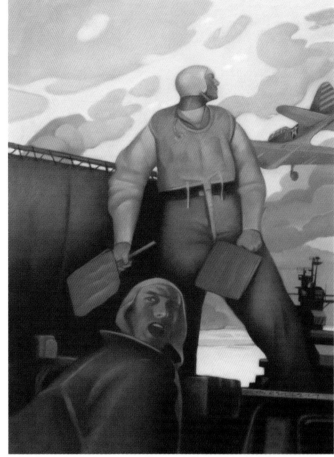

100

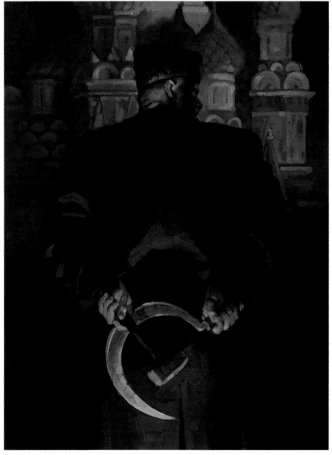

101

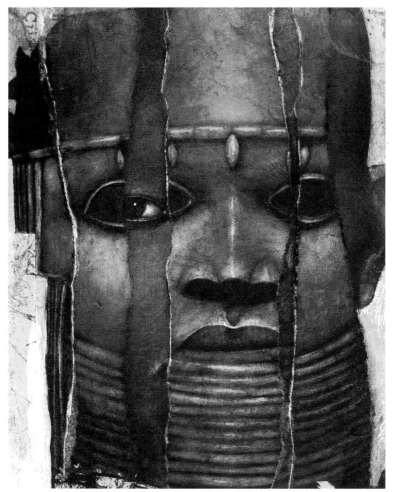

102

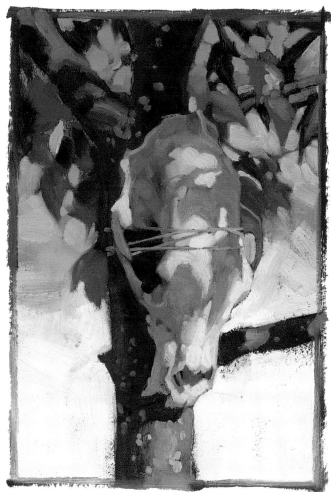

103

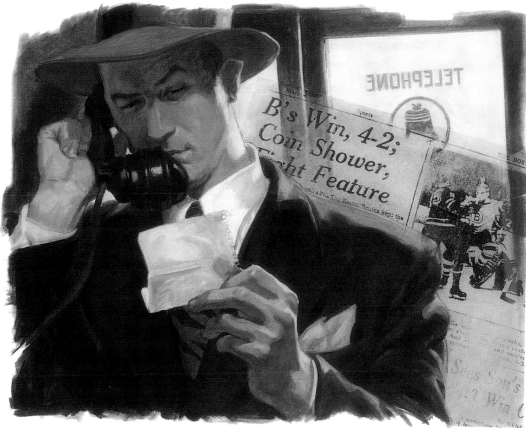

104

105

Artist: **Jeffrey Smith**

Art Director: Joseph P. Connolly

Client: Boys' Life

Medium: Watercolor on board

Size: 25" x 18"

106

Artist: **Edel Rodriguez**

Art Director: Chris Curry

Client: The New Yorker

Medium: Pastel, ink on paper

Size: 9" x 15"

107

Artist: **Loren Long**

Art Director: Steve Hoffman

Client: Sports Illustrated

Medium: Acrylic on linen

Size: 14" x 19"

108

Artist: **Loren Long**

Art Director: Lachelle Via O'Connor

Client: Delta Sky Magazine

Medium: Acrylic on linen

Size: 17" x 11"

109

Artist: **Theo Rudnak**

Art Director: Ron Ramsey

Client: Golf Magazine

Medium: Gouache on Strathmore

Size: 14" x 20"

110

Artist: **Guy Billout**

Art Director: Robin Gilmore-Barnes

Client: The Atlantic Monthly

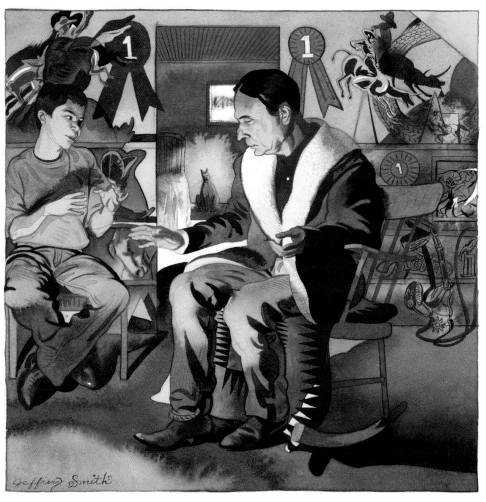

105

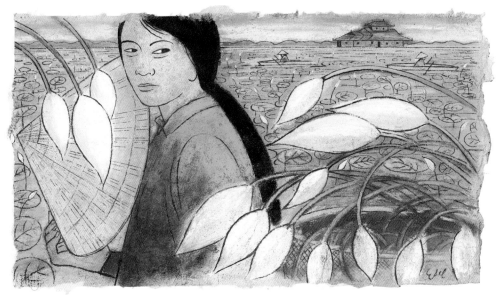

106

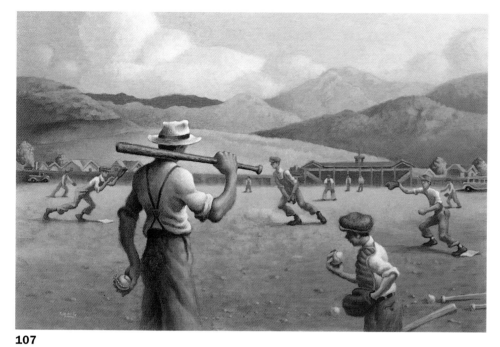

107

108

109

110

111

Artist: **Peter de Sève**

Art Director: Ron Comiskey

Client: Security Management

Medium: Watercolor, ink on
 watercolor paper

Size: 14" x 11"

112

Artist: **Bryn Barnard**

Art Director: Tony Jacobson

Client: Spider Magazine

Medium: Oil on board

Size: 24" x 21"

113

Artist: **Martin Matje**

Art Director: Sterling Chen

Client: The Philadelphia Inquirer

Medium: Gouache on paper

Size: 9" x 16"

114

Artist: **Leah Palmer Preiss**

Art Director: Ron McCutchan

Client: Cicada

Medium: Acrylic on color-aid paper

Size: 9" x 7"

115

Artist: **Earl Keleny**

Art Director: Cheryl Sorenson

Medium: Acrylic on Strathmore board

Size: 17" x 14"

111

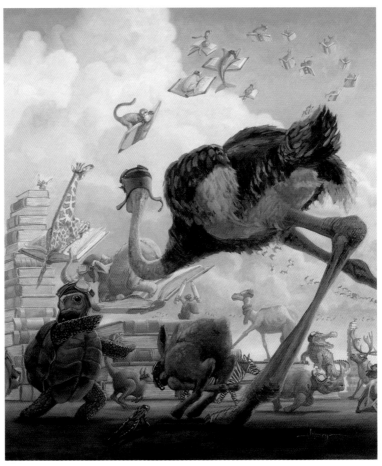

112

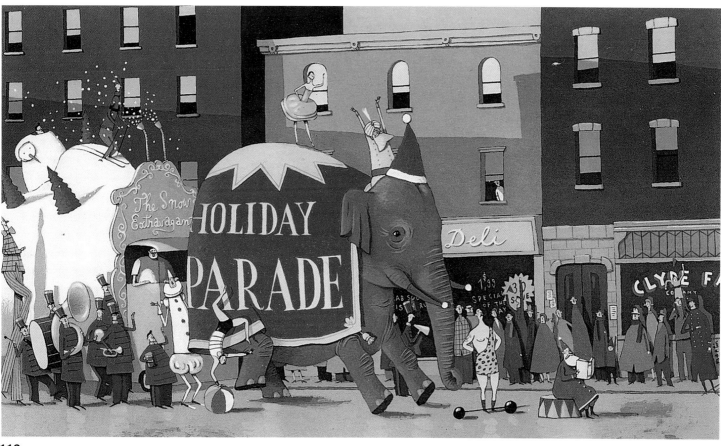

113

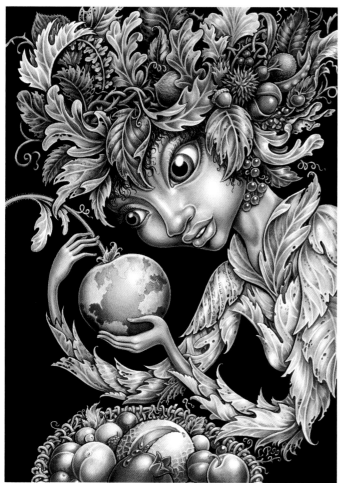

114

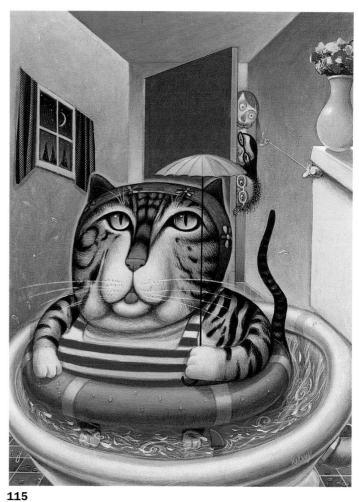

115

116

Artist: **Kazuhiko Sano**

Art Director: Edward Bell

Client: Scientific American Magazine

Medium: Acrylic on board

Size: 22" x 37"

117

Artist: **Kazuhiko Sano**

Art Directors: Jeff Osborn
Christopher Sloan

Client: National Geographic Society

Medium: Acrylic on board

Size: 16" x 28"

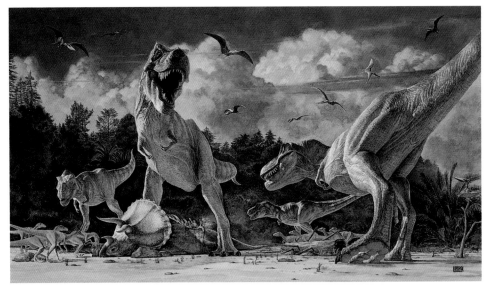

116

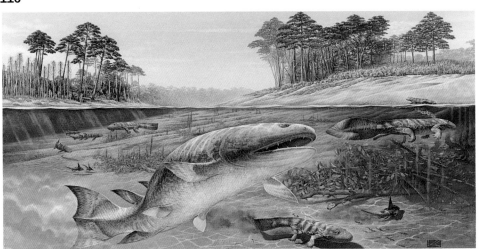

117

book

Wilson McLean, Chair
Illustrator

Tom Christopher
Artist

Jim de Barros
RDA International

Regan Todd Dunnick
Illustrator/Astronaut

Kit Hinrichs
*Art Director,
Pentagram Design Inc.*

Mike Hodges
Illustrator

Gregory Manchess
Illustrator

Coco Masuda
Illustrator

Minh Uong
Art Director, Village Voice

Jury

118 Silver Medal

Artist: **Jody Hewgill**

Art Director: Peter Cotton

Client: Little, Brown & Company

Medium: Acrylic on board with
waterproof ink for script

Size: 12" x 10"

"Whenever I am asked to illustrate a book cover I try to create an image that reflects the mood of the novel as well as the style of the writing. *If the World Were Mine* is a story about four old college friends who create a 'journal writing group' and gather each month to share their personal diaries. I chose a graphic approach, playing with the color and composition, juxtaposed with selected words from the diaries, to reflect the emotions and relationships of the four characters."

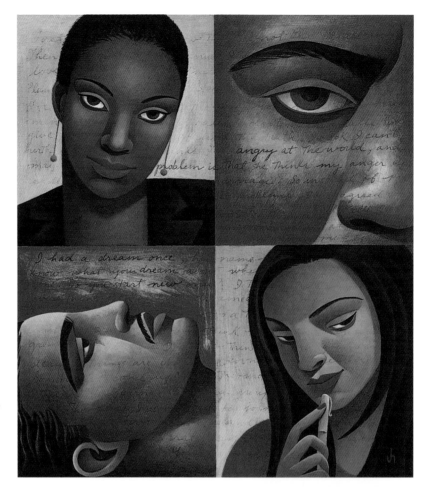

119 Silver Medal

Artist: **Gary Kelley**

Art Director: Atha Tehon

Client: Viking Children's Books

Medium: Pastel on paper

Size: 16" x 12"

"As usual, I'm happy to be part of this annual exhibition and especially happy to be an award winner. But that really wouldn't mean anything if I wasn't still excited and anxious to walk into my studio every day!"

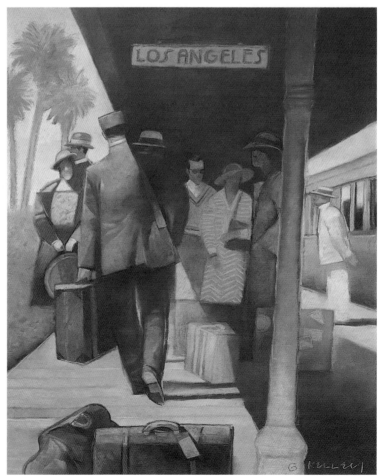

120 Silver Medal

Artist: **Ward Schumaker**

Art Directors: Carolyn Robertson
James Robertson

Client: The Yolla Bolly Press

Medium: 3-Color letterpress print on paper

Size: 13" x 9"

"Like many illustrators, I spend most days brooding over whether it'll cause me more pain to do a job the way a client wants or the way I'd like. Once in awhile, the two coincide—as it was with this limited-edition, letterpress book. Working with Yolly Bolly was a joy; their production values are unexcelled and we've learned to give and take, with the result that both succeed in ways we couldn't have achieved separately."

121

Artist: **Ward Schumaker**

Art Directors: Carolyn Robertson
James Robertson

Client: The Yolla Bolly Press

Medium: 3-Color letterpress print on paper

Size: 13" x 9"

122

Artist: **Ward Schumaker**

Art Directors: Carolyn Robertson
James Robertson

Client: The Yolla Bolly Press

Medium: 3-Color letterpress print on paper

Size: 13" x 9"

121

122

123

Artist: **Gary Kelley**

Art Director: Richard Aquan

Client: William Morrow & Company

Medium: Pastel on paper

Size: 15" x 14"

124

Artist: **Lynne Cannoy**

Art Director: Irene Gallo

Client: Forge Books

Medium: Pastels on paper

125

Artist: **Mike Benny**

Art Director: Nick Krenitsky

Client: HarperCollins

Medium: Acrylic on board

Size: 15" x 12"

126

Artist: **Jody Hewgill**

Art Director: Tom Stvan

Client: Scribner

Medium: Acrylic on board

Size: 14" x 14"

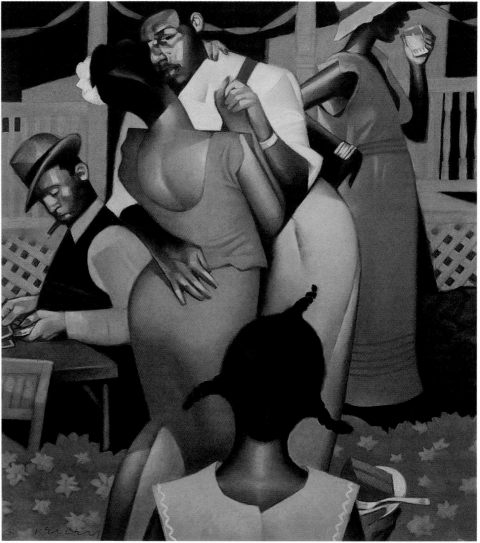

123

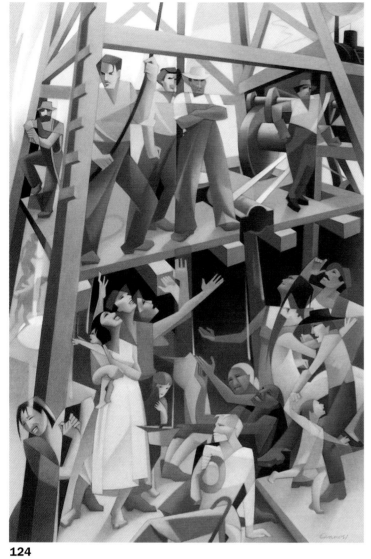

124

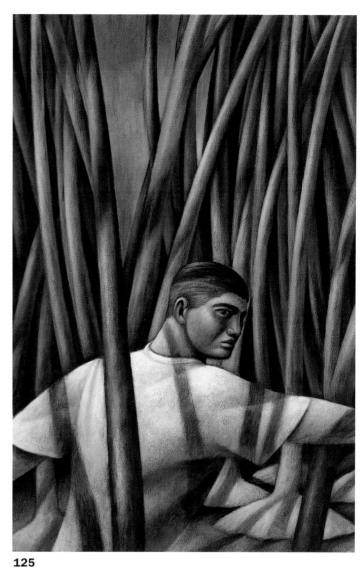

125

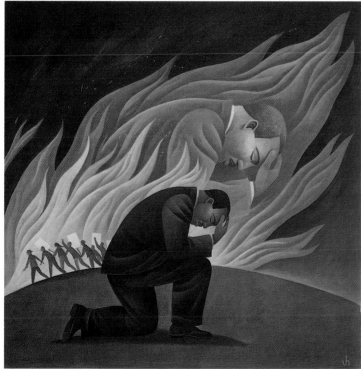

126

127

Artist: **John M. Thompson**

Art Director: Rita Marshall

Client: The Creative Company

Medium: Acrylic on paper

Size: 14" x 17"

128

Artist: **Dave Lantz**

Art Director: Ophilia M. Chamblis

Client: Contemporary Books

Medium: Pencil, acrylic on masonite

Size: 11" x 16"

129

Artist: **Dave McKean**

Client: Higher Octive

Medium: Digital

Size: 12" x 9"

130

Artist: **Paul Lee**

Art Director: Filomena Tuosto

Client: Farrar Straus Giroux

Medium: Acrylic on Bristol

Size: 16" x 12"

131

Artist: **Michael Koelsch**

Art Director: Nick Krenitsky

Client: HarperCollins

Medium: Acrylic, mixed on board

Size: 18" x 11"

127

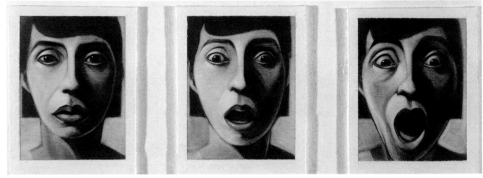

128

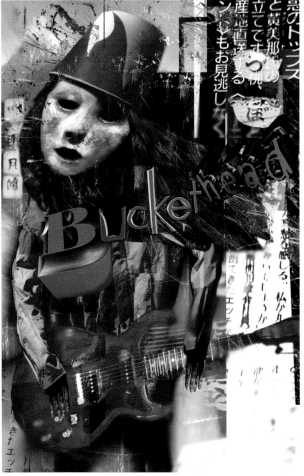

129

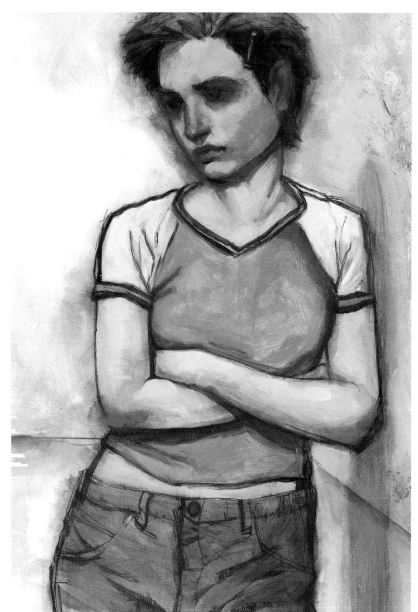

130

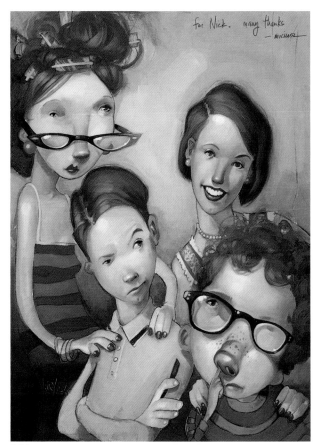

131

132

Artist: **Tim O'Brien**

Art Directors: Atha Tehon
Julie Rauer

Client: Dial Books

Medium: Oil on panel

Size: 13" x 10"

133

Artist: **Kazuhiko Sano**

Art Director: Semadar Megged

Client: BDD (Bantam Doubleday Dell)

Medium: Acrylic on board

Size: 24" x 15"

134

Artist: **John Jude Palenca**

Art Director: Donald Puckey

Client: Warner Books

Medium: Acrylic on panel

Size: 21" x 27"

135

Artist: **Bernie Fuchs**

Art Director: Sue Dennen

Client: Little, Brown & Company

Medium: Oil on canvas

Size: 31" x 23"

136

Artist: **Raul Colón**

Art Director: Linda Lockowitz

Client: Harcourt Brace & Company

Medium: Watercolor, colored pencil
on paper

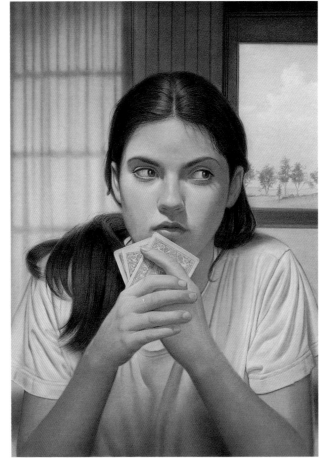

132

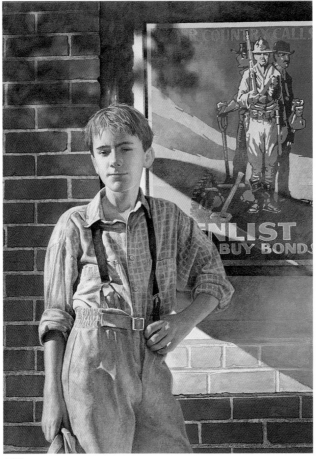

133

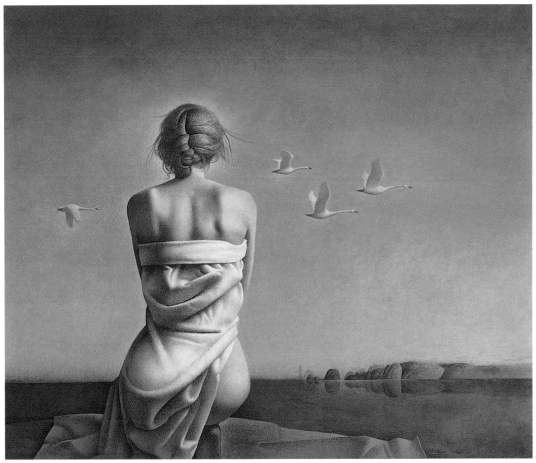

134

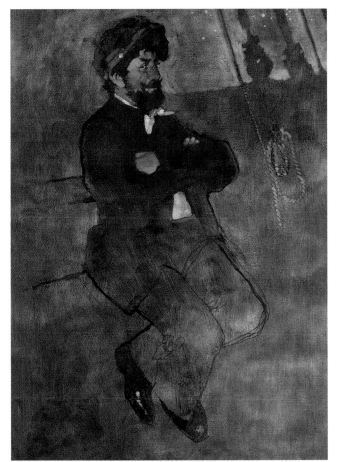

135

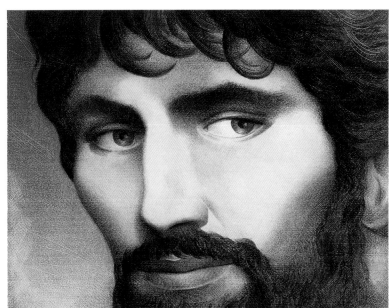

136

137

Artist: **Will Wilson**

Art Director: Kathleen DiGrado

Client: Scribner Poetry

Medium: Oil on canvas

Size: 13" x 10"

138

Artist: **Michael J. Deas**

Art Director: Richard Aquan

Client: William Morrow & Company

Medium: Oil on panel

Size: 16" x 12"

139

Artist: **Peter de Sève**

Art Director: Rich Pracher

Client: HarperCollins

Medium: Watercolor on watercolor paper

Size: 8" x 18"

140

Artists: **Glen Orbik**
 Laurel Blechman

Art Director: Jordan Gorfinkel

Client: DC Comics

Medium: Oil on board

Size: 24" x 16"

141

Artist: **Mark Summers**

Art Director: Eileen Max

Client: Kodansha America

Medium: Scratchboard

Size: 16" x 12"

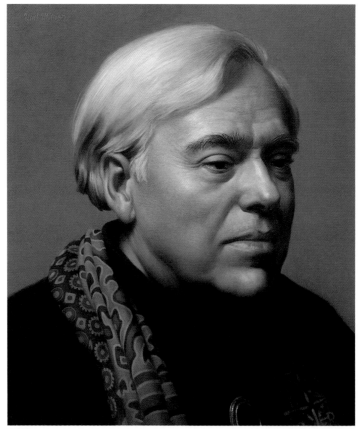

137

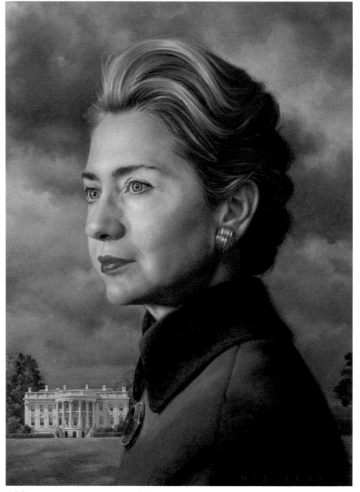

138

139

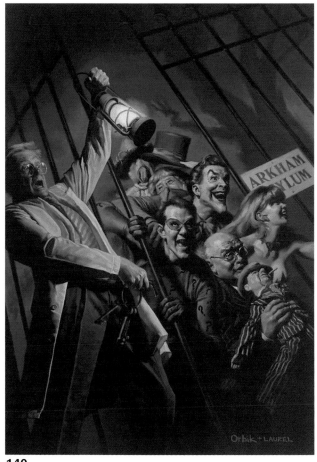

140

141

142

Artist: **Peter Scanlan**

Art Director: Jim Nelson

Client: FASA

Medium: Digital

Size: 18" x 14"

143

Artist: **James Ransome**

Art Director: Heather Wood

Client: Simon & Schuster Books for
Young Readers

Medium: Acrylic on paper

Size: 23" x 17"

144

Artist: **James Ransome**

Art Director: Heather Wood

Client: Simon & Schuster Books for
Young Readers

Medium: Acrylic on paper

Size: 15" x 26"

145

Artist: **Mark English**

Art Director: Laura Ettinger

Client: HarperCollins

Size: 16" x 14"

146

Artist: **Mark English**

Art Director: Laura Ettinger

Client: HarperCollins

Size: 16" x 14"

142

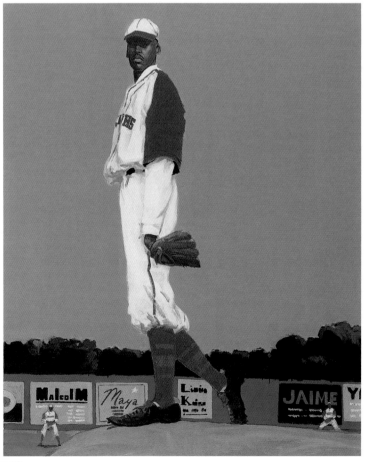

143

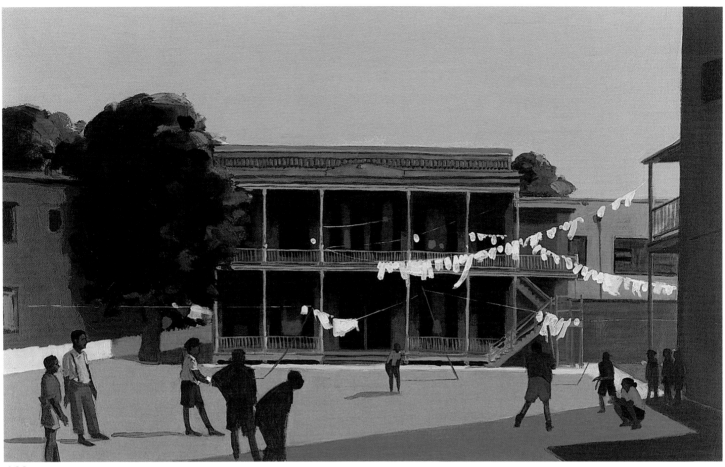

144

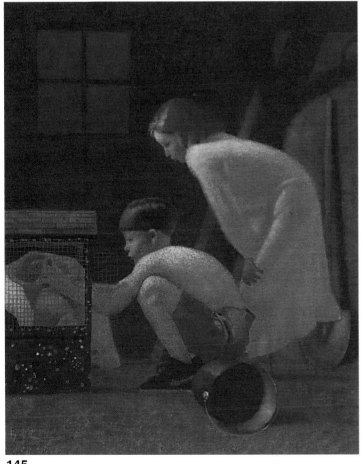

145

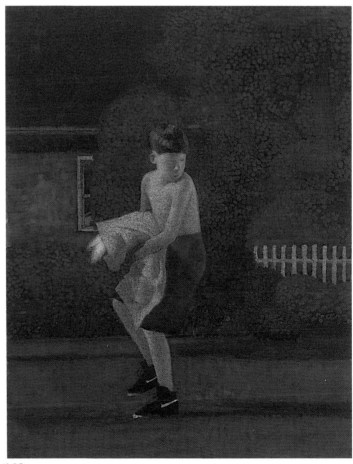

146

147

Artist: **Mark English**

Art Director: Laura Ettinger

Client: HarperCollins

Size: 16" x 14"

148

Artist: **Leonid Gore**

Art Director: Ann Bobco

Client: Simon & Schuster Books for
Young Readers

Medium: Acrylic on paper

Size: 14" x 12"

149

Artist: **Leonid Gore**

Art Director: Ann Bobco

Client: Simon & Schuster Books for
Young Readers

Medium: Acrylic on paper

Size: 14" x 12"

150

Artist: **S. Saelig Gallagher**

Art Director: Cecilia Yung

Client: Philomel Books, a division of
Penguin Putnam

Medium: Acrylic, pastel on ragboard

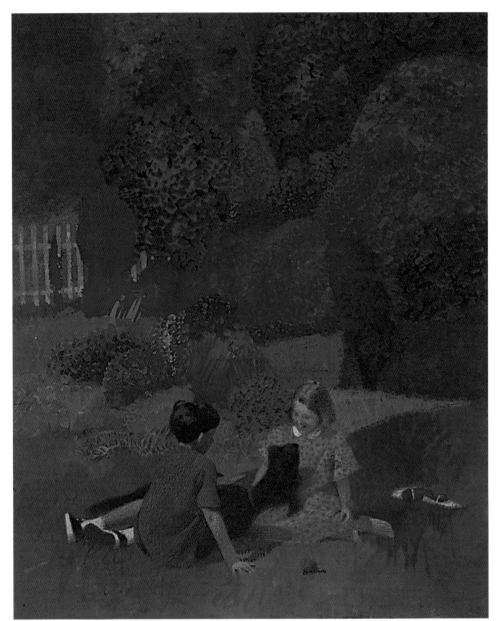

147

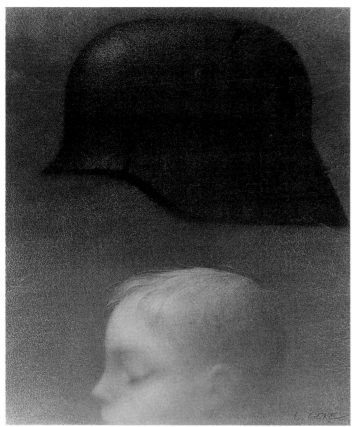

148

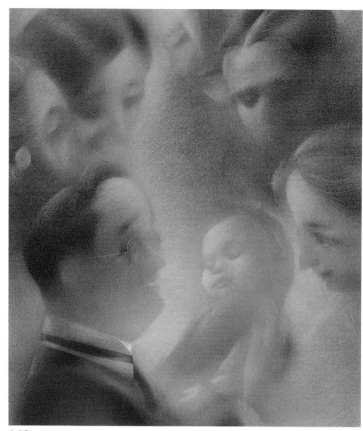

149

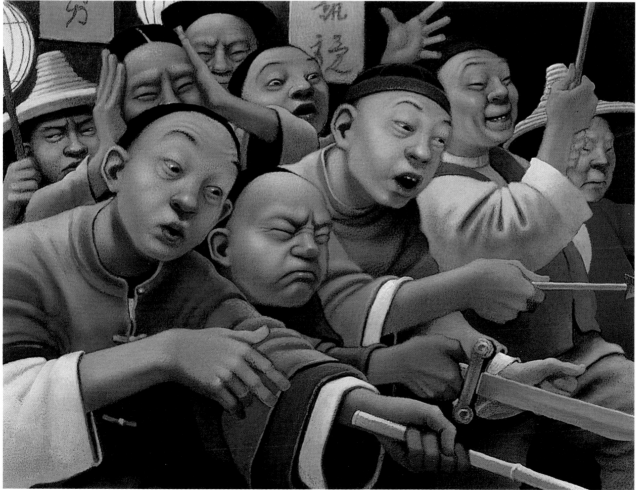

150

151

Artist: **Greg Couch**

Art Director: Sarah Reynolds

Client: Dutton Children's Book

Medium: Acrylic, colored pencil,
table salt for texture on
2-ply museum board

Size: 15" x 12"

152

Artist: **David Christiana**

Art Director: Martha Rago

Client: Henry Holt & Company

Medium: Watercolor on paper

Size: 9" x 6"

153

Artist: **Greg Couch**

Art Director: Paul Zakris

Client: Simon & Schuster

Medium: Acrylic, colored pencil,
table salt for texture on
2-ply museum board

Size: 14" x 26"

154

Artist: **David Shannon**

Art Director: Cecilia Yung

Client: G.P. Putnam's Sons

Medium: Acrylic on board

Size: 14" x 22"

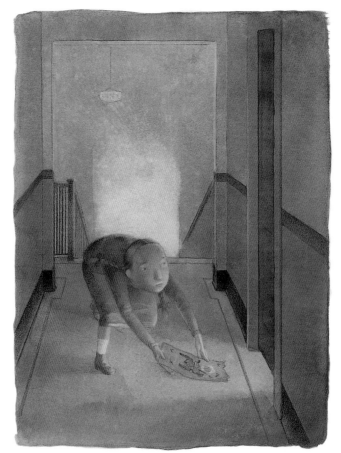

151

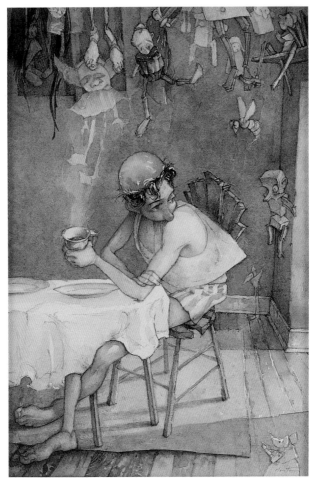

152

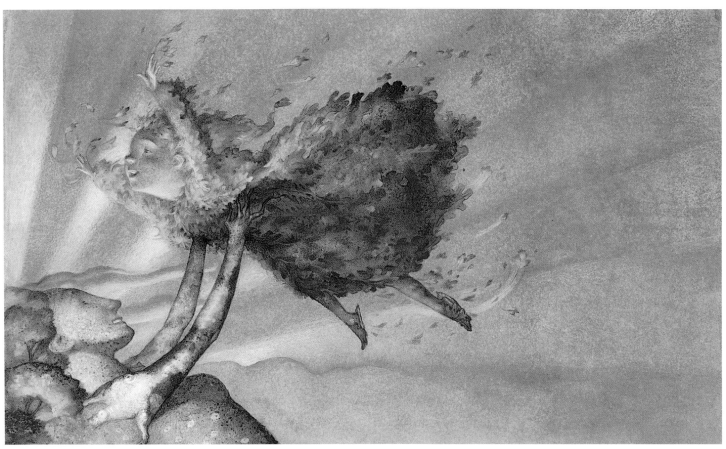

153

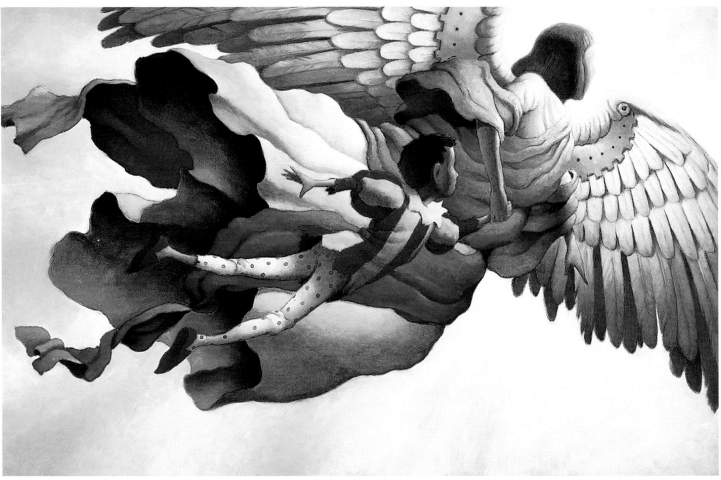

154

155

Artist: **Etienne Delessert**

Art Director: Rita Marshall

Client: Jacqueline Reuge

Medium: Watercolor on paper

156

Artist: **Oki Han**

Art Director: Kelly Gabrysch

Client: McGraw-Hill

Medium: Watercolor on paper

Size: 7" x 8"

157

Artist: **David Shannon**

Art Director: Kathleen Westray

Client: Blue Sky Press/Scholastic

Medium: Mixed on board

Size: 11" x 17"

158

Artist: **Robert Crawford**

Art Director: Jean Traina

Client: Random House

Medium: Acrylic on panel

Size: 16" x 12"

159

Artist: **Jean-Manuel Duvivier**

Client: Art Box Amsterdam

Medium: Colored pencils and paper

Size: 100 cm x 65 cm

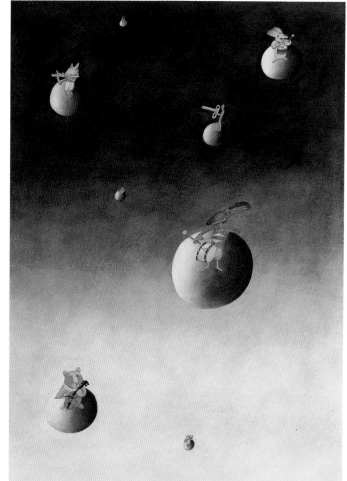

155

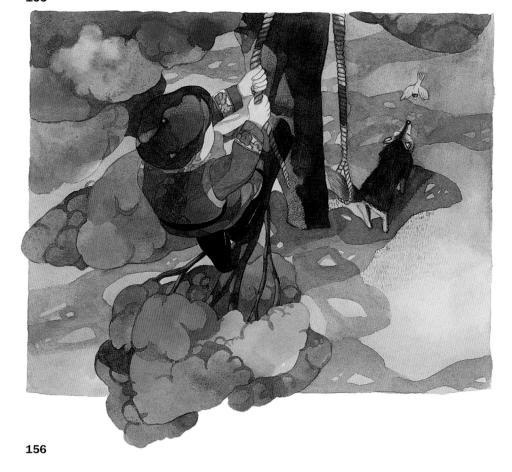

156

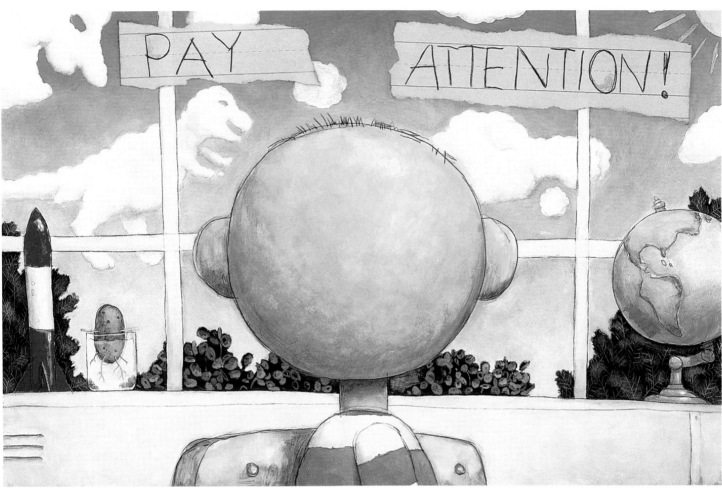

157

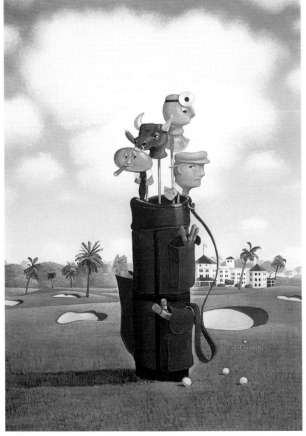

158

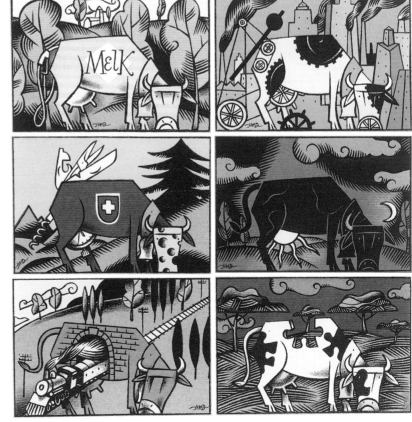

159

160

Artist: **William Joyce**

Art Director: Alicia Mikles

Client: HarperCollins

Medium: Digital

Size: 10" x 10"

161

Artist: **William Joyce**

Art Director: Alicia Mikles

Client: HarperCollins

Medium: Digital

Size: 10" x 10"

162

Artist: **J. Otto Seibold**

Client: Chronicle Books

Medium: Digital

163

Artist: **Steven Guarnaccia**

Art Director: Nina Putignano

Client: Viking Publishing

Medium: Pen & ink, watercolor on
watercolor paper

Size: 10" x 25"

164

Artist: **Andrej Dugin**

Art Director: Mathias Berg

Client: Esslinger Verlag J.F. Schreiber

Medium: Watercolor on paper

Size: 36 cm x 50 cm

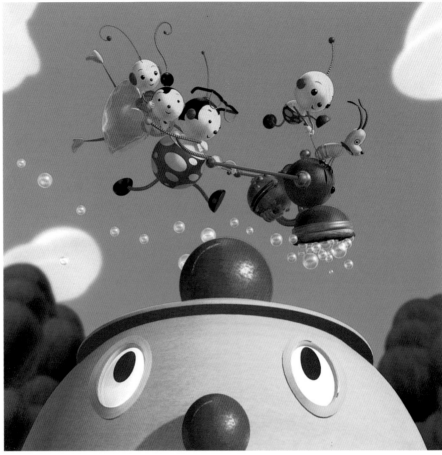

160

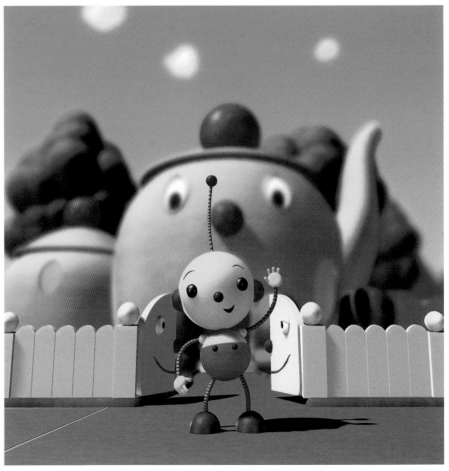

161

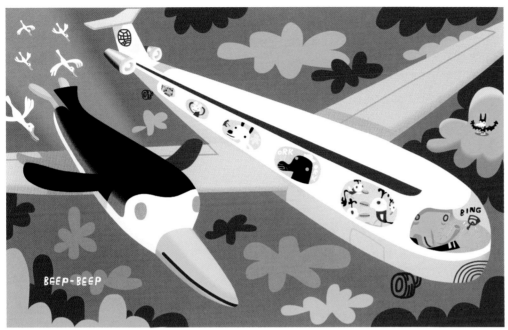

162

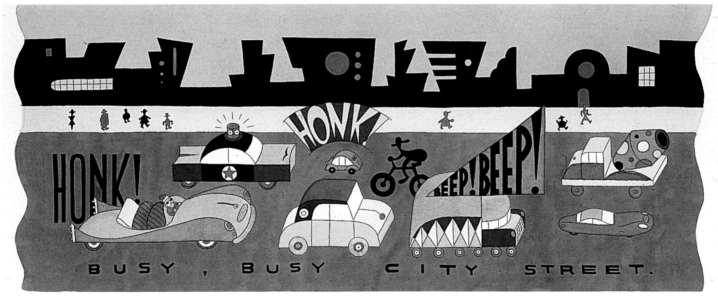

163

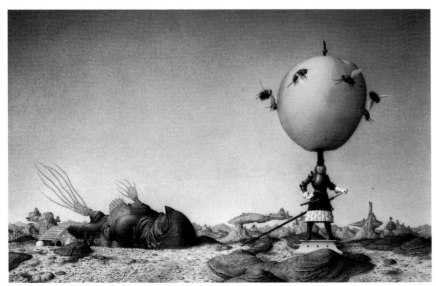

164

165

Artist: **Yoshinori Hashimot**

Art Director: Kazuhiro Tada

Client: Foresto Publishing

Size: 43 cm x 36 cm

166

Artist: **Loren Long**

Art Director: Bob Kosturko

Client: Houghton Mifflin Company

Medium: Acrylic on linen

Size: 16" x 12"

167

Artist: **Stephen T. Johnson**

Art Director: Denise Cronin

Client: Viking Children's Books

Medium: Watercolor on paper

Size: 18" x 37"

168

Artist: **Stephen T. Johnson**

Art Director: Denise Cronin

Client: Viking Children's Books

Medium: Pastel, watercolor, gouache,
 charcoal on paper

Size: 28" x 22"

169

Artist: **Stephen T. Johnson**

Art Director: Denise Cronin

Client: Viking Children's Books

Medium: Pastel, watercolor, gouache,
 charcoal on paper

Size: 30" x 23"

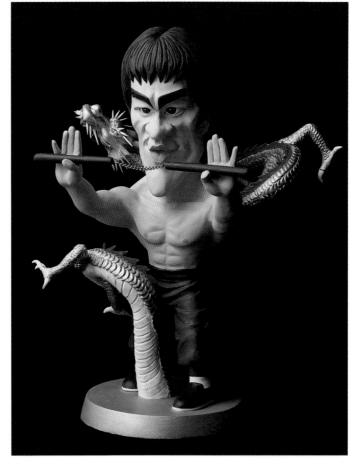

165

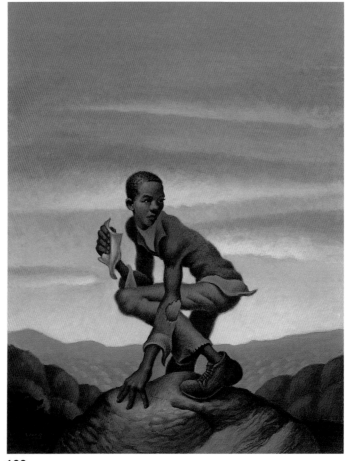

166

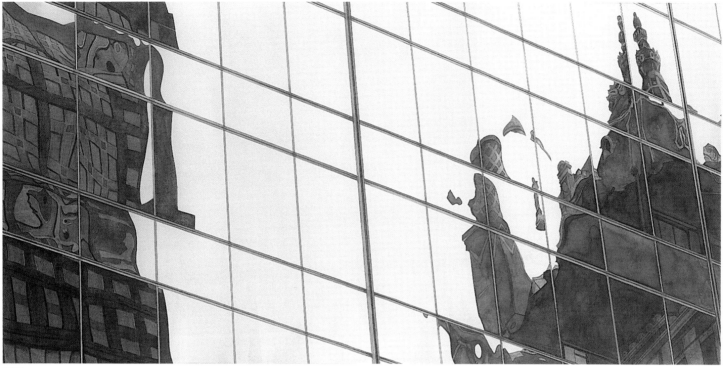

167

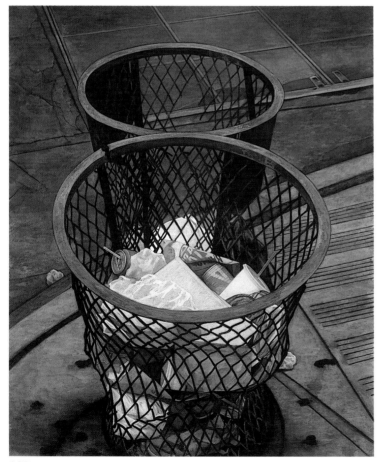

168

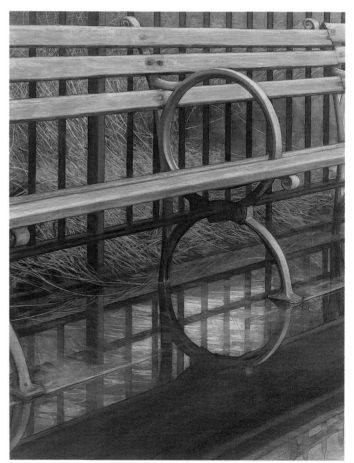

169

170

Artist: **Joan Steiner**

Art Director: Sheila Smallwood

Client: Little, Brown & Company

Medium: Mixed, found objects

Size: 30" x 42" x 10"

171

Artist: **John H. Howard**

Art Director: Krystyna Skalski

Client: Walker & Co.

Medium: Acrylic on canvas

Size: 24" x 16"

172

Artist: **Yan Nascimbene**

Art Director: Rita Marshall

Client: Creative Editions

Medium: Watercolor, ink on paper

Size: 12" x 16"

173

Artist: **Yan Nascimbene**

Art Director: Rita Marshall

Client: Creative Editions

Medium: Watercolor, ink on paper

Size: 12" x 16"

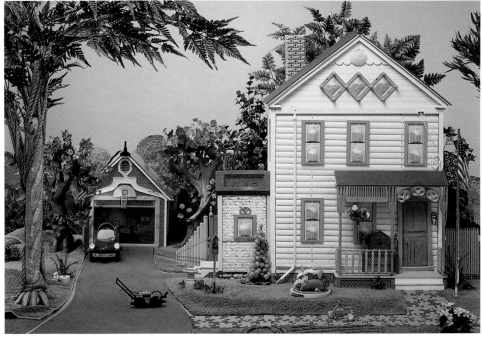

170

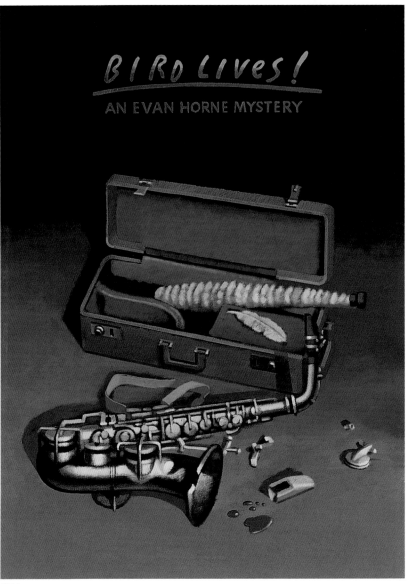

171

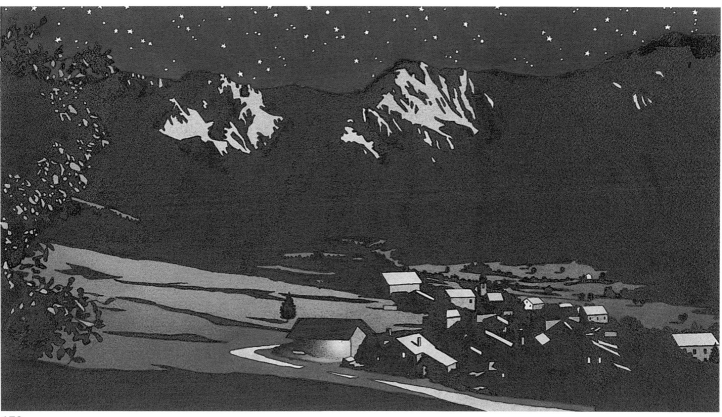

172

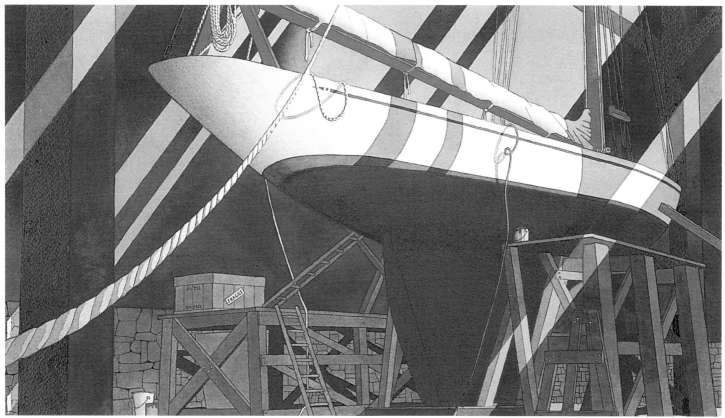

173

174

Artist: **Leonard Jenkins**

Art Director: Al Cetta

Client: HarperCollins

Medium: Mixed on board

Size: 18" x 24"

175

Artist: **Chris Gall**

Art Director: Nick Krenitsky

Client: HarperCollins

Medium: Scratchboard

Size: 10" x 8"

176

Artist: **Douglas Smith**

Art Director: Leslie Goldman

Client: Little, Brown & Company

Medium: Scratchboard, watercolor

Size: 15" x 10"

177

Artist: **Douglas Smith**

Art Director: Leslie Goldman

Client: Little, Brown & Company

Medium: Scratchboard, watercolor

Size: 15" x 10"

178

Artist: **Tim O'Brien**

Art Director: Jean Traina

Client: Doubleday

Medium: Oil on panel

Size: 14" x 11"

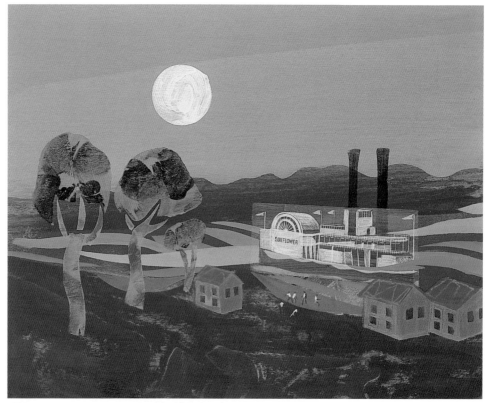

174

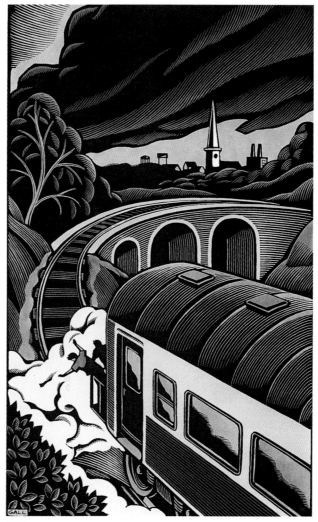

175

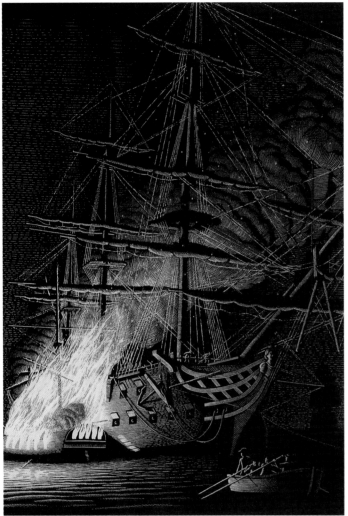

176

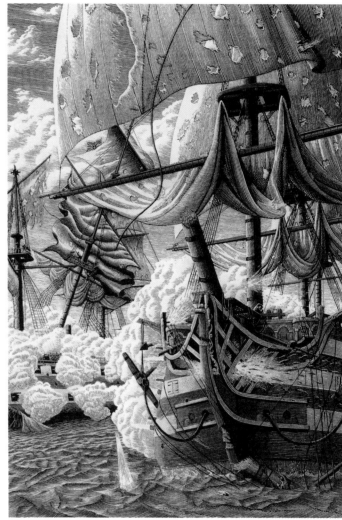

177

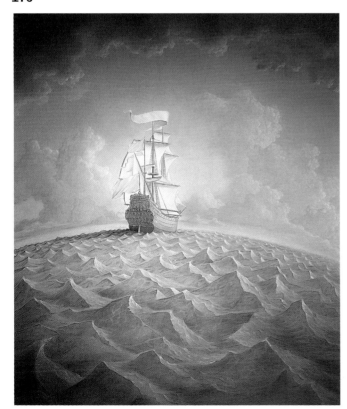

178

179

Artist: **Tristan Elwell**

Art Director: Vikki Sheatsley

Client: Bantam Books

Medium: Oil on board

Size: 17" x 12"

180

Artist: **Martin French**

Art Director: Jennifer Phillips

Client: International Bible Society

Medium: Ink, acrylic, digital

Size: 15" x 12"

181

Artist: **Daniel Craig**

Art Director: Paolo Pepe

Client: Pocket Books

Medium: Acrylic on canvas

Size: 16" x 12"

182

Artist: **David Bowers**

Art Director: Erika Fusari

Client: Berkley Publishing Group

Medium: Oil and crackling varnish
on masonite

Size: 19" x 12"

183

Artists: **Leo, Diane & Lee Dillon**

Art Director: Al Cetta

Client: HarperCollins

Medium: Watercolor, pastel, pencil
on Arches

Size: 17" x 13"

184

Artist: **John Jude Palencar**

Art Director: Judith Murello

Client: Berkley Publishing Group

Medium: Acrylic on masonite

Size: 20" x 30"

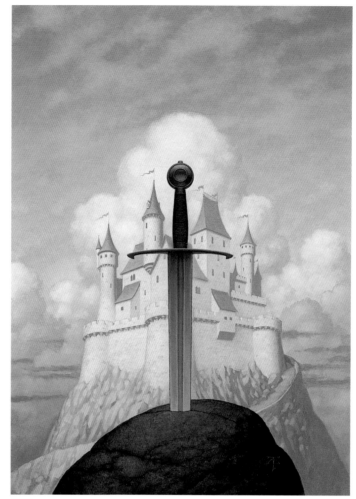

179

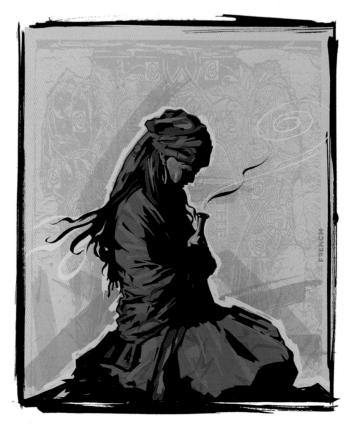

180

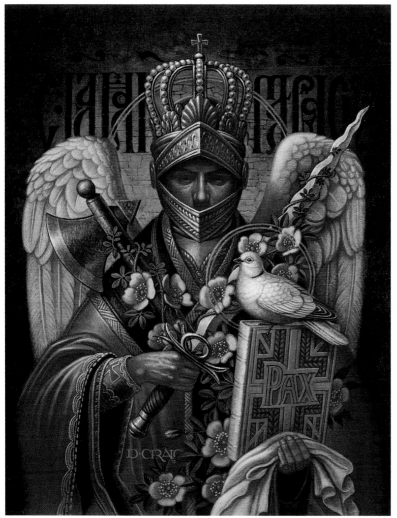

181

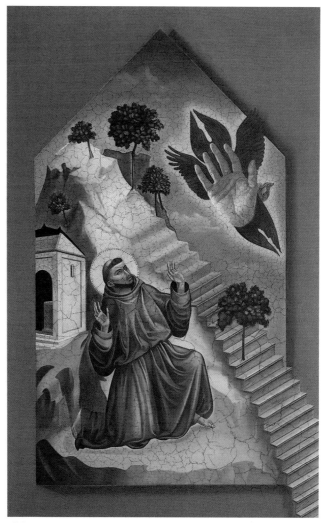

182

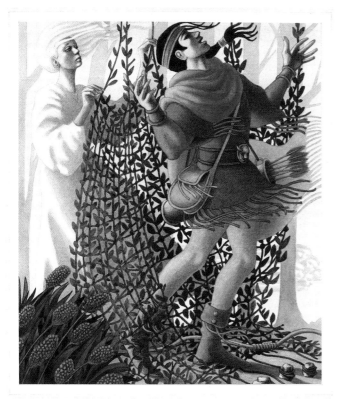

183

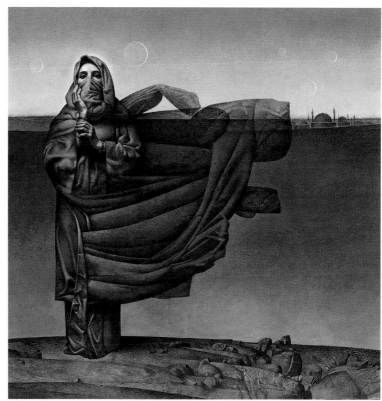

184

185

Artist: **Peter Malone**

Art Director: Patricia Evangelista

Client: Chronicle Books, San Francisco

Medium: Gouache on watercolor paper

Size: 12" x 9"

186

Artist: **Peter Malone**

Art Director: Patricia Evangelista

Client: Chronicle Books, San Francisco

Medium: Gouache on watercolor paper

Size: 12" x 9"

187

Artists: **Stephen John Phillips**
Jose Villarrubia

Art Director: Amie Brockway

Client: DC Comics, Vertigo Imprint

Medium: Digital

Size: 16" x 20"

188

Artist: **Gennady Spirin**

Art Director: Cecilia Yung

Client: Penguin Putnam Books for
Young Readers

Medium: Watercolor, tempera on paper

189

Artist: **Charles Santore**

Art Director: Tom Tafuri

Client: One Plus One Studio

Medium: Pencil on vellum

Size: 7" x 7"

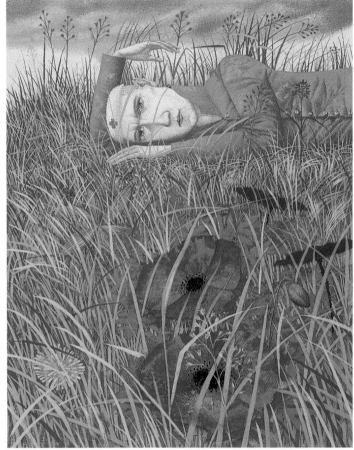

185

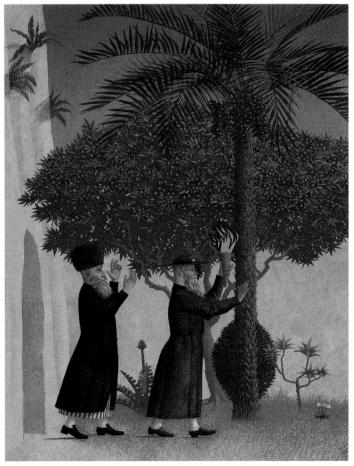

186

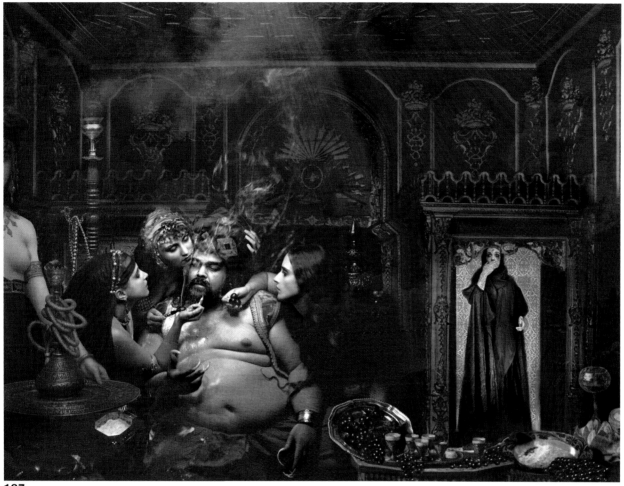

187

188

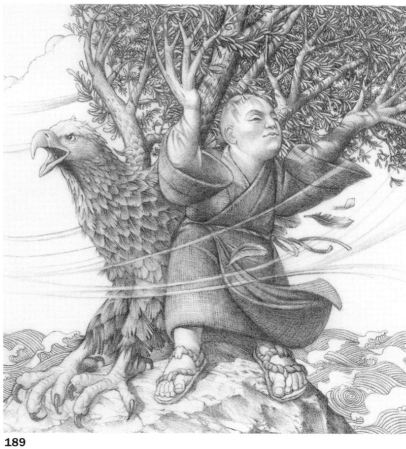

189

190

Artist: **Jerry Pinkney**

Art Director: Michael Farmer

Client: Gulliver Books

Medium: Pencil, watercolor, Prismacolor
pencils on paper

Size: 15" x 22"

191

Artist: **Peter M. Sylvada**

Art Director: Diane D'Andrade

Client: Harcourt Brace & Company

Medium: Oil on board

Size: 18" x 24"

192

Artist: **Peter M. Sylvada**

Art Director: Diane D'Andrade

Client: Harcourt Brace & Company

Medium: Oil on board

Size: 18" x 24"

193

Artist: **Peter M. Sylvada**

Art Director: Diane D'Andrade

Client: Harcourt Brace & Company

Medium: Oil on board

Size: 18" x 24"

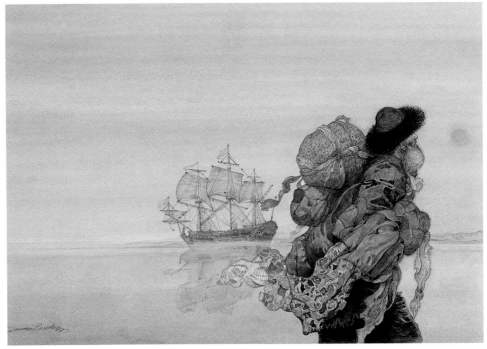

190

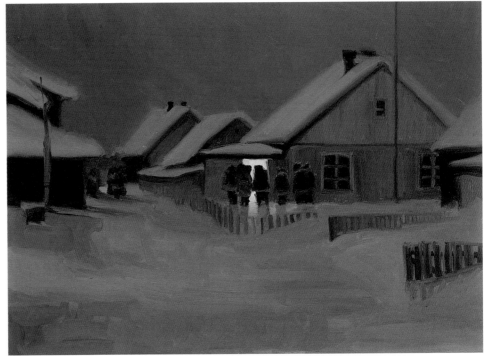

191

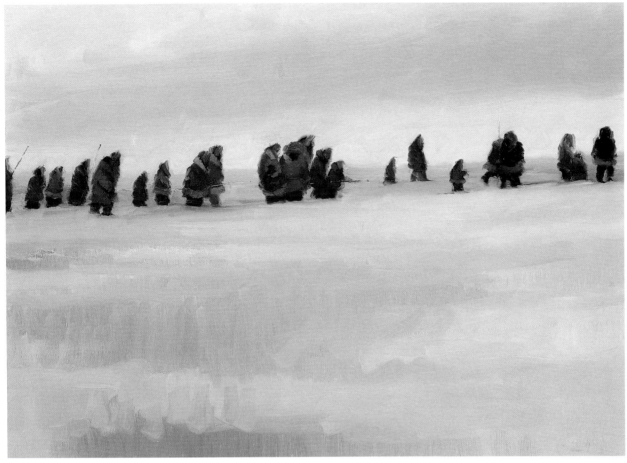

192

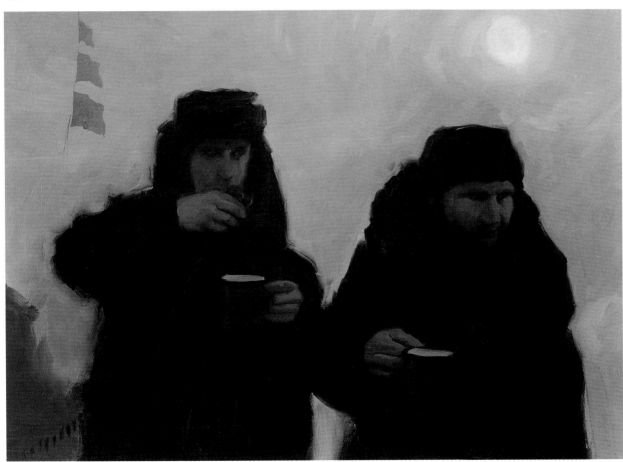

193

194

Artist: **Jon J. Muth**

Art Director: David Saylor

Client: Scholastic Inc.

Medium: Watercolor on paper

Size: 18" x 24"

195

Artist: **Kazuhiko Sano**

Art Directors: Deborah Kaplan
Stefanie Rosenfeld

Client: Penguin Putnam/Puffin Books

Medium: Acrylic on board

Size: 22" x 14"

196

Artist: **S. Saelig Gallagher**

Art Director: Cecilia Yung

Client: Philomel Books, a division of
Penguin Putnam

Medium: Acrylic, pastel on ragboard

Size: 12" x 15"

197

Artist: **Jerry Pinkney**

Art Director: Atha Tehon

Client: Dial Books

Medium: Pencil, watercolor, gouache
on paper

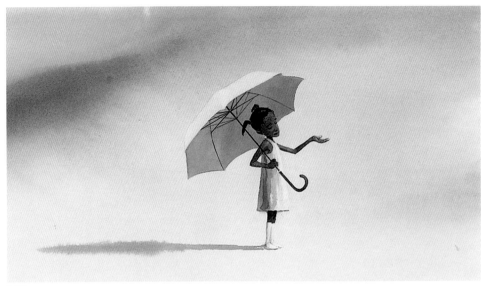

194

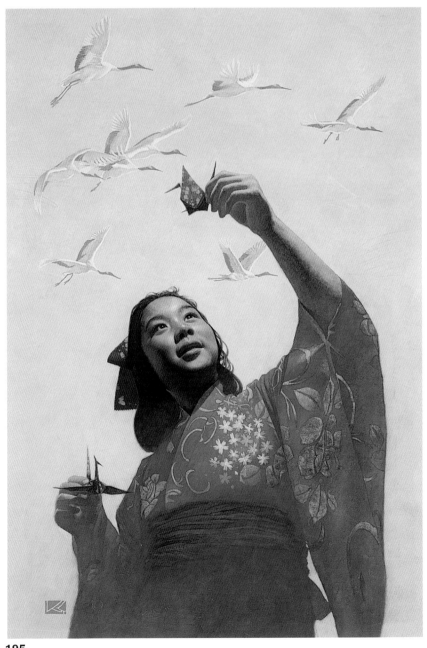

195

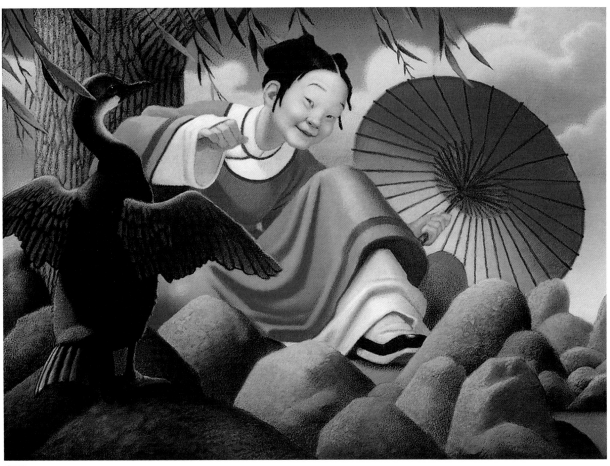

196

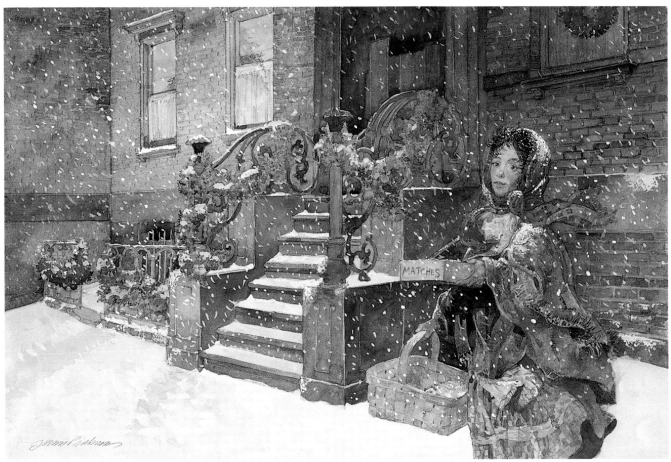

197

198

Artist: **Chris Sheban**

Art Director: Michael Rosen

Client: American Kennel Club Museum
of the Dog

Medium: Watercolor, Prismacolor pencils
on paper

Size: 13" x 13"

199

Artist: **Daniel Craig**

Art Director: Janet Hill

Client: Scott Foresman

Medium: Acrylic on canvas

Size: 16" x 23"

200

Artist: **Mark Buehner**

Art Director: Golda Laurens

Client: HarperCollins

Medium: Acrylic, oil on board

Size: 30" x 24"

201

Artist: **Mark Buehner**

Art Director: Golda Laurens

Client: HarperCollins

Medium: Acrylic, oil on board

Size: 30" x 24"

202

Artist: **Kristin Kest**

Art Director: Diane Hinze Kanzler

Client: Soundprints

Medium: Oil on paper

Size: 10" x 25"

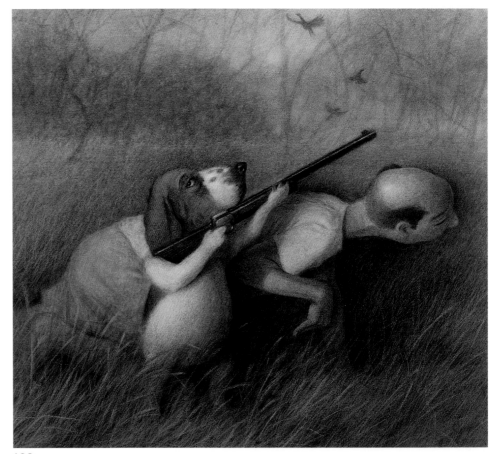

198

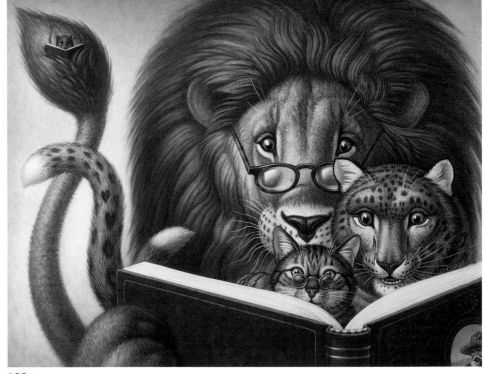

199

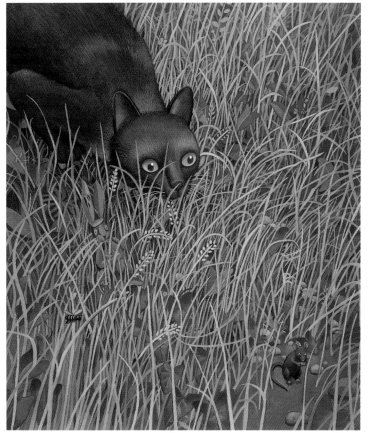

200

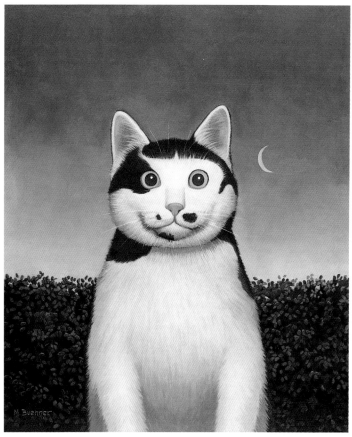

201

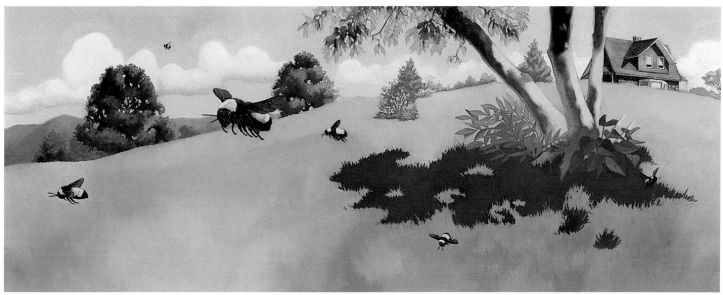

202

203

Artist: **John Backlund**

Art Director: Wendy Wentworth

Client: The Greenwich Workshop Press

Medium: Watercolor on paper

Size: 14" x 20"

204

Artist: **Richard Wehrman**

Art Director: Martha Rago

Client: Henry Holt & Company

Medium: Acrylic on ragboard

Size: 9" x 12"

205

Artist: **Don Daily**

Art Director: Frances J. Soo Ping Chow

Client: Running Press

Medium: Watercolor, gouache on
Strathmore

Size: 13" x 9"

206

Artist: **Don Daily**

Art Director: Frances J. Soo Ping Chow

Client: Running Press

Medium: Watercolor, gouache on
Strathmore

Size: 13" x 9"

207

Artist: **Don Daily**

Art Director: Frances J. Soo Ping Chow

Client: Running Press

Medium: Watercolor, gouache on
Strathmore

Size: 13" x 9"

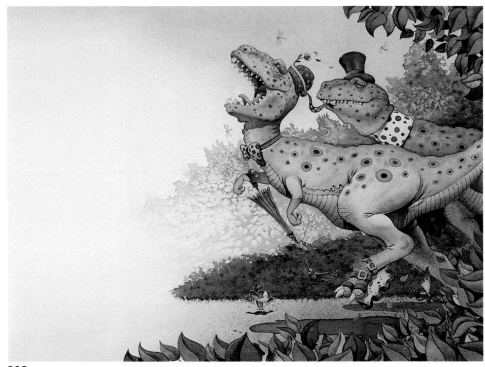

203

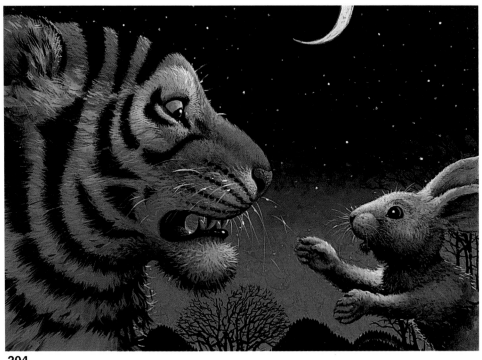

204

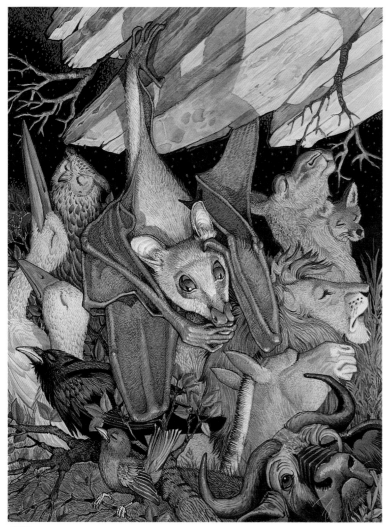

205

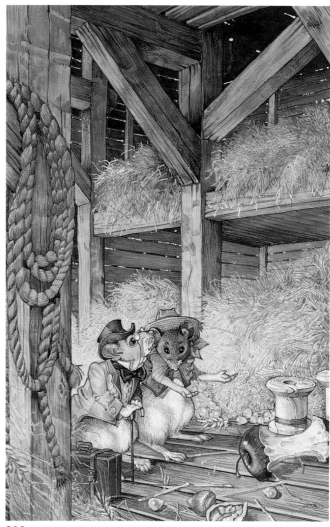

206

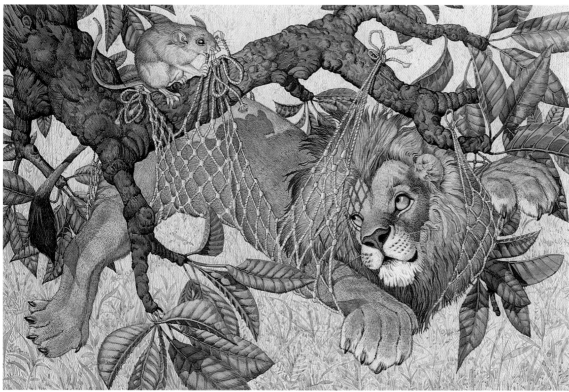

207

208

Artists: **Steve Johnson**
Lou Fancher

Art Directors: Lou Fancher
Ann Bobco

Client: Simon & Schuster

Medium: Oil on paper

Size: 15" x 24"

209

Artist: **Jan Machalek**

Art Director: Diane Kanzler

Client: Soundprints Publishing

Medium: Acrylic on paper

Size: 9" x 22"

210

Artists: **Steve Johnson**
Lou Fancher

Art Directors: Lou Fancher
Cecilia Yung

Client: Penguin Putnam

Medium: Oil on canvas

Size: 16" x 23"

211

Artists: **Steve Johnson**
Lou Fancher

Art Directors: Lou Fancher
Cecilia Yung

Client: Penguin Putnam

Medium: Oil on canvas

Size: 16" x 23"

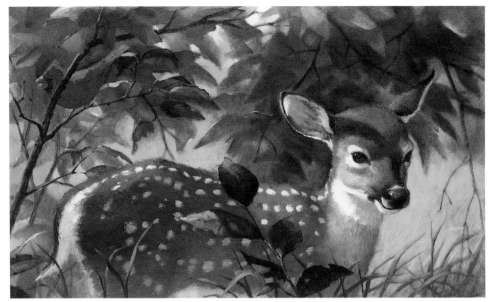

208

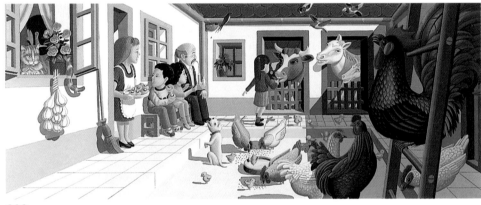

209

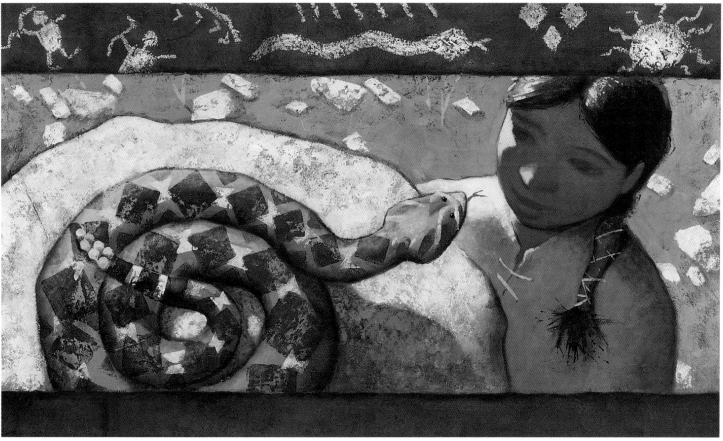

210

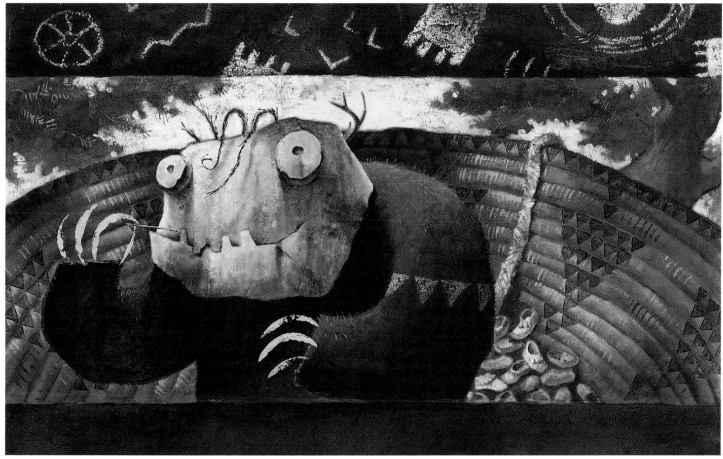

211

212

Artist: **Malcolm Tarlofsky**

Art Director: Adrian Stark

Client: Houghton Mifflin Company

Medium: Collage

213

Artist: **Donato**

Art Director: Irene Gallo

Client: Tor Books

Medium: Oil on paper on masonite

Size: 22" x 36"

214

Artist: **Donato**

Art Director: Irene Gallo

Client: Tor Books

Medium: Oil on paper on masonite

Size: 26" x 16"

215

Artist: **Donato**

Art Director: Heather Kern

Client: Ballantine Books

Medium: Oil on paper on masonite

Size: 27" x 18"

216

Artist: **Jon Foster**

Art Director: Jon Schindehette

Client: Wizards of the Coast

Medium: Oil on paper mounted on board

Size: 24" x 28"

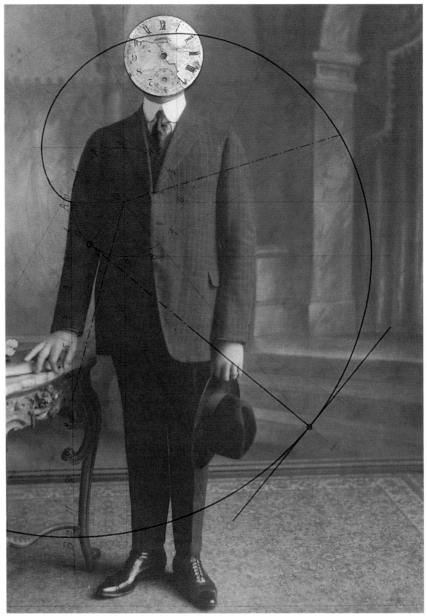

212

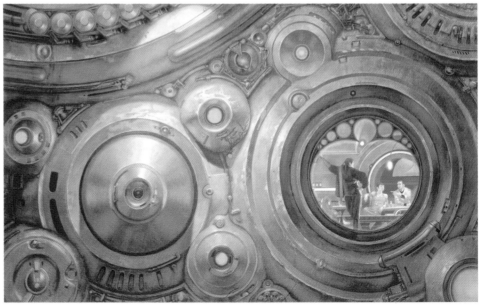

213

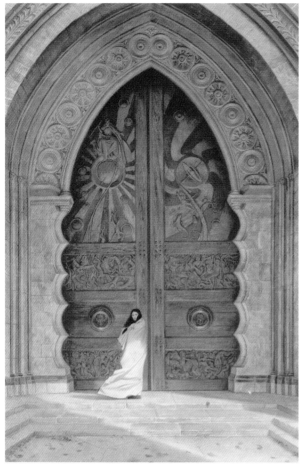

214

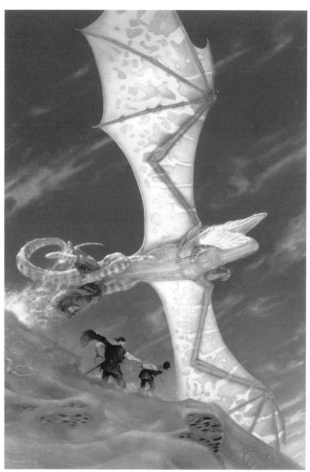

215

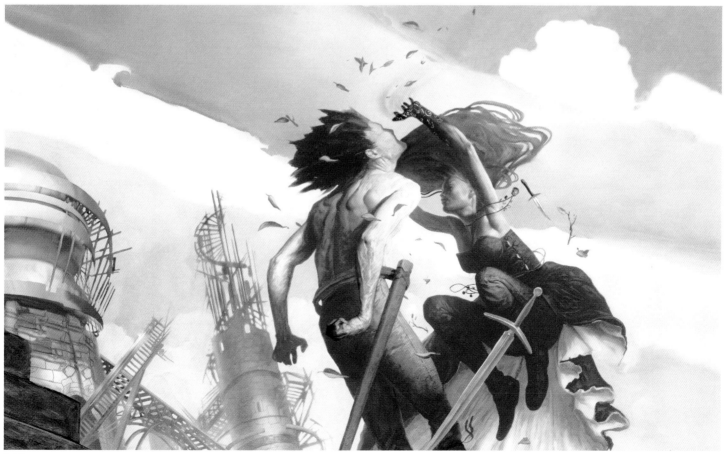

216

217

Artist: **Bart Forbes**

Art Director: Dana Arnett

Client: Heritage Press

Medium: Oil on board

Size: 20" x 14"

218

Artist: **David Ho**

Client: Sungood Books

Medium: Digital

Size: 20" x 16"

219

Artist: **John Jude Palencar**

Art Directors: John Fontana
 Susan Lurie

Client: HarperCollins &
 Parachute Publishing

Medium: Acrylic on ragboard

Size: 18" x 22"

220

Artist: **Robert Myers**

Art Director: Maria Carella

Client: Main Street Books/Doubleday

Medium: Pen & ink on Arches hot press

Size: 8" x 15"

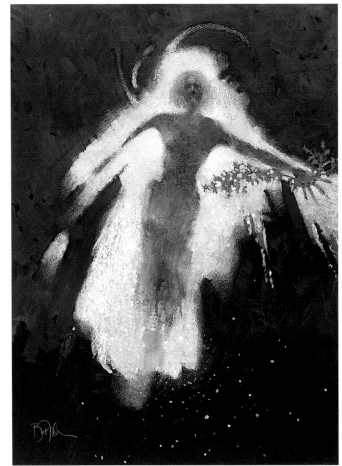

217

218

219

220

221

Artist: **Greg Spalenka**

Art Director: Karen Hudson

Client: Scholastic

Medium: Digital, mixed, paint, collage

Size: 14" x 11"

221

advertising

Geoffrey Moss, Chair
Illustrator

Pamela Berry
Creative Director,
Travel & Leisure

Leslie Cober-Gentry
Illustrator

Michael Gibbs
Illustrator

Lonni Sue Johnson
Illustrator

Robert W. Kosturko
Art Director, Houghton Mifflin
Children's Books

Charles Santore
Illustrator/Author

Christopher Sloan
Art Director, National
Geographic Magazine

John Thompson
Illustrator

Jury

222 Gold Medal

Artist: **Rafal Olbinski**

Client: Opera Company of Philadelphia

Medium: Acrylic on canvas

Size: 36" x 24"

"Richard Strauss's *Salome* has a history of scandalizing audiences. Based on Oscar Wilde's poem, the opera tells the story of Find Herold's depraved stepdaughter, Salome, and her love-object, John the Baptist. When Herod asks Salome to dance for him, she refuses until the King promises to grant her any wish. She performs the Dance of the Seven Veils, essentially a striptease. Then she asks for the head of John the Baptist. After its premier in 1907 at the Metropolitan Opera, the work was banned there until 1934. I wanted to create the image which would be as controversial as the opera, yet also give the audience emotional and intellectual insight into the subject.

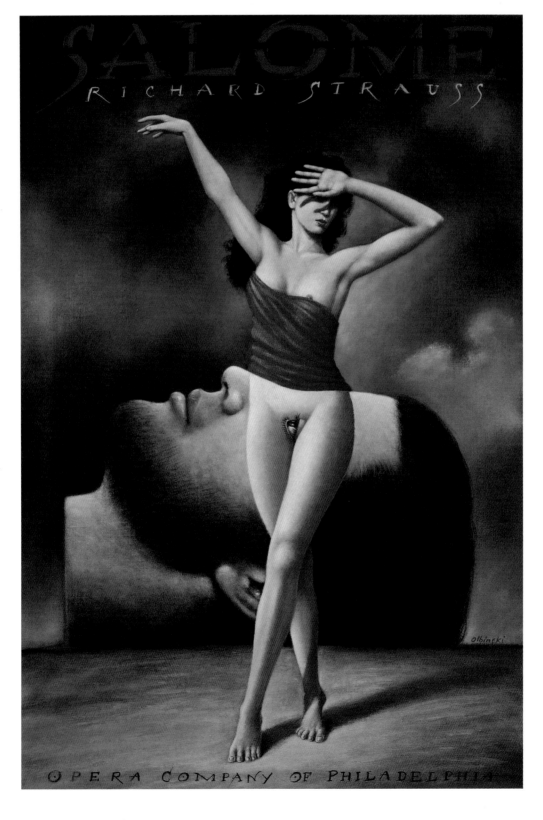

223 Gold Medal

Artist: **Davor Vrankic**

Art Director: Mirko Ilić

Client: Moderna Galerija

Medium: Pencil on paper

Size: 50" x 36"

"I started at the Art School in Sarajevo in 1986 and finished in Zagreb in 1991. During the last nine years I have been working on large format drawings in graphite on paper. Without using any model or documentation, I create a kind of virtual drawing by using all visual experience which I have assimilated: classical paintings, strip cartoons, cinema, video clips, photography, video games. The result gives an image which seems almost real, but which is entirely invented, combining the logic of synthetic images with classical drawing."

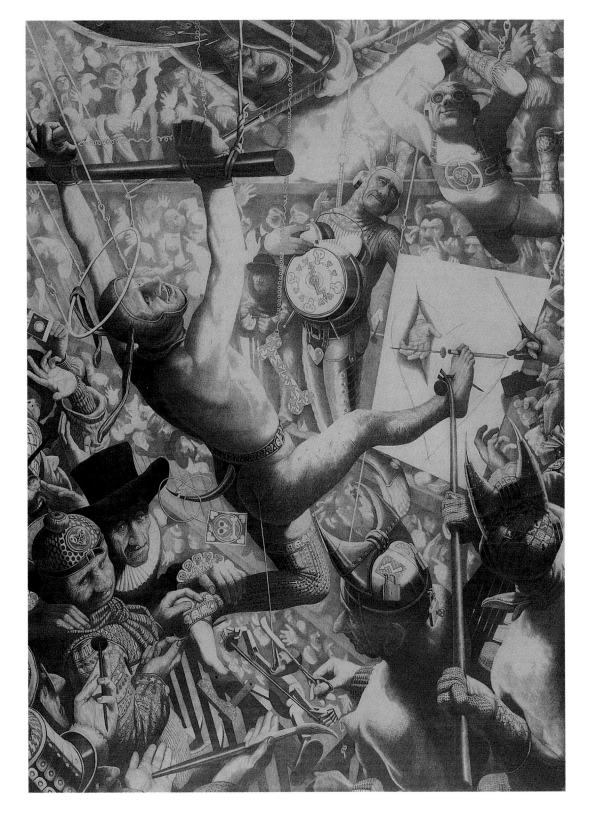

224 Silver Medal

Artist: **Etienne Delessert**

Art Director: Rita Marshall

Client: CIMA Museum

Medium: Watercolor, digital (Photoshop)

This work advertised the exhibition of the work of Guido Reuge, an engineer who created the best music boxes in the world. The showing of the boxes and his collection of antique automation was held in Sainte-Croix, Switzerland, home of the Center International for Mechanical Art. Etienne Delessert also designed the exhibition which included ten-foot-tall, animated figures replicating the watercolor images in the poster.

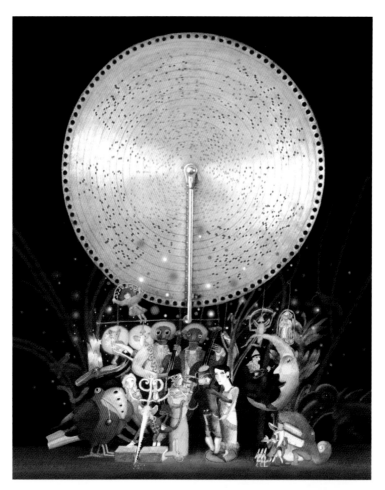

225 Silver Medal

Artist: **Brad Holland**

Art Director: Roxy Moffitt

Client: Long Wharf Theatre

Medium: Acrylic on board

Red is by a Chinese writer commenting on the effect the Communist revolution and later the Red Guard had on traditional Chinese theater. The hero has three incarnations: capitalist, actor and finally, successful commercial writer in America. It's not a happy story and Brad Holland played up the bloody tears against the actor's stark makeup. Holland has done eight posters for the Long Wharf Theater.

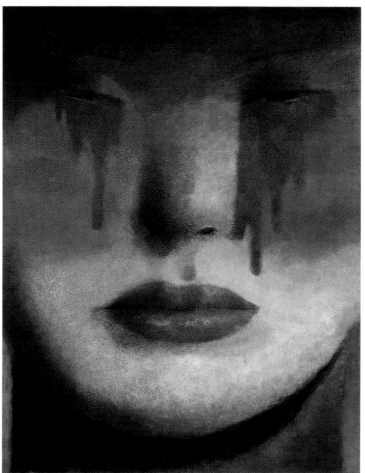

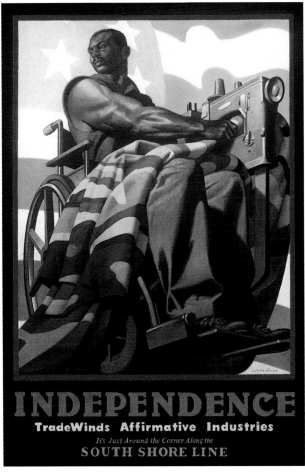

226 Silver Medal

Artist: **John Rush**

Art Director: Mitch Markovitz

Client: Northwest Indiana Forum & Tradewinds Affirmative Industries

Medium: Oil on canvas

Size: 42" x 28"

"This poster was commissioned by a manufacturing company that hires handicapped workers. When I visited the factory with my camera I discovered this fellow working an industrial sewing machine. He seemed to be the physical manifestation of triumph over adversity. I am indebted not only to my model, but also to Michelangelo for teaching me about the nobility of the human spirit expressed through the power and grace of the human figure."

227

Artist: **Mark English**

Client: Ussery Printing

Medium: Oil on board

Size: 20" x 15"

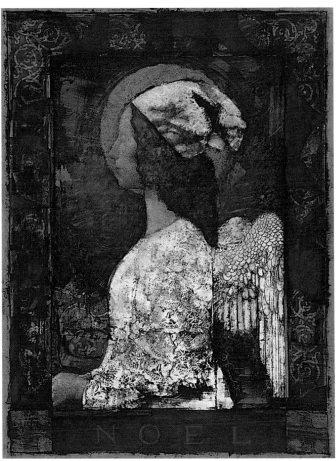

228

Artist: **Greg Swearingen**

Art Director: James Bundy

Client: Great Lakes Theater Festival

Medium: Mixed on board

Size: 12" x 7"

229

Artist: **Glenn Harrington**

Art Director: Jim Plumeri

Client: Bantam Doubleday Dell
Audio Publishing

Medium: Oil on board

Size: 26" x 16"

230

Artist: **Jody Hewgill**

Art Directors: Scott Mires
Neill Archer Roan

Client: Arena Stage

Medium: Acrylic on board

Size: 15" x 10"

231

Artist: **Jody Hewgill**

Art Directors: Scott Mires
Neill Archer Roan

Client: Arena Stage

Medium: Acrylic, ink on board

Size: 14" x 9"

232

Artist: **M. Kyle Hollingsworth**

Art Director: Edem Elesh

Client: Buffalo Nights Theatre Company

Medium: Mixed on board

Size: 17" x 11"

233

Artist: **Mary GrandPré**

Art Director: Brian Oakes

Client: Colorado Symphony Orchestra

Medium: Pastel on paper

Size: 20" x 16"

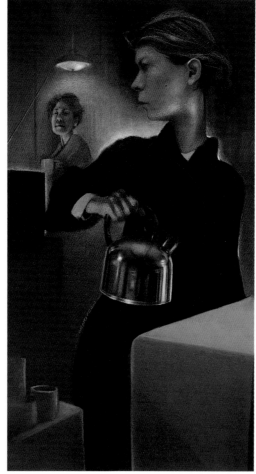

228

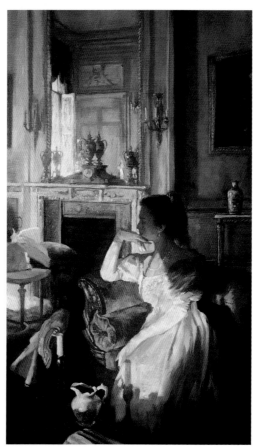

229

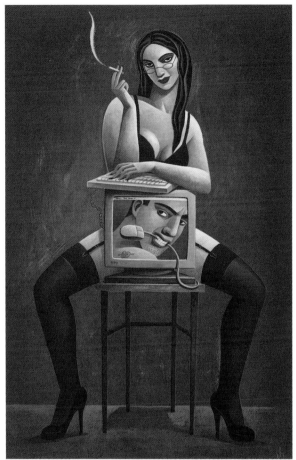

230

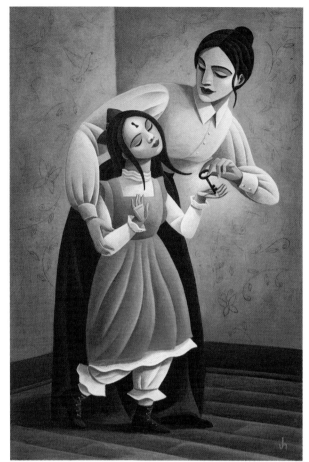

231

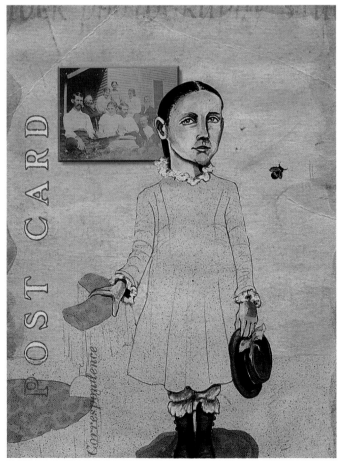

232

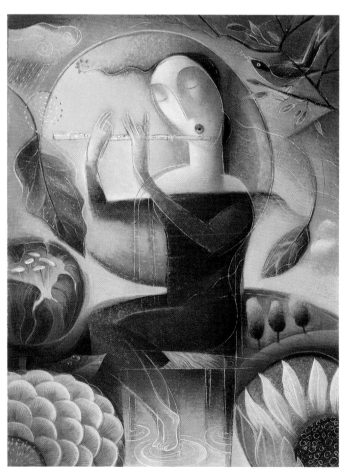

233

234

Artist: **Tom Curry**

Art Director: Lori Braun

Client: Data Systems Group

Medium: Acrylic on hardboard

Size: 15" x 15"

235

Artist: **Cathleen Toelke**

Client: The Premier/Millennium Broadway

Medium: Oil on linen

Size: 66" x 90"

236

Artist: **Wilson McLean**

Art Director: Neill Archer Roan

Client: Arena Stage

Medium: Oil on canvas

Size: 22" x 12"

237

Artist: **Gary Kelley**

Art Director: David Bartels

Client: St. Patrick Center

Medium: Pastel on paper

Size: 24" x 17"

238

Artist: **Michael Schwab**

Art Director: Brooks Branch

Medium: Pen & ink, digital

Size: 38" x 27"

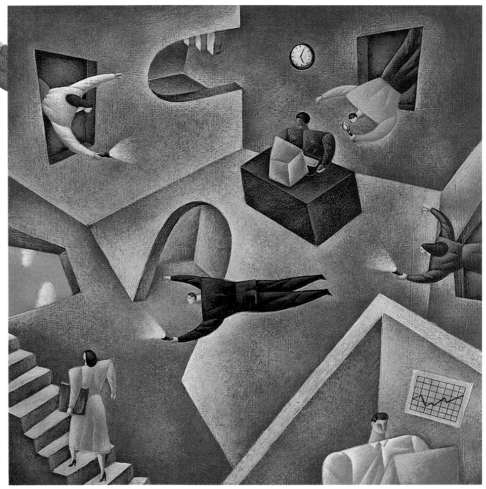

234

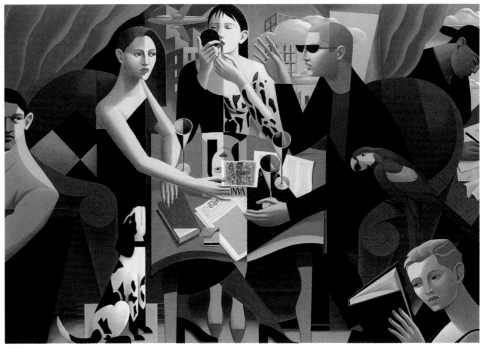

235

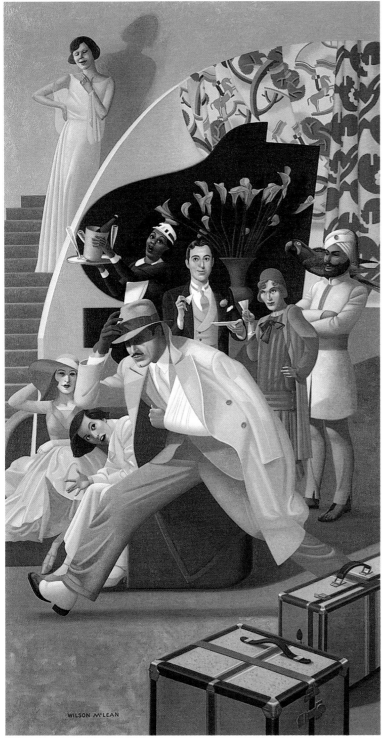

236

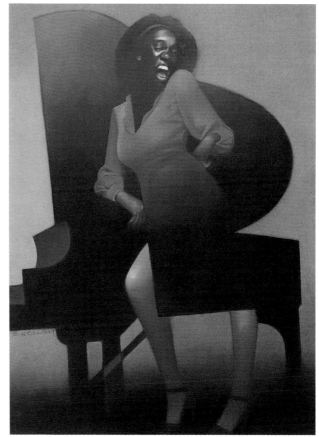

237

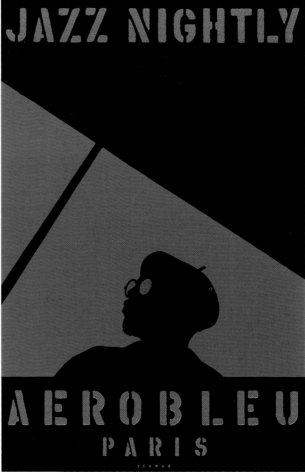

238

239

Artist: **Joe Sorren**

Art Director: John Rafferty

Client: Evans Drumheads

Medium: Acrylic on canvas

Size: 36" x 24"

240

Artist: **Mark Dancey**

Client: Ritual, Inc.

Medium: Silk screen print, watercolor
on cardstock

Size: 17" x 14"

241

Artist: **Curtis Parker**

Art Director: Peter Jones

Client: International Children's Choir

Medium: Acrylic on linen

Size: 28" x 20"

242

Artist: **Joe Sorren**

Art Director: Paul Berg

Client: Mountain School

Medium: Acrylic on canvas

Size: 30" x 40"

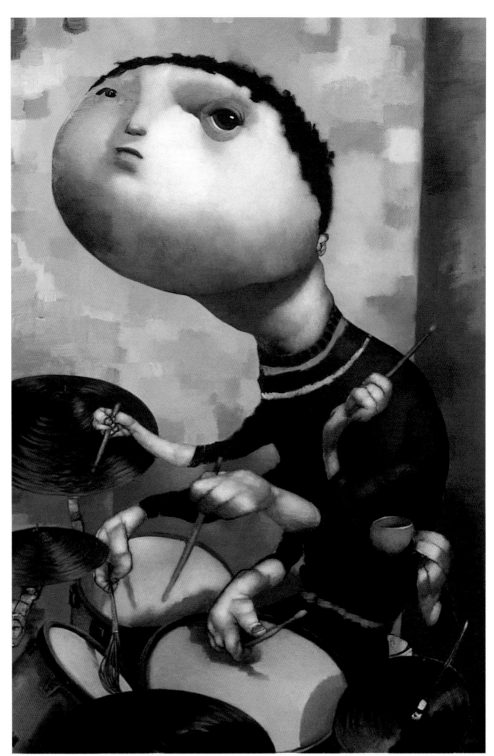

239

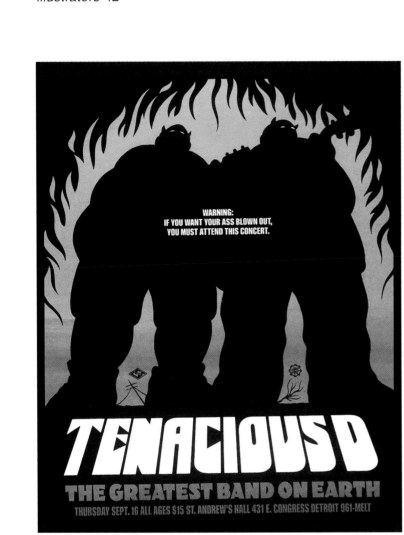

240

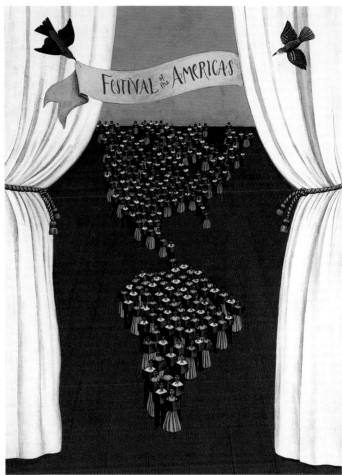

241

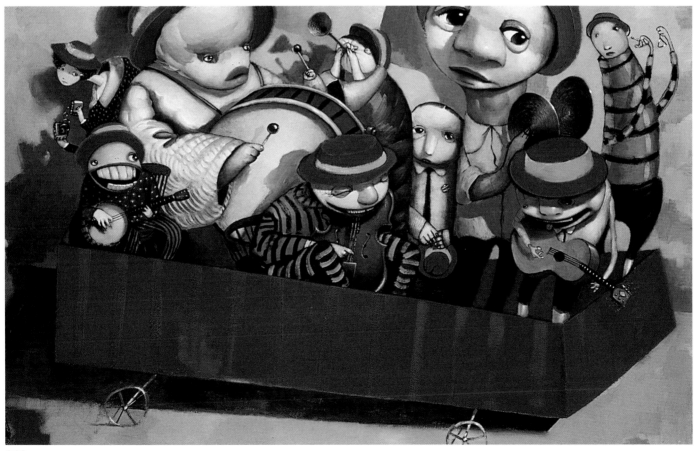

242

243

Artist: **Richard Borge**

Art Director: Mike Shavalier

Client: Cleveland Scene Paper

Medium: Found objects, photographed on printmaking paper

Size: 14" x 12"

244

Artist: **Edem Elesh**

Art Director: M. Kyle Hollingsworth

Client: Buffalo Nights Theatre Company

Medium: Mixed on cardboard

Size: 17" x 11"

245

Artist: **Milton Glaser**

Art Director: Steven Heller

Client: Fox River Paper Company

Medium: Collage, colored pencil

Size: 18" x 16"

246

Artist: **Milton Glaser**

Client: Theatre for a New Audience

Medium: Mixed

247

Artist: **Jane George**

Art Director: David Hay

Client: Walnut Creek Center Repertory Theatre

Medium: Watercolor, acrylic on Arches 140 lb. cold press

Size: 19" x 14"

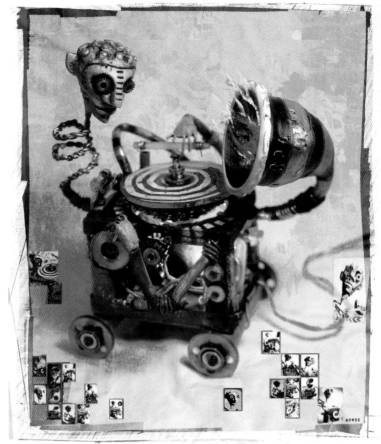

243

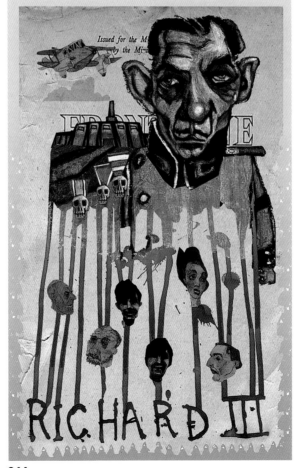

244

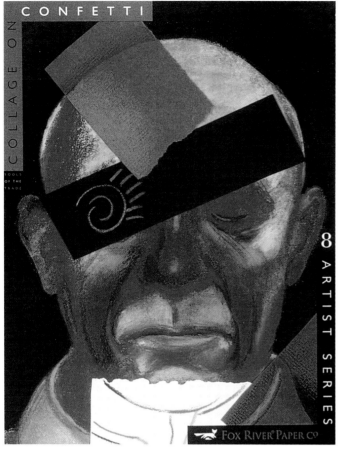

245

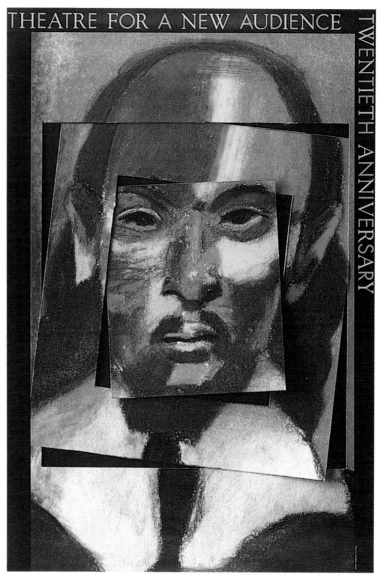

246

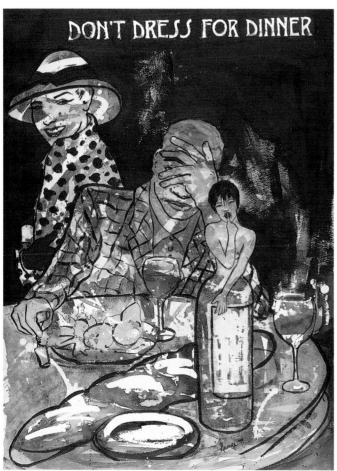

247

248

Artist: **Jack Unruh**

Art Director: Danny Kamerath

Client: Peisner Johnson & Company

Medium: Ink, watercolor on board

Size: 12" x 20"

249

Artist: **Jack Unruh**

Art Director: Danny Kamerath

Client: Peisner Johnson & Company

Medium: Ink, watercolor on board

Size: 12" x 20"

250

Artist: **Mark Stutzman**

Art Directors: Stella Bugbee
Drew Hodges

Client: Spot Design/David Blaine

Medium: Watercolor, airbrush on board

Size: 24" x 18"

251

Artist: **Albert Lorenz**

Art Director: Tony Tropea

Client: Bepuzzled

Medium: Mixed on Bristol

Size: 30" x 40"

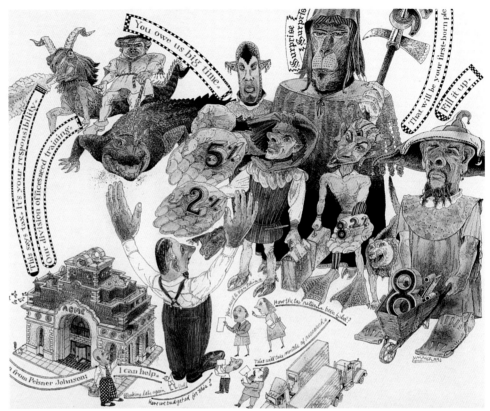

248

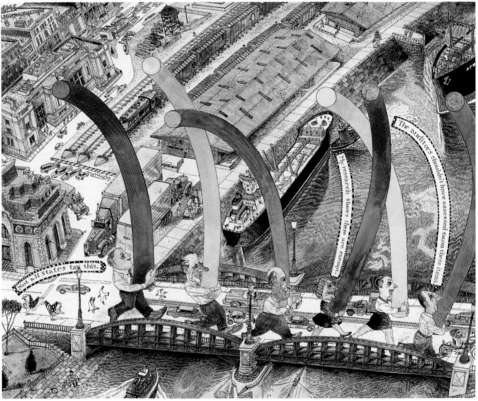

249

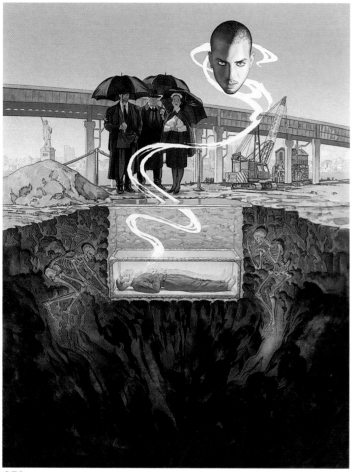

250

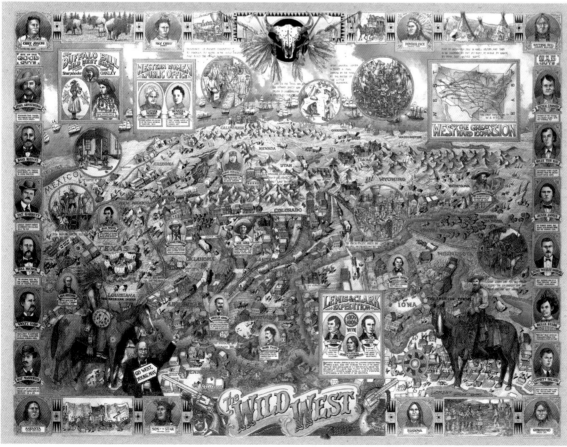

251

253

Artist: **Scott McKowen**

Client: Roundabout Theatre Company

Medium: Scratchboard

Size: 24" x 14"

254

Artist: **Scott McKowen**

Client: Roundabout Theatre Company

Medium: Scratchboard

Size: 22" x 14"

255

Artist: **Scott McKowen**

Client: Roundabout Theatre Company

Medium: Scratchboard

Size: 22" x 14"

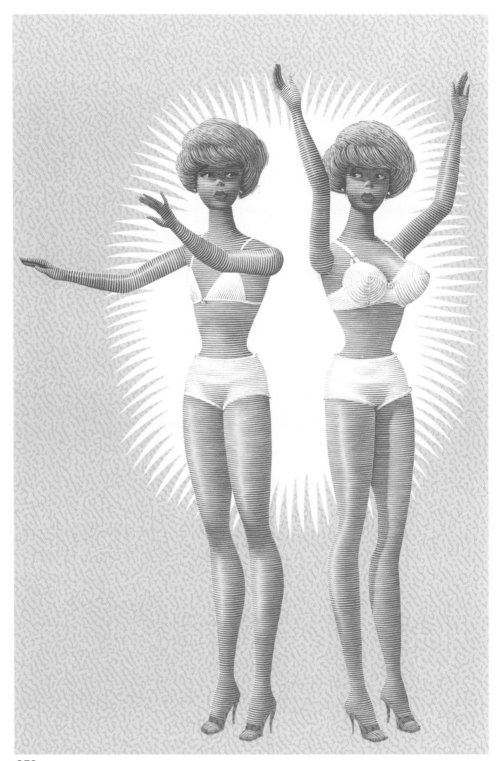

253

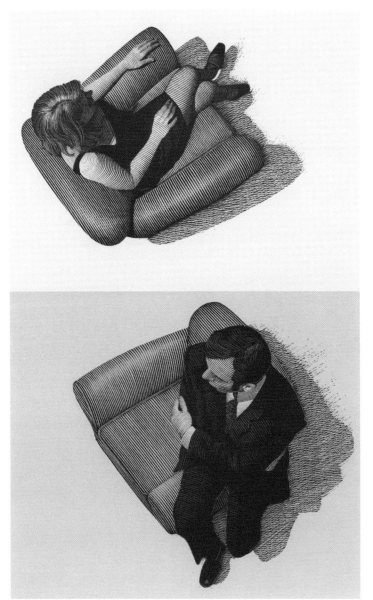

254

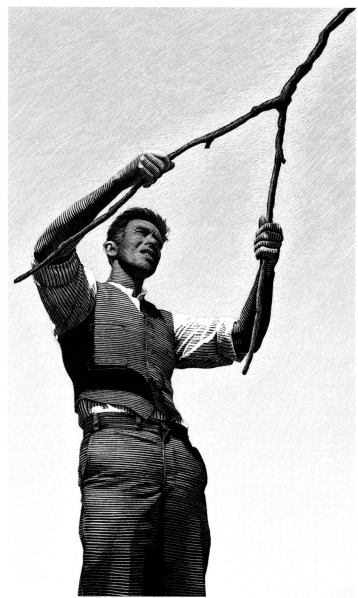

255

256
Artist: **Pierre Le-Tan**
Art Director: Reed Krakoff
Client: Coach
Size: 12" x 9"

257
Artist: **Laurent Cilluffo**
Art Director: Don Morris
Client: Sundance Film Festival
Medium: Silkscreen on paper
Size: 8" x 12"

258
Artist: **Rafal Olbinski**
Client: Cincinnati Opera
Medium: Acrylic on canvas
Size: 30" x 20"

259
Artist: **Larry Moore**
Client: Orlando Opera Company
Medium: Pastel on sanded paper
Size: 24" x 20"

260
Artist: **Larry Moore**
Client: Orlando Opera Company
Medium: Pastel on paper
Size: 28" x 20"

261
Artist: **Stephen Kasner**
Client: Century Media
Medium: Oil on canvas

256

257

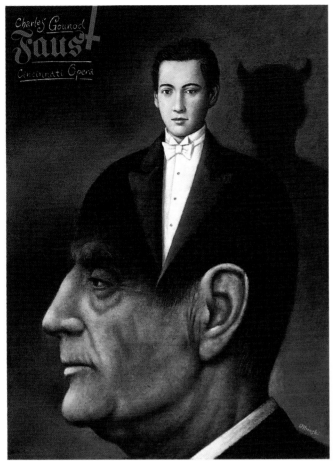

258

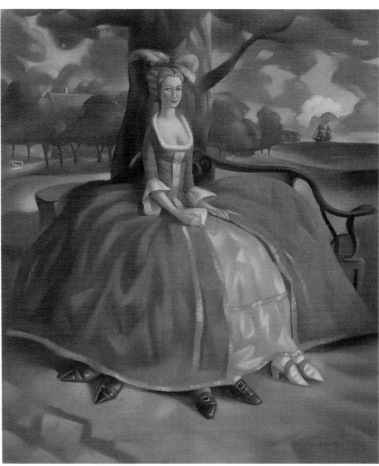

259

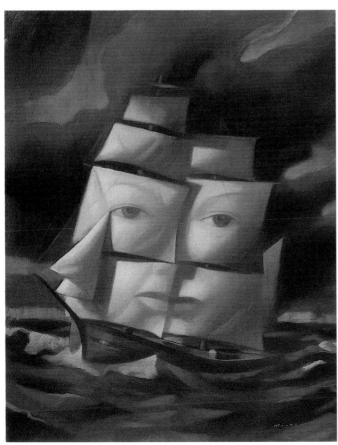

260

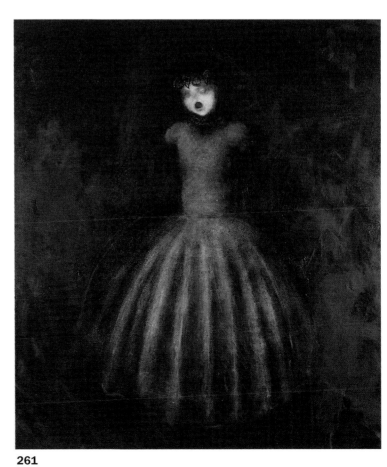

261

262

Artist: **Brad Holland**

Art Director: Jami Glovanopolous

Client: the i spot

Medium: Pastel on paper

263

Artist: **Dave McKean**

Client: Feral Records

Medium: Digital

Size: 11" x 11"

264

Artist: **Joe Sorren**

Art Director: Eiming

Client: Minna Street Gallery

Medium: Acrylic on canvas

Size: 40" x 30"

265

Artist: **John Jude Palencar**

Art Director: David Evans

Client: National Geographic Television

Medium: Acrylic on board

Size: 17" x 34"

262

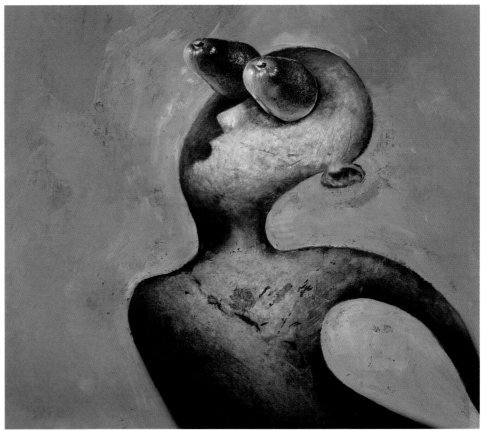

263

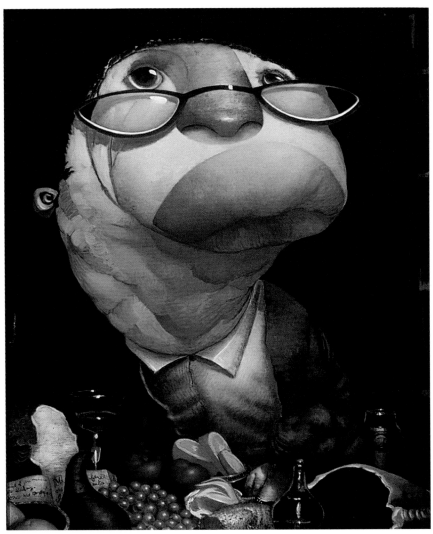

264

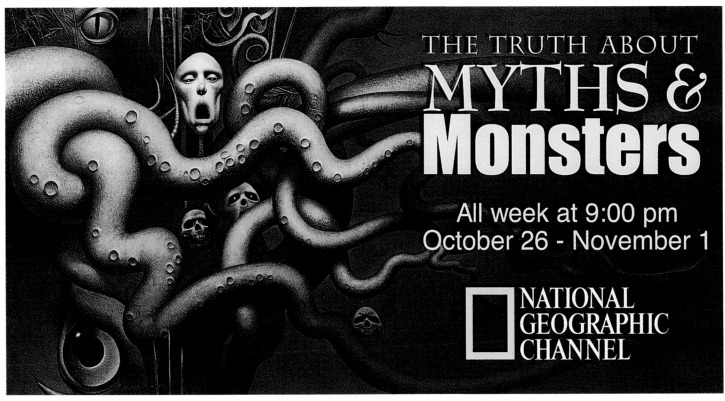

265

266

Artist: **Anita Kunz**

Art Director: Elspeth Lynn

Client: The Stratford Chefs School

Medium: Watercolor on board

Size: 12" x 10"

267

Artist: **Daniel Craig**

Art Director: Hilde McNeil

Client: Arizona Theatre Company

Medium: Acrylic on canvas

Size: 25" x 16"

268

Artist: **C.F. Payne**

Art Director: Paul Kreutus

Client: Zions Bank

Medium: Mixed on board

Size: 16" x 12"

269

Artist: **Etienne Delessert**

Art Director: Rita Marshall

Client: Visual Arts Museum at the
School of Visual Arts

Medium: Watercolor on paper

270

Artist: **Larry McEntire**

Art Director: Tom Berno

Client: Dancie Perugini Ware Public
Relations Advertising

Medium: Acrylic on canvas

Size: 12" x 16"

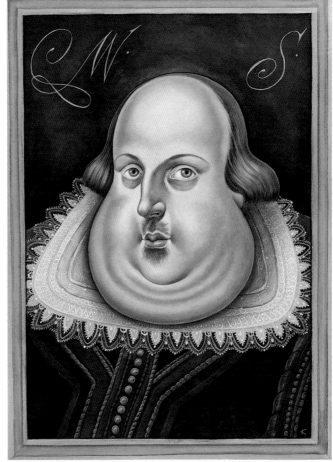

266

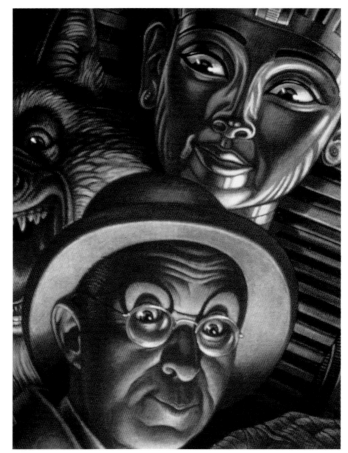

267

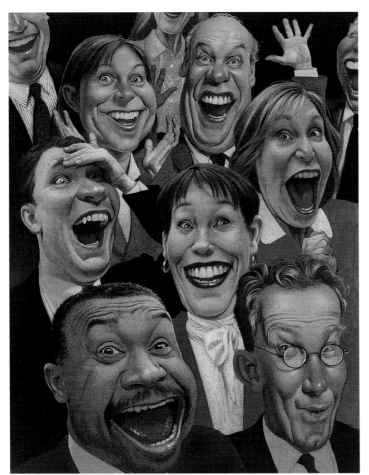

268

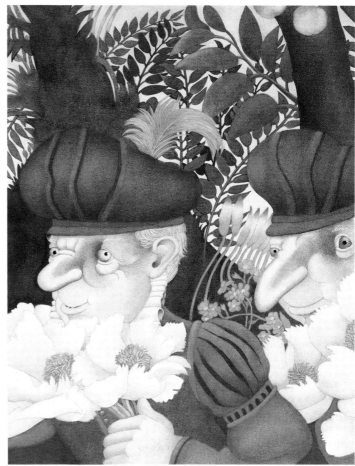

269

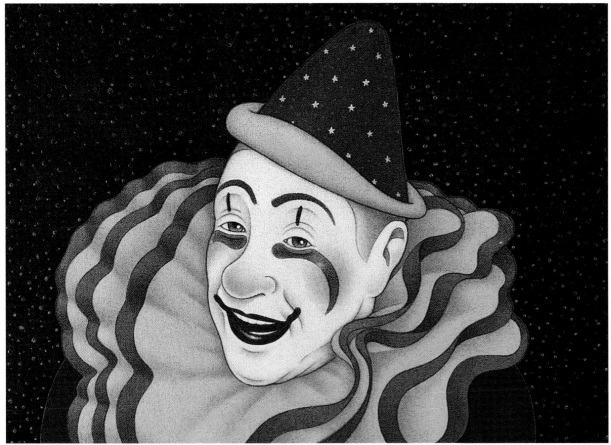

270

271

Artist: **Brad Holland**

Client: Dallas Society of Visual
 Communications

Medium: Acrylic on board

272

Artist: **Brad Holland**

Art Director: Nathalie Roux

Client: Musée des Beaux-Arts

Medium: Acrylic on board

273

Artist: **Gregory Manchess**

Art Director: John Krull

Client: Farm Credit Services of America

Medium: Oil on board

Size: 18" x 26"

274

Artist: **Wendell Minor**

Client: Muskegon Museum of Art

Medium: Acrylic on masonite

Size: 12" x 20"

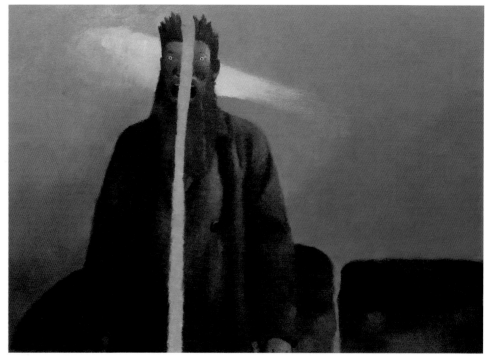

271

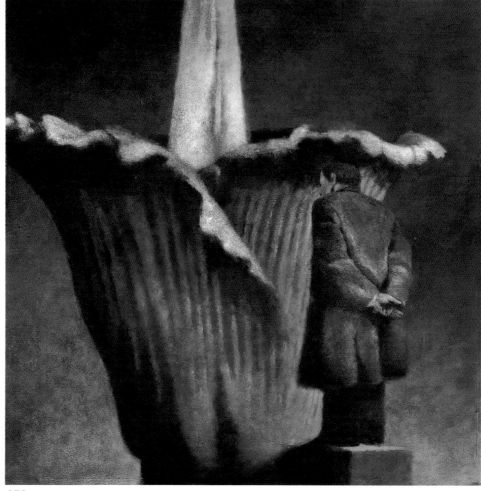

272

273

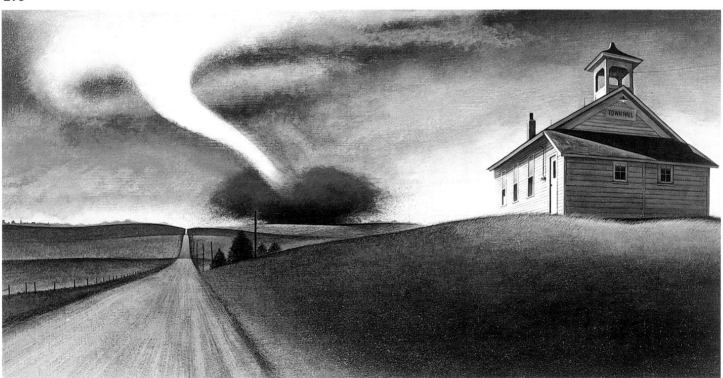

274

275

Artist: **Stephen Savage**

Art Director: Robert Kastigar

Client: Goodby, Silverstein & Partners

Medium: Digital

276

Artist: **John Patrick**

Art Directors: Kit Hinrichs
Brian Jacobs

Client: Dreyers/Pentgram Design

Medium: Gouache, acrylic on board

278

Artist: **John P. Maggard III**

Client: Cincinnati Heart Association

Medium: Acrylic, oil on Strathmore 240

Size: 14" x 28"

278

Artist: **Nanette Biers**

Art Director: Michael Braley

Client: New Energy Ventures

Medium: Oil on canvas

Size: 24" x 18"

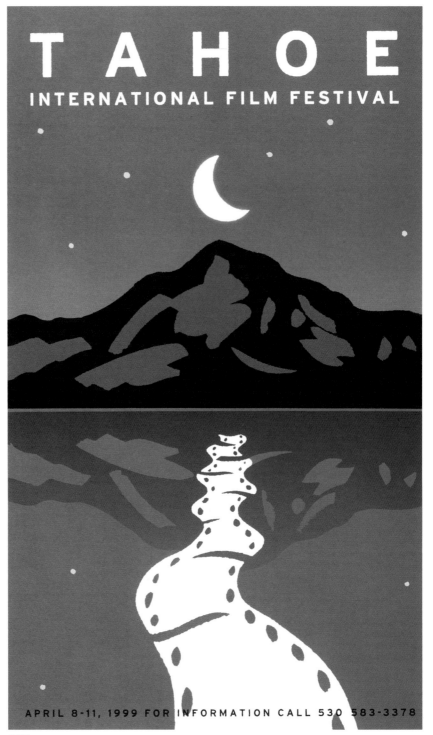

275

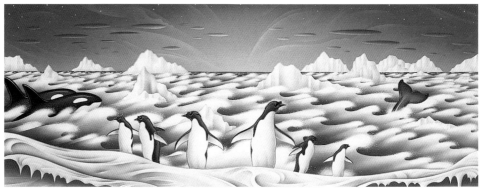

276

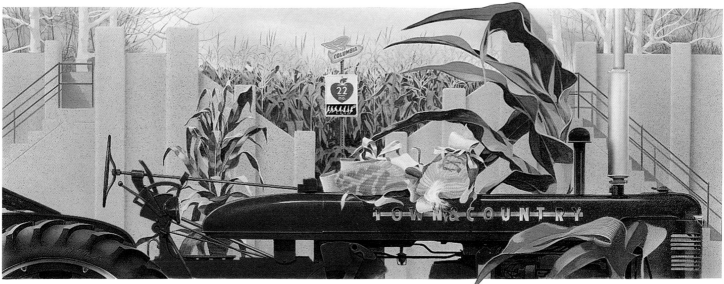

277

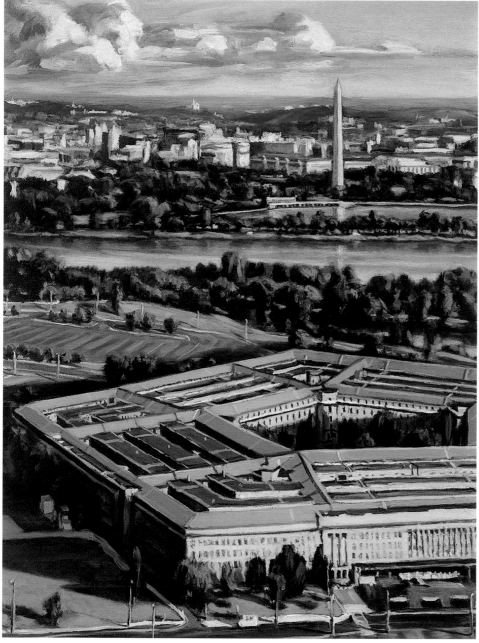

278

279

Artist: **Bruce Waldman**

Art Director: Sharon Shiraga

Client: Phillip Nichols Fine Art

Medium: Monoprint on BFK paper

Size: 26" x 34"

280

Artist: **Michael J. Deas**

Art Director: Lynn Frederickson

Client: Chik-Fil-A Restaurants

Medium: Oil on panel

Size: 24" x 36"

281

Artist: **Robert Giusti**

Art Director: Kit Hinrichs

Client: Dreyers/Pentagram Design

Medium: Acrylic on linen

Size: 10" x 24"

282

Artist: **Daniel Craig**

Art Directors: Mark Oliver
　　　　　　　Patty Devlin-Driskel

Client: Breeder's Choice Catfood

Medium: Acrylic on canvas

Size: 22" x 15"

283

Artist: **Cathie Bleck**

Art Director: Steve Blair

Client: Bicardi

Medium: Scratchboard, gouache

Size: 18" x 14"

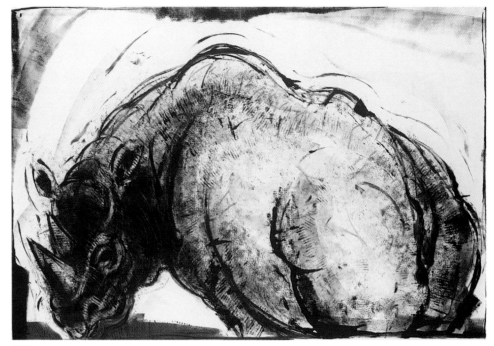

279

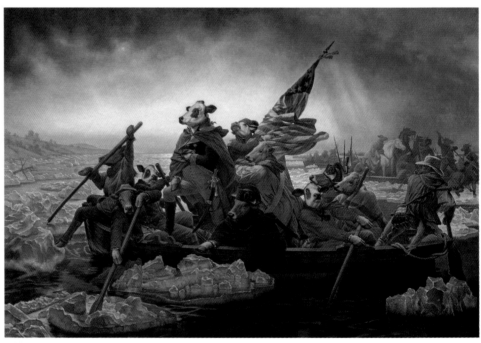

280

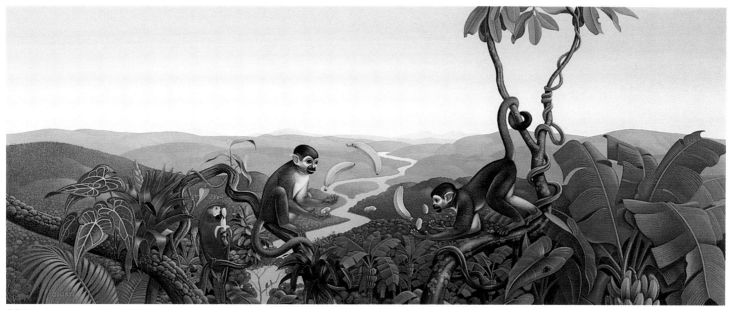

281

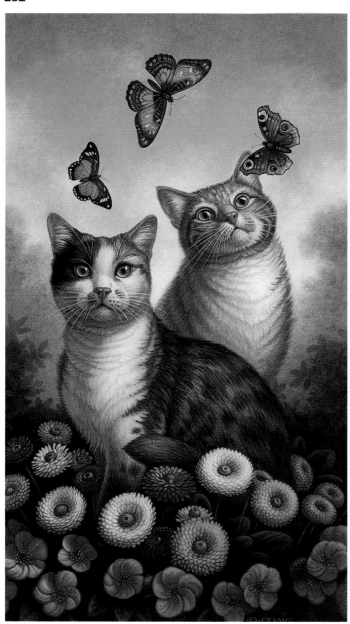

282

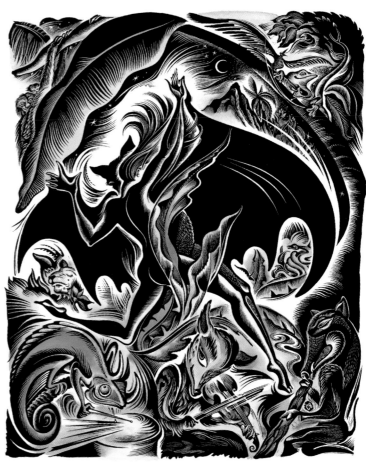

283

284

Artist: **Bill Mayer**

Art Director: Harry Hartofelis

Client: Hartford Stage

Medium: Gouache on hot press Strathmore

Size: 20" x 15"

285

Artist: **Tsukushi**

Art Director: Richard Jackson

Client: DK Publishing, Inc.

Medium: Cut paper

Size: 16" x 24"

286

Artist: **Yan Nascimbene**

Client: Wallace & Vannucci Haven House

Medium: Watercolor, ink on paper

Size: 14" x 14"

287

Artist: **Yan Nascimbene**

Art Director: Mary Claire Beckette

Client: St. Louis Family Theater

Medium: Watercolor, ink on paper

Size: 10" x 7"

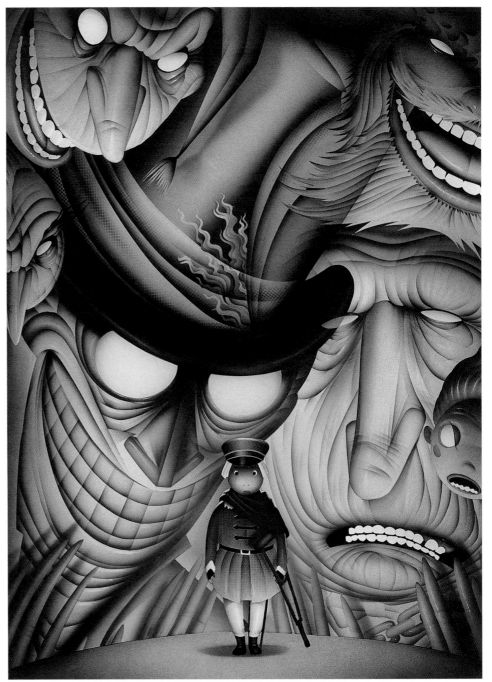

284

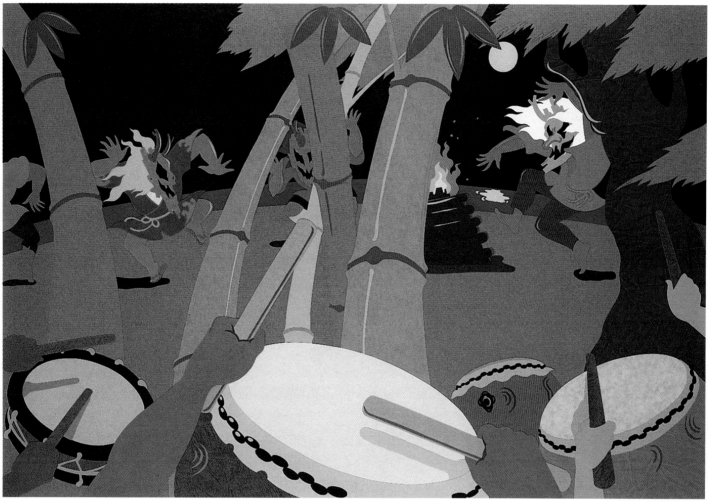

285

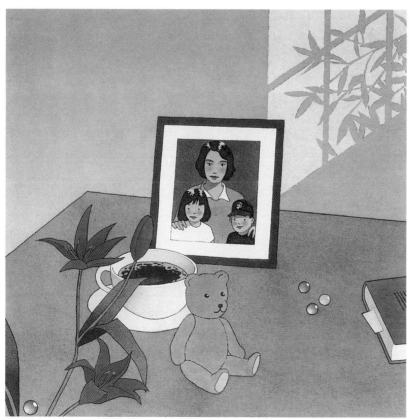

286

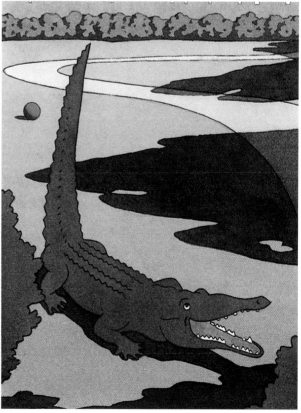

287

288
Artist: **Yan Nascimbene**
Art Director: Mary Claire Beckette
Client: St. Louis Family Theater
Medium: Watercolor, ink on paper
Size: 10" x 7"

289
Artist: **Yenpitsu Nemoto**
Art Director: Ryuichi Okeda
Client: Enicom
Medium: Colored Maker's Ink

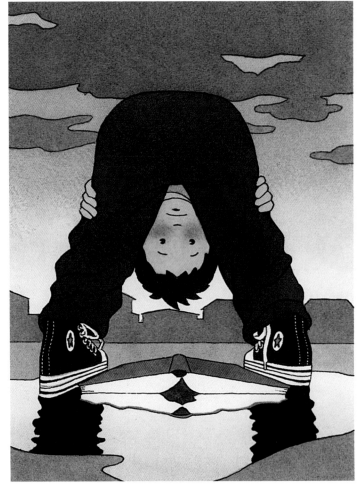

288

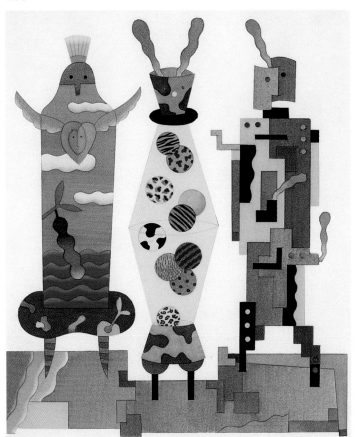

289

institutional

Linda Fennimore, Chair
Illustrator

Vivienne Flesher
Illustrator

Robert Giusti
Illustrator

Kathy Legg
Designer,
The Washington Post

Bill Mayer
Illustrator

Kadir Nelson
Illustrator

Robert Andrew Parker
Illustrator

Chalkley Calderwood Pratt
Art Director

Kazuhiko Sano
Illustrator

Jury

290 Gold Medal

Artist: **Jim Burke**

Client: Strauss Payton

Medium: Oil on canvas

Size: 16" x 14"

"During my three-year stay in Kansas City, the historic jazz district became an endless source of inspiration for paintings. 'The Bass Player' was painted for a limited edition gliclée print. The composition had been in my mind for quite some time and provided probably the most exciting two hours of painting I've experienced yet! Thank you to the Society for this prestigious award, I am truly honored."

291 Gold Medal

Artist: **Etienne Delessert**

Art Directors: Rita Marshall
François Rochaix

Client: Fête Des Vignerons

Medium: Watercolor on paper

Etienne Delessert created this as the poster for a major arts festival in Switzerland. Since 1700 the Fête des Vignerons has been held every 25 years, lasts 15 days, encompasses 5,000 actors and has 500,000 visitors. The workers who care for the vineyards are honored, five of whom are named Kings. Here one of them stands behind the rusted vineyard door. According to Delessert, "We live in hell(!)—behind the door is paradise—and the show."

292 Silver Medal

Artist: **Etienne Delessert**

Art Directors: Rita Marshall
François Rochaix

Client: Fête Des Vignerons

Medium: Watercolor on paper

The Garden of Orpheus is a magical place of tame beasts beholden to the Thracian poet and musician. The vineyard and lakes that surround Vevey, Switzerland, abound with such animals. This piece was one of four done for the Fêtes des Vignerons. Etienne says, "An artist is always observing people and behavior." After living in America for over 20 years, he visits Europe with a fresh, observant eye.

293 Silver Medal

Artist: **Craig Frazier**

Art Director: James Pettus

Client: Orion Capital Corporation

Medium: Cut/Digital

Size: 16" x 12"

"Assigned to illustrate 'understanding the customer,' I chose to put one figure on both sides of the fence. With a simple manipulation, it became possible to say the obvious in a new way. Most importantly, there remained enough unsaid for the viewer to have some fun completing the picture."

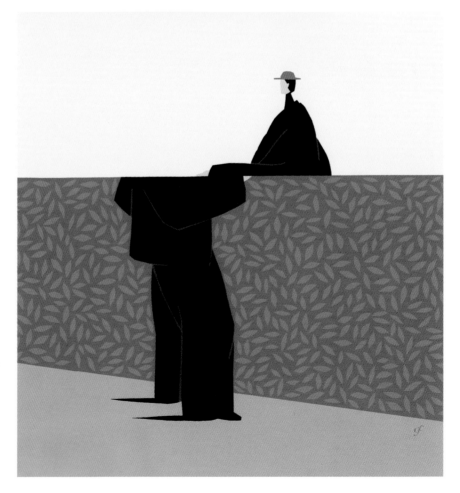

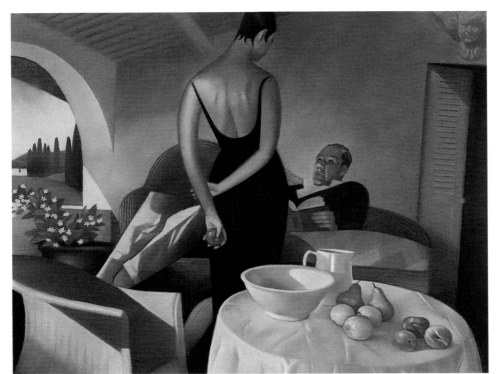

294

Artist: **Gary Kelley**

Art Director: Richard Solomon

Client: Richard Solomon Artists
 Representative

Medium: Pastel on paper

Size: 20" x 22"

295

Artist: **Paul Lee**

Client: Sarah Bain Gallery

Medium: Acrylic on Board

Size: 48" x 36"

294

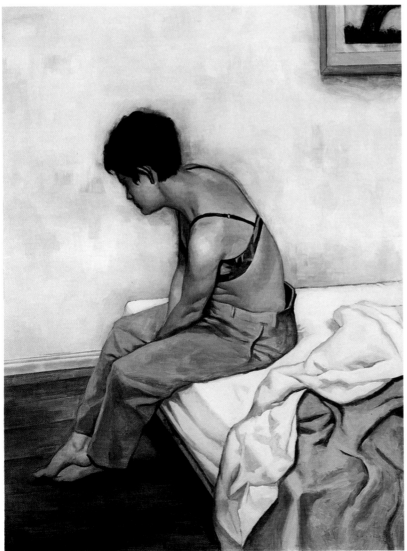

295

296

Artist: **John Collier**

Art Director: Richard Solomon

Client: Richard Solomon Artists
Representative

Medium: Pastel, watercolor on paper

Size: 24" x 18"

297

Artist: **Patrick Fiore**

Medium: Oil on wood panel

Size: 48" x 36"

298

Artist: **Gregory Manchess**

Art Director: Richard Solomon

Client: Richard Solomon Artists
Representative

Medium: Oil on linen canvas

Size: 20" x 30"

299

Artist: **David Johnson**

Art Director: Richard Solomon

Client: Richard Solomon Artists
Representative

Medium: Pen & ink, watercolor on
watercolor paper

Size: 30" x 20"

300

Artist: **John Collier**

Art Director: Richard Solomon

Client: Richard Solomon Artists
Representative

Medium: Pen & ink, watercolor on
watercolor paper

Size: 24" x 18"

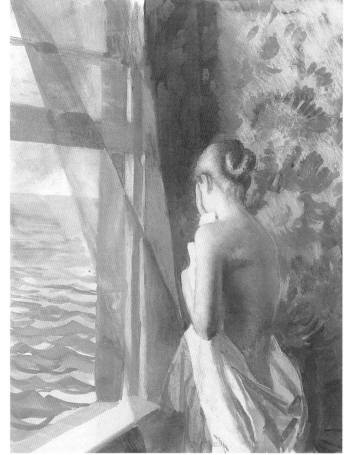

296

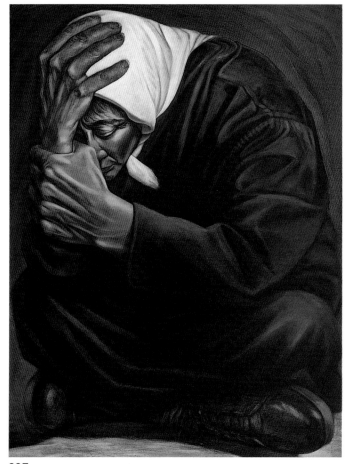

297

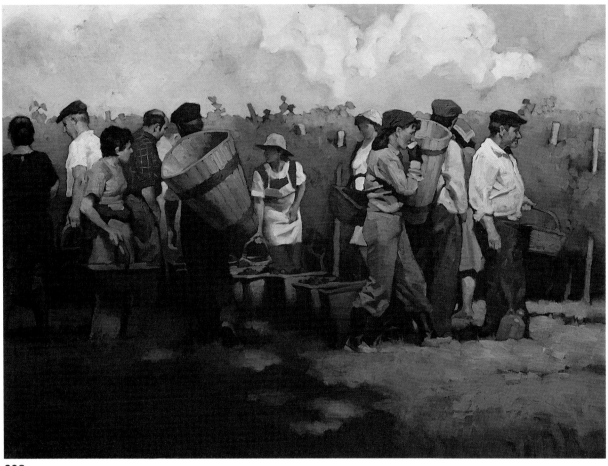

298

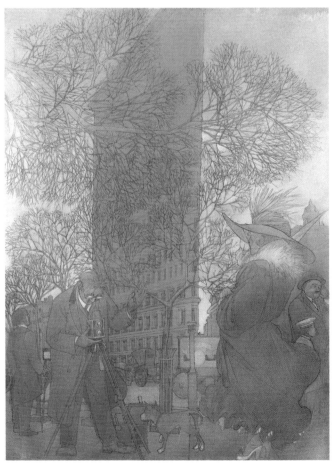

299

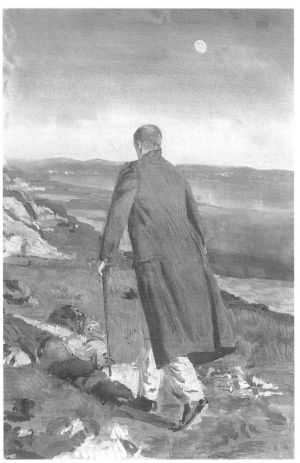

300

301

Artist: **Bill Nelson**

Art Director: Richard Solomon

Client: Richard Solomon Artists
Representative

Medium: Colored pencil on matt board

Size: 15" x 9"

302

Artist: **James Ransome**

Art Director: Martha Rago

Client: Henry Holt & Company

Medium: Oil on paper

Size: 16" x 20"

303

Artist: **Wilson McLean**

Art Director: Neill Archer Roan

Client: Arena Stage

Medium: Oil on canvas

Size: 24" x 16"

304

Artist: **Raymond Verdaguer**

Medium: Multicolored linoleum cut on
rice paper

Size: 12" x 12"

305

Artist: **Andrea Ventura**

Art Director: Richard Solomon

Client: Richard Solomon Artists
Representative

Medium: Acrylic, charcoal on paper

Size: 18" x 15"

306

Artist: **Andrea Ventura**

Art Director: Richard Solomon

Client: Richard Solomon Artists
Representative

Medium: Mixed on paper

Size: 24" x 17"

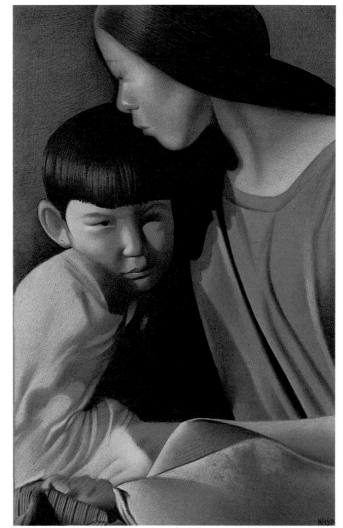

301

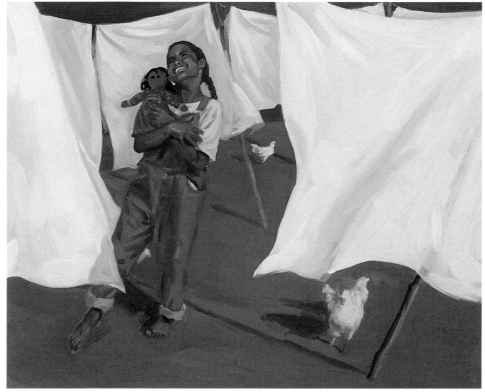

302

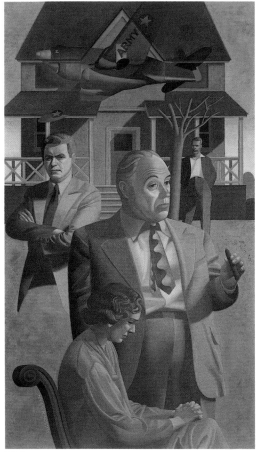

303

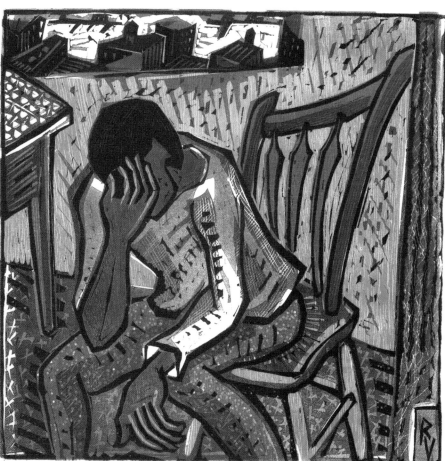

304

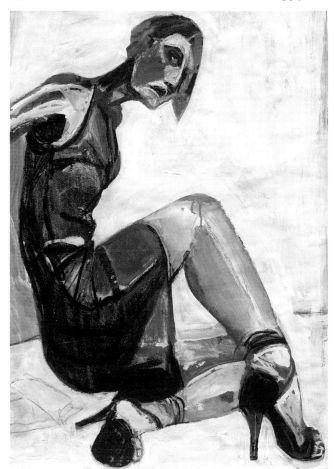

305

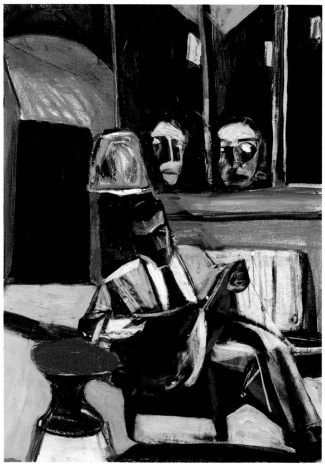

306

307

Artist: **Kevin Eslinger**

Medium: Oil, acrylic on masonite

Size: 36" x 24"

308

Artist: **Sterling Hundley**

Medium: Pen & ink on board

Size: 11" x 9"

309

Artist: **Tatsuro Kiuchi**

Medium: Digital

310

Artist: **Richard Hart**

Client: Disturbance Design

Medium: Digital

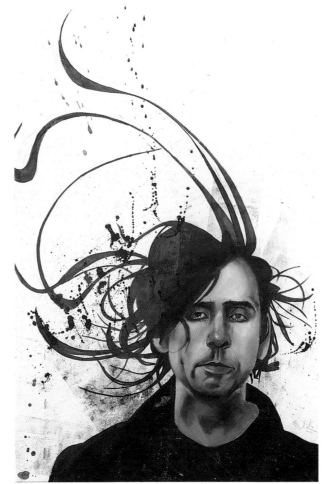

307

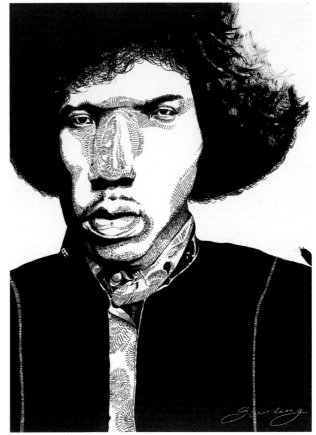

308

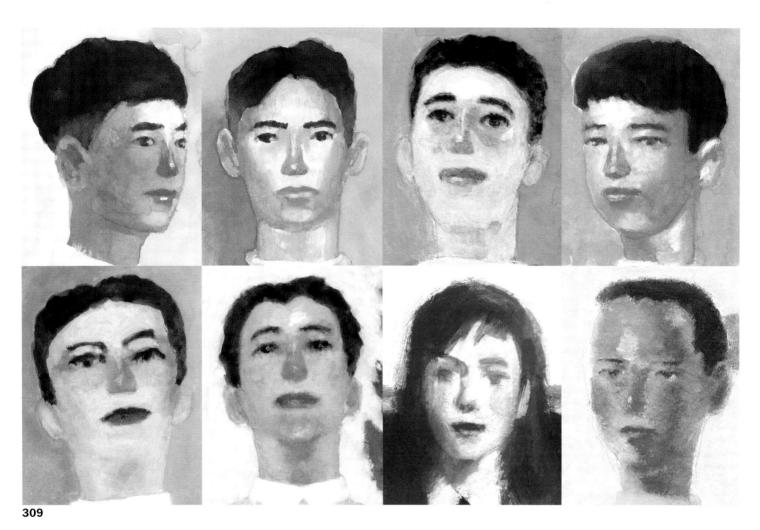

309

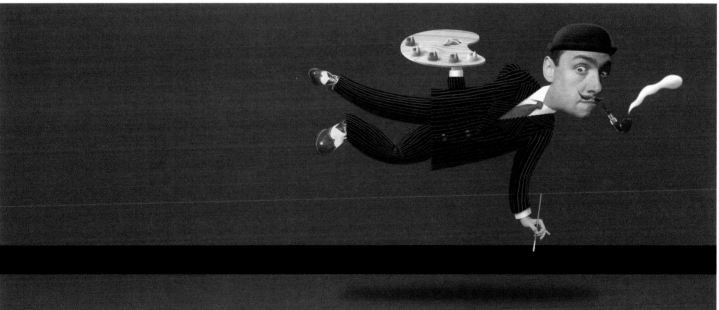

310

311

Artist: **Jack Harris**

Medium: Digital, pastel on Arches
watercolor paper

Size: 17" x 21"

312

Artist: **Steven Verriest**

Medium: Acrylic on canvas

Size: 12" x 9"

313

Artist: **Dale Stephanos**

Medium: Oil on canvas

Size: 40" x 30"

314

Artist: **Gary Cooley**

Medium: Oil on canvas

Size: 16" x 18"

315

Artist: **Eric Strenger**

Client: Reparte

Medium: Acrylic on board

Size: 24" x 20"

316

Artist: **Joe Ciardiello**

Medium: Pen & ink, watercolor on paper

Size: 14" x 10"

311

312

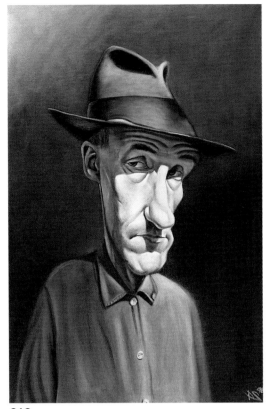

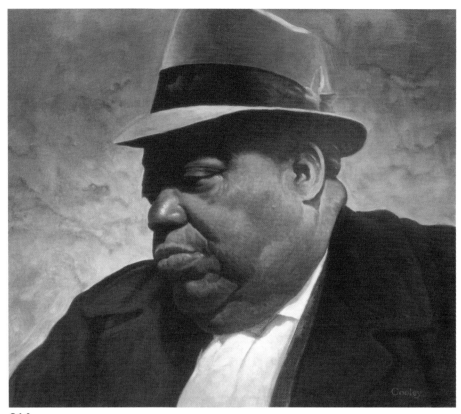

313

314

315

316

317

Artist: **Joe Ciardiello**

Medium: Pen, watercolor, collage on paper

Size: 15" x 12"

318

Artist: **Joe Ciardiello**

Art Director: Clovia Ng

Client: Graphic Artists Guild

Medium: Pen, watercolor, collage on paper

Size: 18" x 14"

319

Artist: **Chip Wass**

Art Director: Scott Stowell

Client: Nick at Nite

Medium: Digital

320

Artist: **Chip Wass**

Art Director: Scott Stowell

Client: Nick at Nite

Medium: Digital

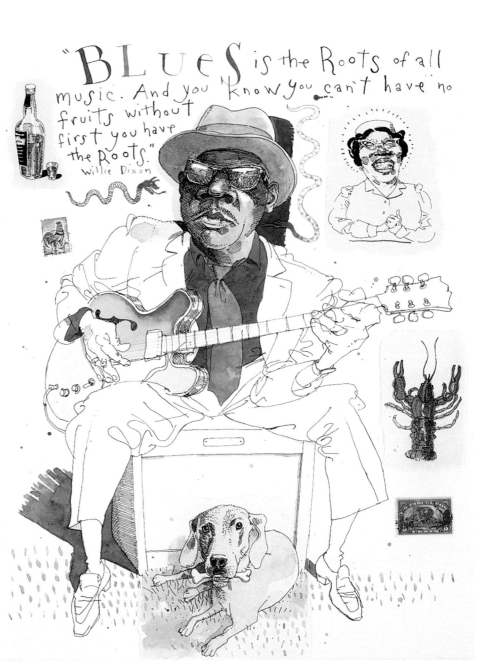

317

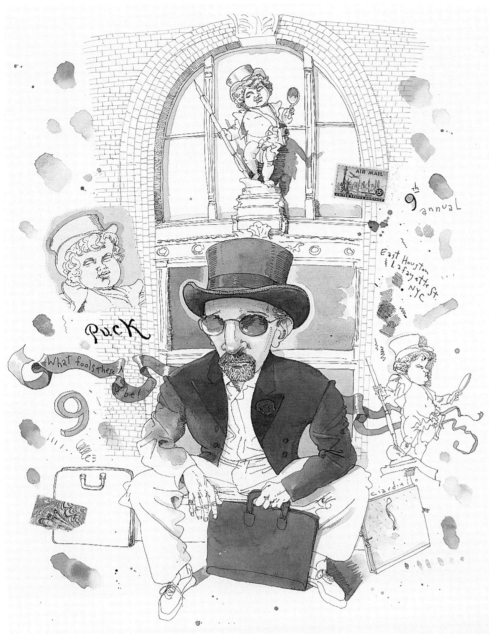

318

319

320

321

Artist: **Victoria Roberts**

Client: Riley Illustration

Medium: Watercolor on paper

322

Artist: **Elvis Swift**

Art Director: Sharon Werner

Client: Joanie Bernstein, Artist
Representative

Medium: Ink, scraps of paper

Size: 14" x 11"

323

Artist: **James McMullan**

Art Director: Eden Lipson

Client: The New York Times

Medium: Watercolor on paper

Size: 11" x 8"

324

Artist: **Stephen Smock**

Client: Silver & Ink Enterprises

Medium: Ink on paper/color-digital

Size: 12" x 9"

325

Artist: **Martin French**

Client: Pat Hackett Artist Representative

Medium: Ink, acrylic, digital

Size: 17" x 15"

321

322

323

324

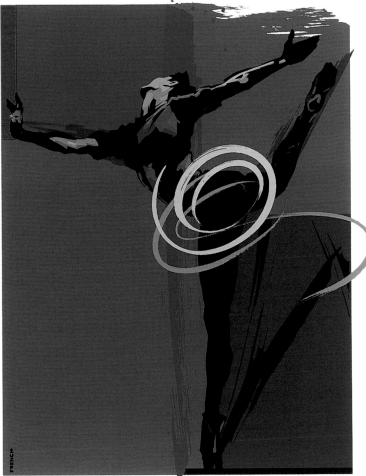

325

326

Artist: **Limbert Fabian**

Medium: Mixed on board

Size: 24" x 24"

327

Artist: **Limbert Fabian**

Medium: Mixed on board

Size: 18" x 20"

328

Artist: **Craig Frazier**

Art Director: James Pettus

Client: Orion Capital Corporation

Medium: Digital

Size: 16" x 12"

329

Artist: **Craig Frazier**

Art Director: Conrad Jorgensen

Client: Redwood Residential Funding

Medium: Cut/Digital

Size: 16" x 12"

330

Artist: **Craig Frazier**

Art Director: James Pettus

Client: Orion Capital Corporation

Medium: Cut/Digital

Size: 16" x 12"

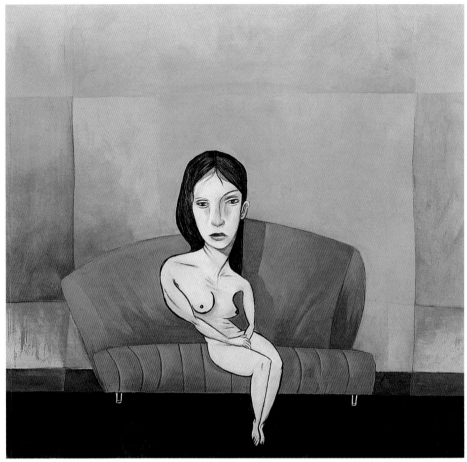

326

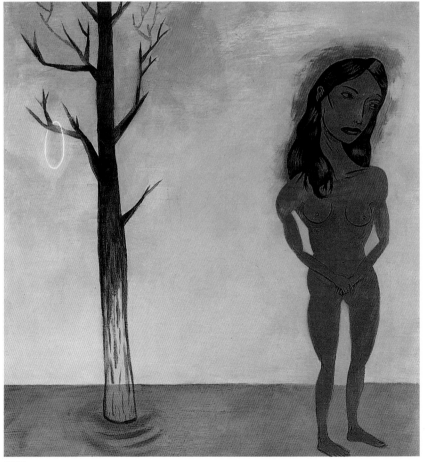

327

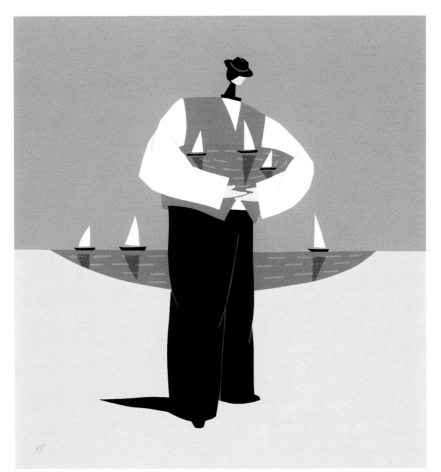

328

329

330

331

Artist: **Marina Sagona**

Medium: Watercolor on paper

332

Artist: **Yuce Minoru**

Art Director: Jean Page

Client: Yupo Paper Company/svp Partners

Medium: Digital

Size: 12" x 16"

333

Artist: **Jay Parnell**

Medium: Acrylic on Bristol

Size: 18" x 12"

334

Artist: **Sergio Ruzzier**

Medium: Watercolor

Size: 10" x 6"

335

Artist: **Dan Yaccarino**

Client: The Image Factory

Medium: Gouache on watercolor paper

Size: 8" x 10"

331

332

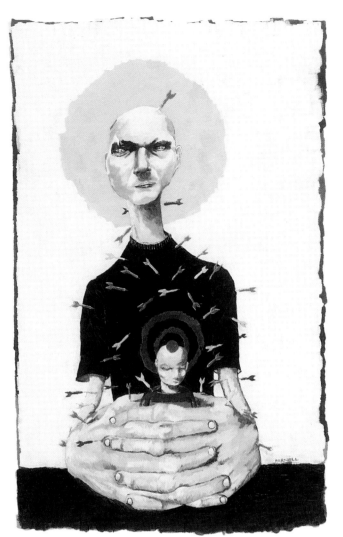

333

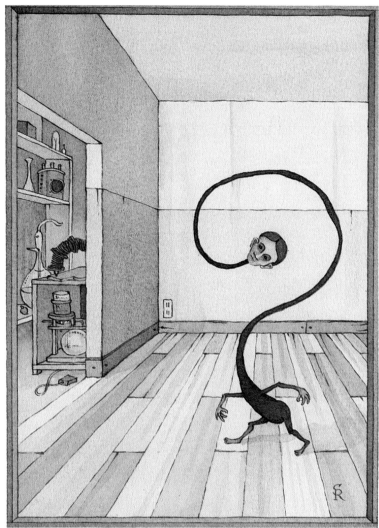

334

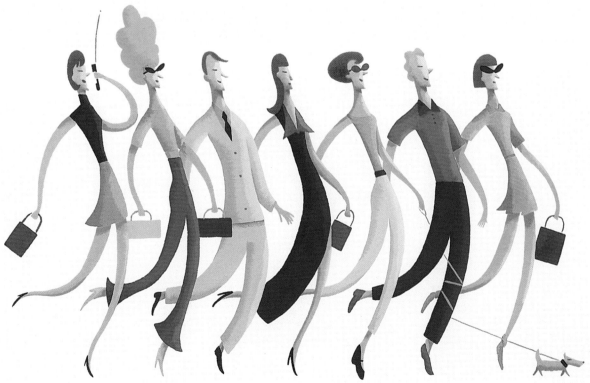

335

336

Artist: **Christian Roux**

Art Director: Susan Slover

Client: Slover and Company

Medium: Pastel, crayon on paper

Size: 12" x 15"

337

Artist: **Anita Kunz**

Art Director: Jim Burke

Client: Dellas Graphics

Medium: Watercolor on board

Size: 12" x 9"

338

Artist: **Regan Todd Dunnick**

Medium: Acrylic on paper

Size: 8" x 10"

339

Artist: **Mary Newell DePalma**

Art Directors: Michael Manning
 Mina Kalemkeryan

Client: Bridge Over Troubled Waters, Inc.

Medium: Acrylic on watercolor paper

Size: 10" x 10"

340

Artist: **Courtney Granner**

Art Directors: Chris Adams
 Jeanne Turner

Client: Unicorp Paper/Envision Media

Medium: Mixed on Lanaquerelle paper

Size: 8" x 6"

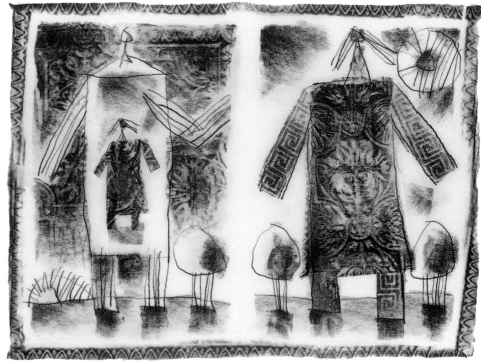

336

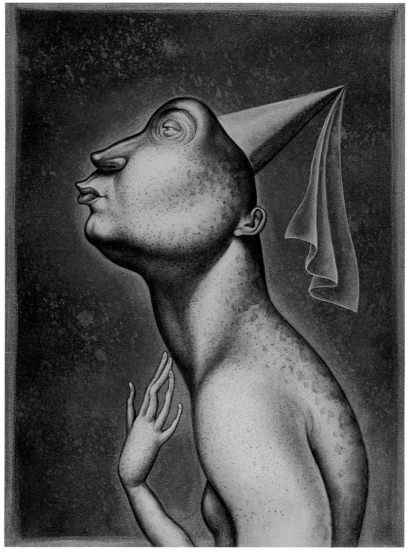

337

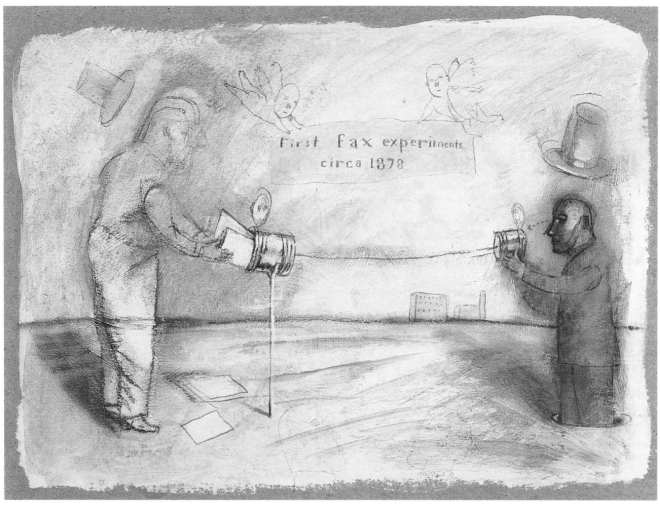

338

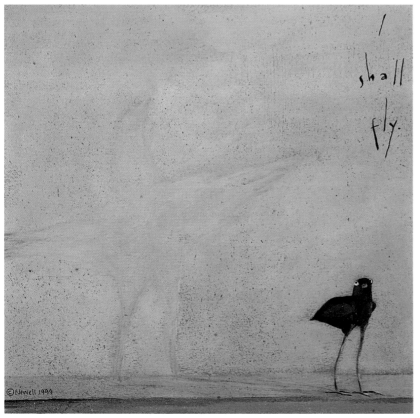

339

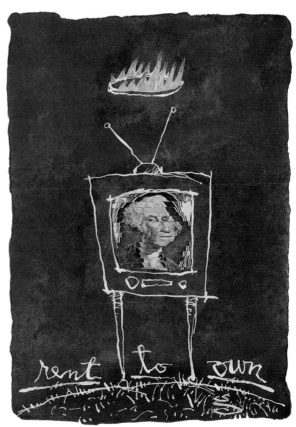

340

341
Artist: **David Lesh**
Medium: Mixed
Size: 12" x 8"

342
Artist: **David Lesh**
Medium: Mixed
Size: 10" x 8"

343
Artist: **Jacques Cournoyer**
Art Director: Susan Slover
Client: Slover and Company
Medium: Oil, pencil, acrylic on board
Size: 12" x 15"

344
Artist: **Richard Hart**
Client: Disturbance Design
Medium: Acrylic, gouache on board

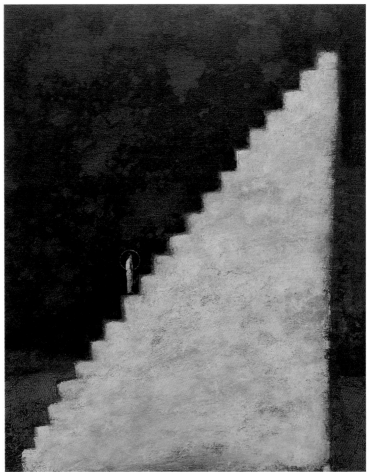

341

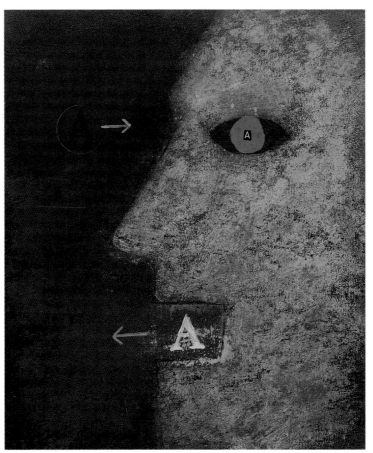

342

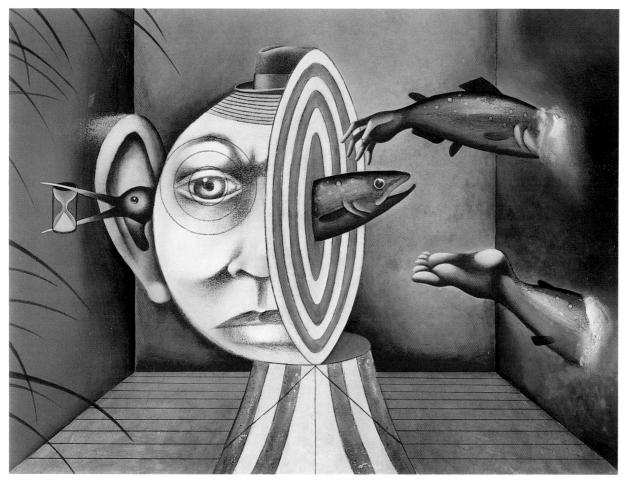

343

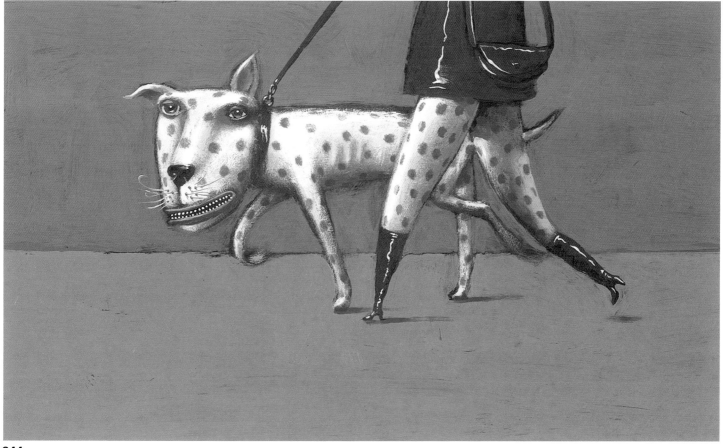

344

345

Artist: **Curtis Parker**

Art Director: Andrew Wicklund

Client: AIGA Arizona Chapter

Medium: Acrylic on linen

Size: 7" x 7"

346

Artist: **Linda Helton**

Art Director: Susan Slover

Client: Slover and Company

Medium: Acrylic on paper

Size: 12" x 15"

347

Artist: **Sarah Wilkins**

Client: Riley Illustration

Medium: Gouache on paper

348

Artist: **Maria Nicklin**

Client: The Earthly Paradise,
 A Coffeehouse, Inc.

Medium: Watercolor, pencil on
 watercolor paper

Size: 6" x 4"

349

Artist: **John H. Howard**

Art Director: Joan Sigman

Client: The Newborn Group

Medium: Acrylic on paper

Size: 14" x 10"

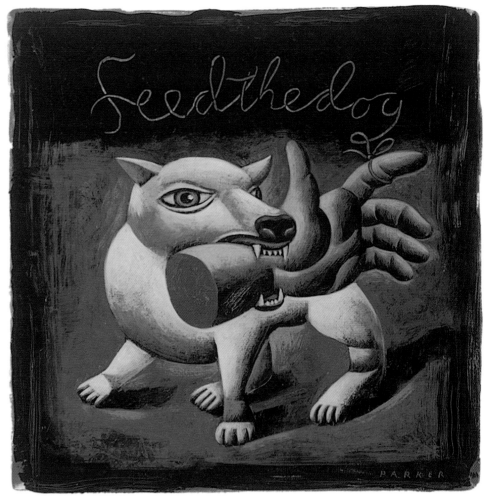

345

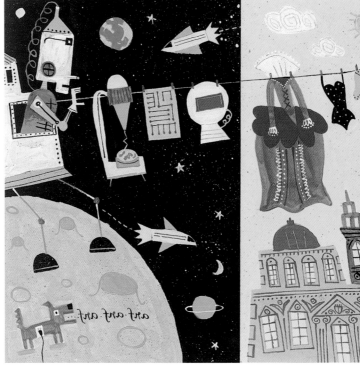

346

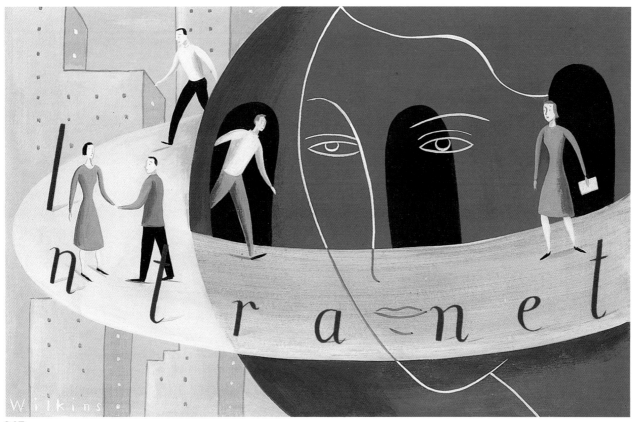

347

348

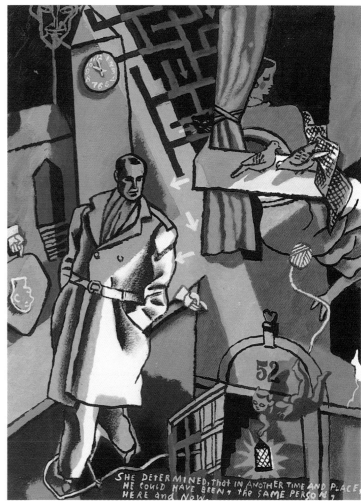

349

350

Artist: **Joel Nakamura**

Art Director: Mark Murphy

Client: Fortran Printing Inc.

Medium: Acrylic on copper

Size: 12" x 12"

351

Artist: **Normand Cousineau**

Art Director: Susan Slover

Client: Slover and Company

Medium: Digital

Size: 8" x 10"

352

Artist: **Courtney Granner**

Art Directors: Mike Bertoni
Jeanne Turner

Client: Unicorp Paper/Envision Media

Medium: Mixed on Lanaquerelle paper

Size: 6" x 8"

353

Artist: **Steven Guarnaccia**

Art Director: Grazia Gotti

Client: Giannino Stoppani

Medium: Pen & ink, watercolor on
watercolor paper

354

Artist: **Steven Guarnaccia**

Art Directors: Brian Webb
Lynn Trickett

Client: Trickett & Webb

Medium: Digital

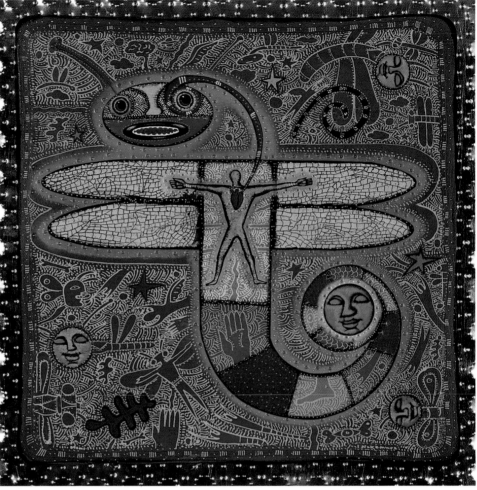

350

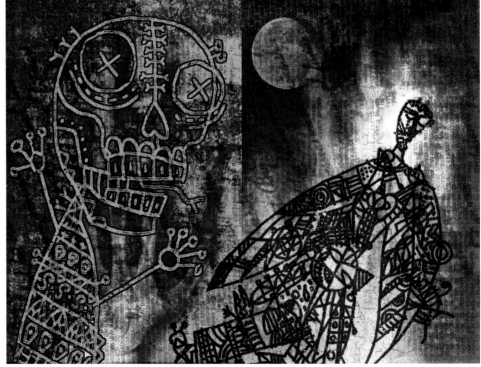

351

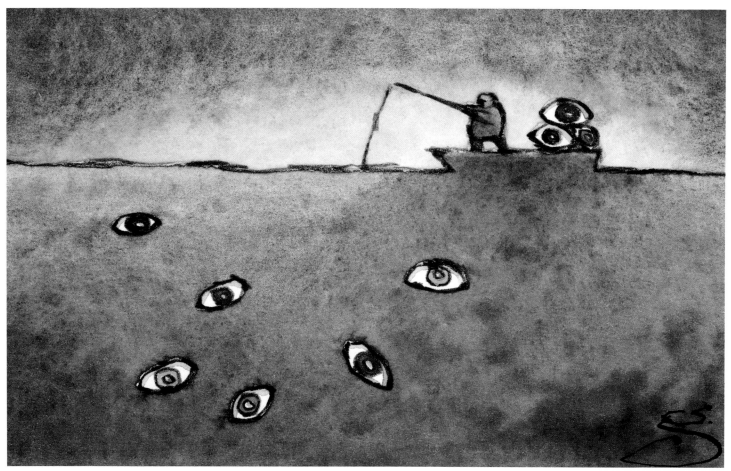

352

353

354

355

Artist: **Seymour Chwast**

Client: The Pushpin Group Inc.

Medium: Pen & ink, colored with Adobe
Illustrator on Riddle Dogs paper

Size: 6" x 8"

356

Artist: **Cyril Cabry**

Art Director: Susan Slover

Client: Slover and Company

Medium: Watercolor on paper

357

Artist: **Ellen Tanner**

Art Director: Stephen Zhang

Client: Fossil

Medium: Collage, acrylic on board

Size: 4" x 11"

358

Artist: **Steven Guarnaccia**

Art Director: Susan Hochbaum

Client: Big Flower Holdings, Inc.

Medium: Digital

Size: 11" x 9"

359

Artist: **Ellen Tanner**

Art Director: Stephen Zhang

Client: Fossil

Medium: Collage, acrylic on board

Size: 42" x 33"

355

356

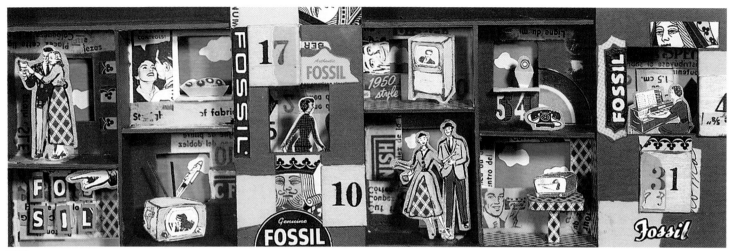

357

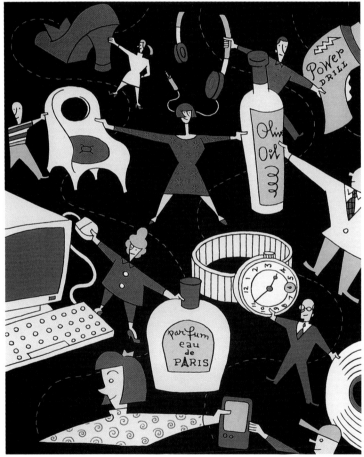

358

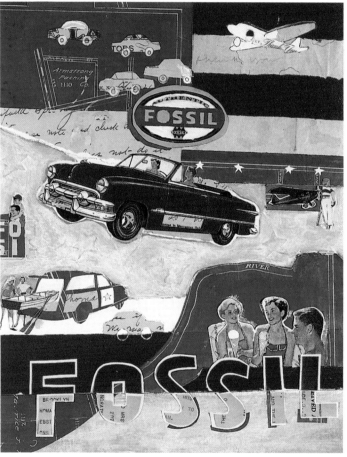

359

360

Artist: **Jay Parnell**

Medium: Acrylic on Bristol

Size: 8" x 8"

361

Artist: **Richard Hart**

Client: Disturbance Design

Medium: Digital

362

Artist: **Rafal Olbinski**

Client: Art For Peace

Medium: Acrylic on canvas

Size: 30" x 30"

363

Artist: **Rafal Olbinski**

Client: Datinae, Inc.

Medium: Acrylic on canvas

Size: 30" x 20"

364

Artist: **Robert Goldstrom**

Medium: Oil on canvas

Size: 13" x 10"

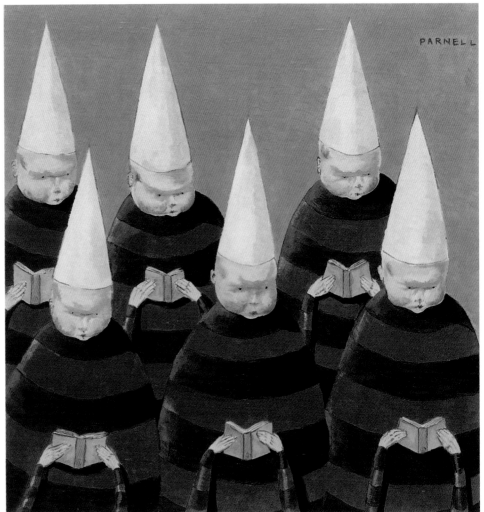

360

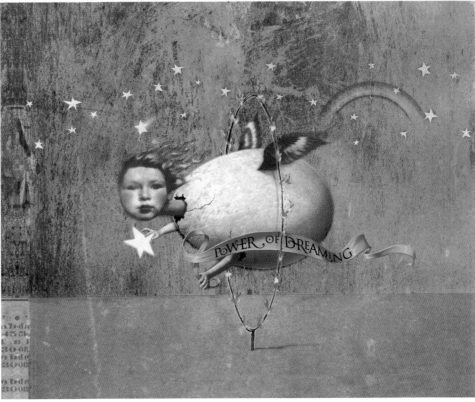

361

362

364

363

365

Artist: **Gary Kelley**

Art Director: Terry Stoffer

Client: Color FX

Medium: Oil on canvas

Size: 30" x 22"

366

Artist: **Whitney Sherman**

Art Director: Robin Soltis-Brach

Client: Loyola College of Maryland

Medium: Digital

367

Artist: **Etienne Delessert**

Art Directors: Rita Marshall
François Rochaix

Client: Fête Des Vignerons

Medium: Watercolor on paper

368

Artist: **Kinuko Y. Craft**

Art Director: Jim Burke

Client: Dellas Graphics

Medium: Mixed

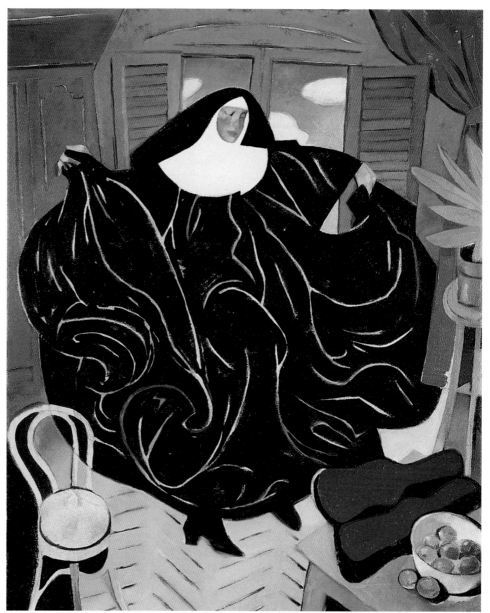

365

JESUITS AND MODERNITY

LOYOLA COLLEGE IN MARYLAND
Saturday, April 17, 1999

BREAKFAST
TIME: 8:30-9:30 a.m.
PLACE: Humanities Center
Refectory

**THE JESUITS
AND EARLY MODERN
THOUGHT**
Louis Dupré, Yale University
TIME: 9:30-10:30 a.m.
PLACE: Knott Hall 02

Tea and Coffee Break

**THE JESUITS
AND EARLY MODERN
EDUCATION**
John Montag, S.J.
St. Edmund's College
University of Cambridge
TIME: 11 a.m.-noon
PLACE: Knott Hall 02

LUNCH
TIME: 12:30-1:30 p.m.
PLACE: Humanities Center
Hug Lounge and Refectory

**FACULTY ROUNDTABLE
DISCUSSION**
TIME: 2-4 p.m.
PLACE: Humanities Center 201

For more information
contact: Graham McAleer
410-617-2027 or
mcaleer@loyola.edu

366

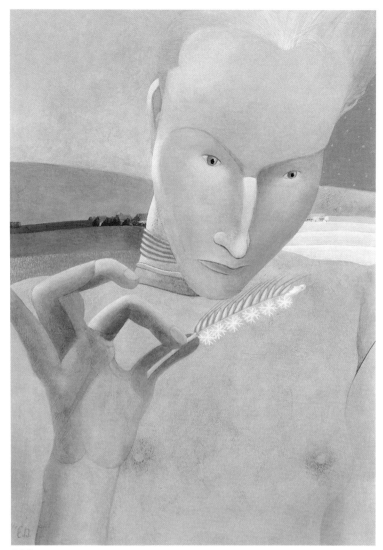

367

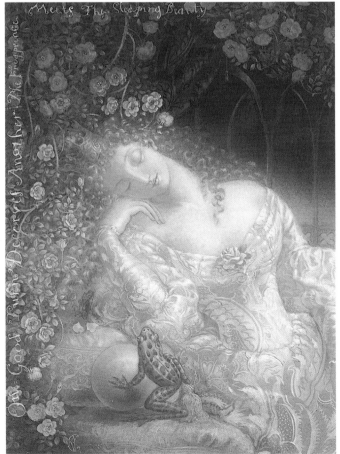

368

369
Artist: **Kazuhiko Sano**
Medium: Acrylic on board
Size: 17" x 13"

370
Artist: **David Bowers**
Art Director: James Fredrick
Client: James Gallery
Medium: Oil on masonite
Size: 19" x 9"

371
Artist: **Michel Bohbot**
Client: San Francisco Society of Illustrators
Medium: Mixed, digital on paper
Size: 14" x 10"

372
Artist: **Rafal Olbinski**
Client: Satyrykon
Medium: Acrylic on canvas
Size: 30" x 20"

373
Artist: **Allen Douglas**
Art Director: Tom Slizewski
Client: Wizard Entertainment
Medium: Oil on paper on masonite
Size: 19" x 13"

374
Artist: **Lee Ballard**
Client: Rico Gallery
Medium: Oil on linen
Size: 36" x 24"

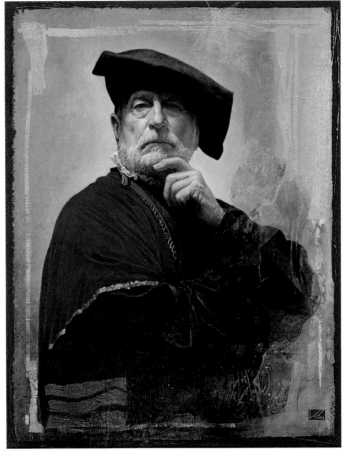

369

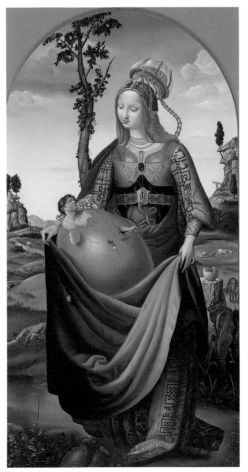

370

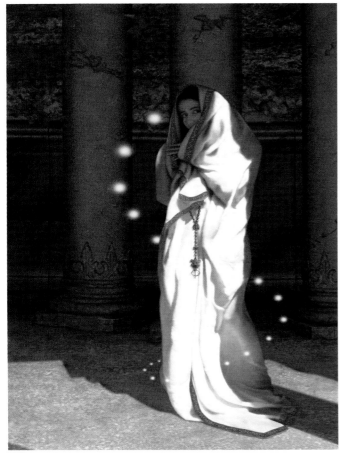

371

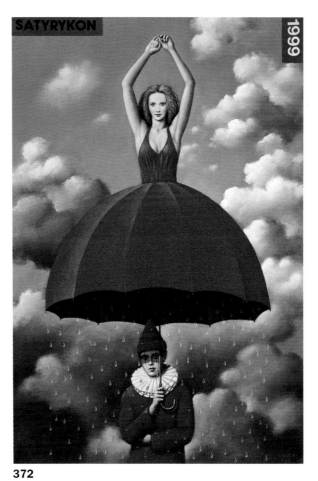

372

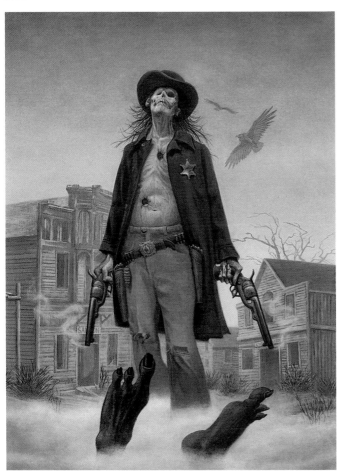

373

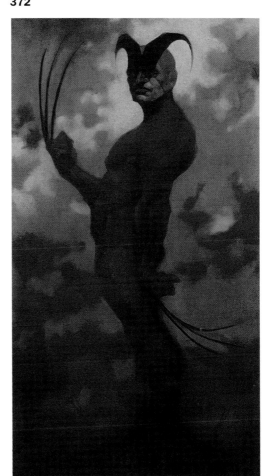

374

375

Artist: **John Rush**

Client: Eleanor Ettinger Gallery

Medium: Oil on canvas

Size: 50" x 33"

376

Artist: **John Rush**

Client: Eleanor Ettinger Gallery

Medium: Oil, acrylic on canvas

Size: 30" x 40"

377

Artist: **Michael Whelan**

Client: Tree's Place

Medium: Acrylic on board

Size: 45" x 25"

378

Artist: **Robert Hunt**

Art Director: Victor Snowder

Client: Victor Jeffries Fine Art Publishing

Medium: Oil on linen

Size: 24" x 32"

379

Artist: **Lorena Pugh**

Medium: Oil on linen

Size: 12" x 36"

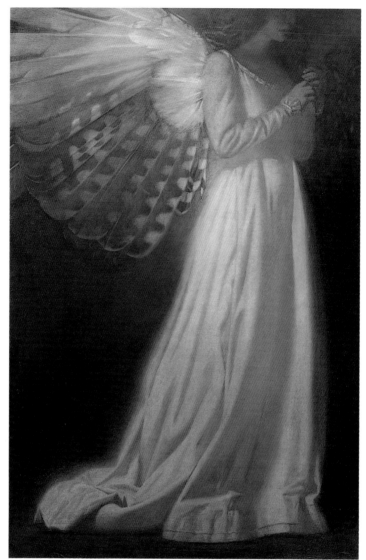

375

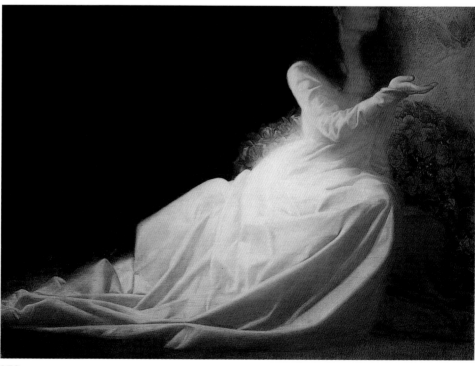

376

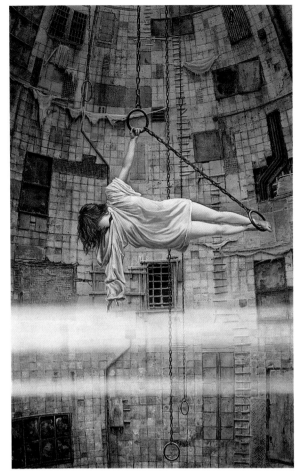

377

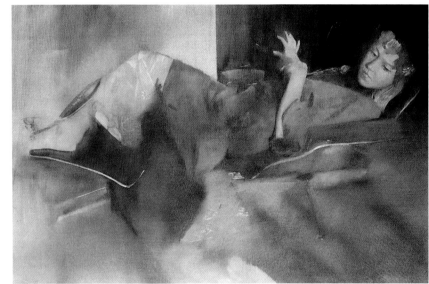

378

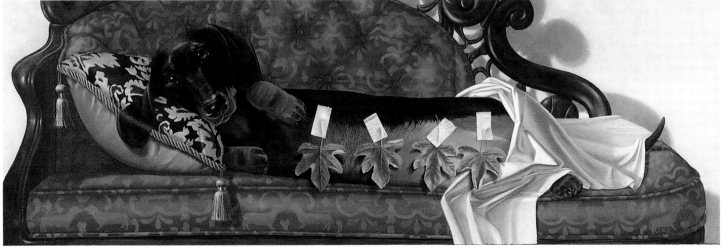

379

380

Artist: **Eric Bowman**

Client: Fox Creative Group

Medium: Oil on paper

Size: 22" x 17"

381

Artist: **Morgan Carver**

Medium: Acrylic on panel

Size: 10" x 16"

382

Artist: **Jody Hewgill**

Art Director: Diane Woolverton

Client: US Information Agency

Medium: Acrylic, watercolor ink on board

383

Artist: **Jon Krause**

Art Director: Steve Sitarski

Client: National Park Service

Medium: Acrylic on linen canvas

Size: 24" x 18"

384

Artist: **Mark Summers**

Art Director: Richard Solomon

Client: Richard Solomon Artists
Representative

Medium: Scratchboard

Size: 10" x 14"

385

Artist: **Dean Kennedy**

Art Director: Carol Guenzi

Client: Tumbleweed Press

Medium: Oil on board

Size: 20" x 22"

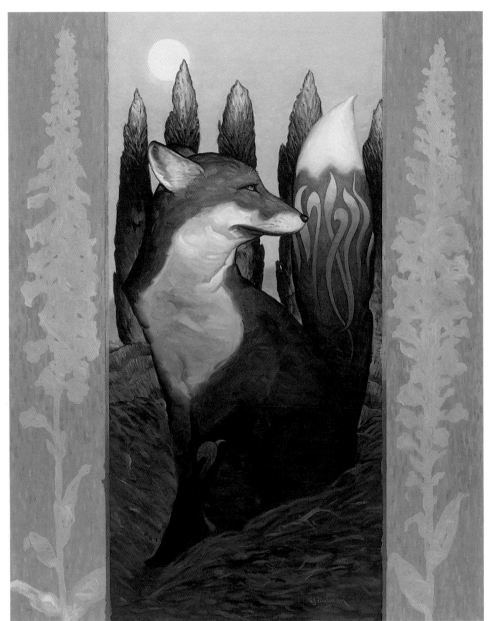

380

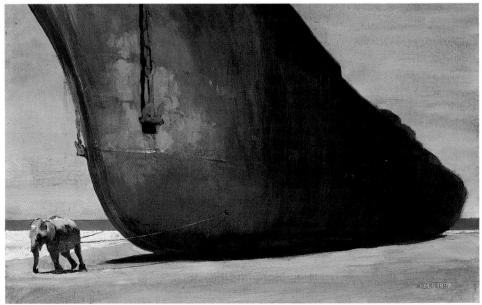

381

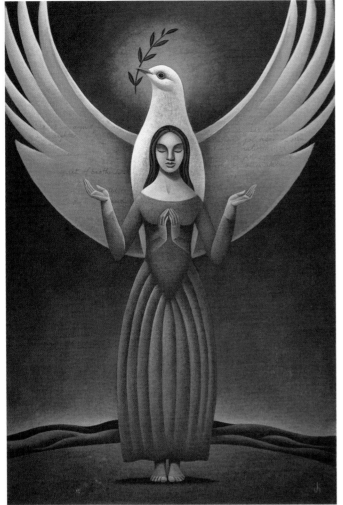

382

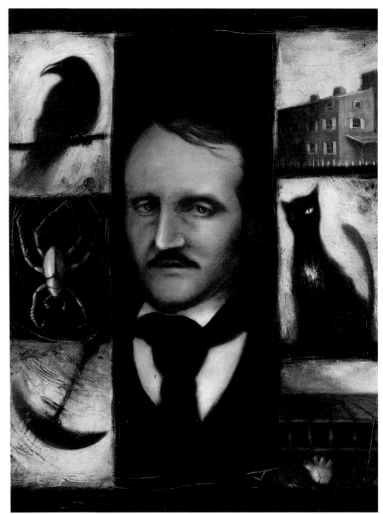

383

384

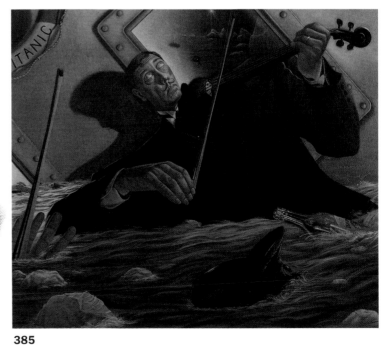

385

386

Artist: **Mike Benny**

Art Director: Bob Beyn

Client: Seraphein Beyn

Medium: Acrylic on board

Size: 24" x 18"

387

Artist: **Ted Wright**

Art Director: R.L. Neel

Client: Australian Olympic Committee

Medium: Silkscreen on canvas

Size: 60" x 45"

388

Artist: **William Low**

Medium: Digital

Size: 20" x 16"

389

Artist: **Andrea Ventura**

Art Director: Richard Solomon

Client: Richard Solomon Artists
 Representative

Medium: Mixed on paper

Size: 23" x 17"

390

Artist: **Bruce Waldman**

Art Director: Alycia Duckler

Client: Alycia Duckler Gallery

Medium: Monoprint on BFK paper

Size: 26" x 34"

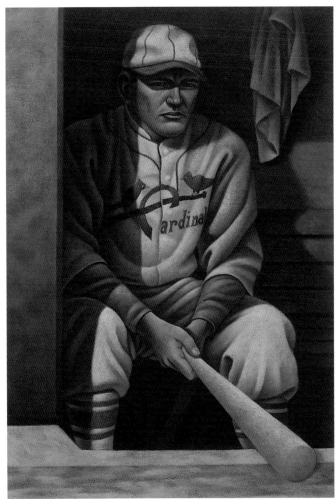

386

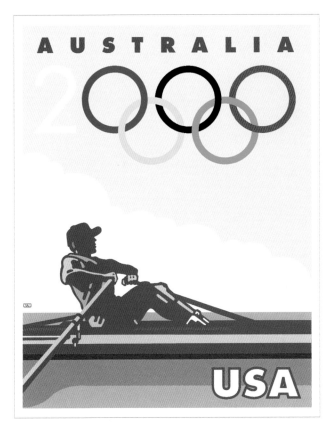

387

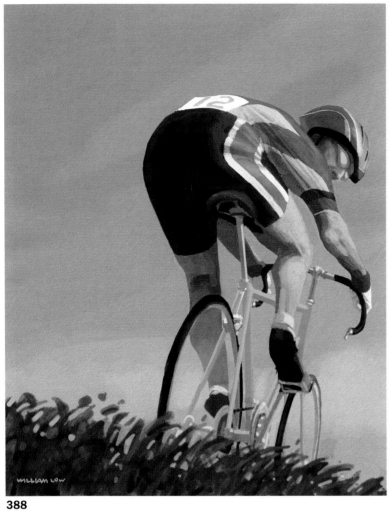

388

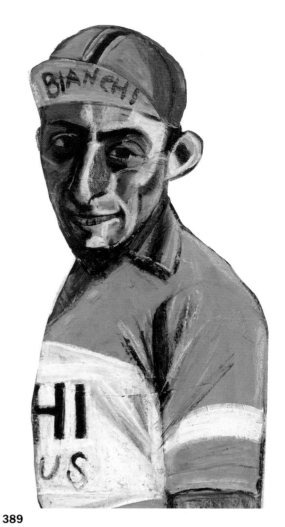

389

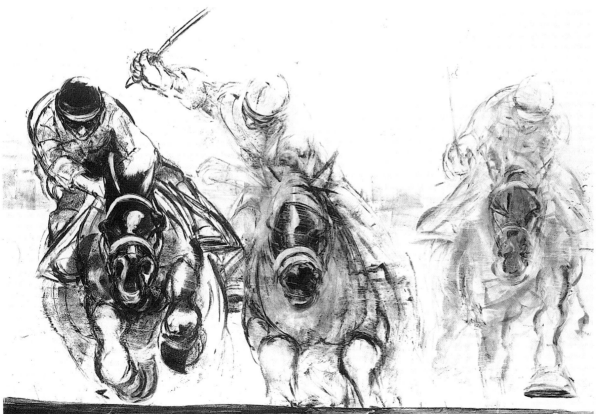

390

391

Artist: **Raymond Verdaguer**

Art Director: Richard Solomon

Client: Richard Solomon Artists
Representative

Medium: Multicolored linoleum cut on
fine printing paper

Size: 16" x 14"

392

Artist: **Thomas L. Fluharty**

Art Director: Sarah Micklem

Client: Sports Illustrated for Kids

Medium: Acrylic on Bristol

Size: 30" x 20"

393

Artist: **David Johnson**

Art Director: Richard Solomon

Client: Richard Solomon Artists
Representative

Medium: Pen & ink on watercolor paper

Size: 20" x 20"

394

Artist: **Bart Forbes**

Client: Somerset House

Medium: Oil on canvas

Size: 30" x 38"

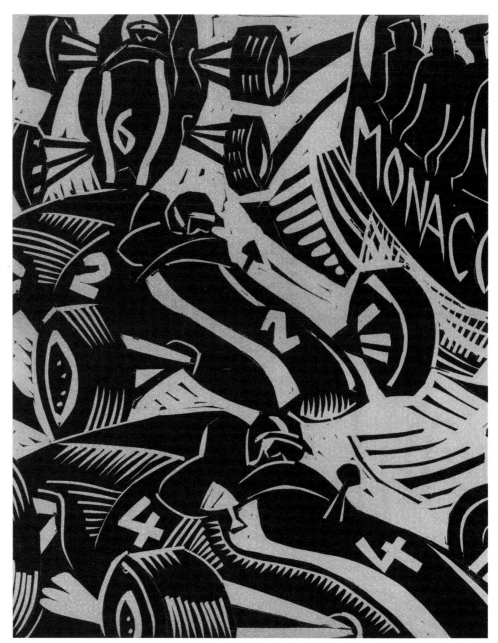

391

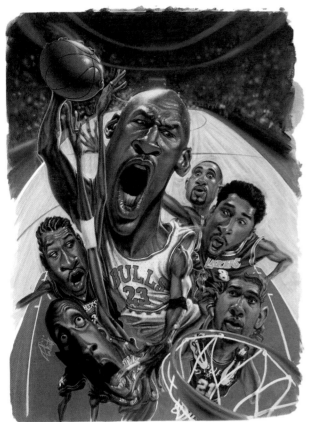

392

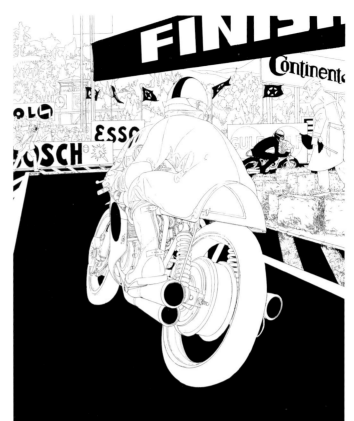

393

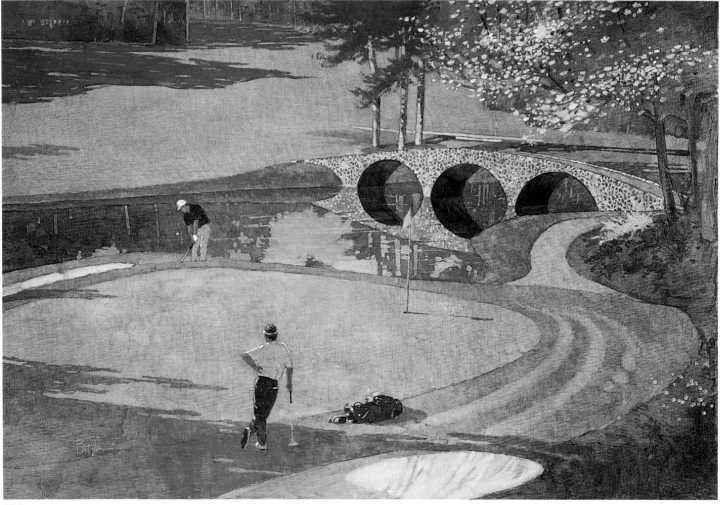

394

395

Artist: **Sarah Waldron**

Art Director: Joanie Fink

Client: Northwest Publishing

Medium: Oil on wood

Size: 11" x 11"

396

Artist: **Sarah Waldron**

Art Director: Joanie Fink

Client: Northwest Publishing

Medium: Oil on wood

Size: 11" x 11"

397

Artist: **Sarah Waldron**

Art Director: Joanie Fink

Client: Northwest Publishing

Medium: Oil on wood

Size: 6" x 15"

398

Artist: **Tom Voss**

Art Director: Rita Hoffman

Client: Taylor Guitars

Medium: Pastel on paper

Size: 18" x 12"

399

Artist: **David Lesh**

Medium: Mixed

Size: 10" x 8"

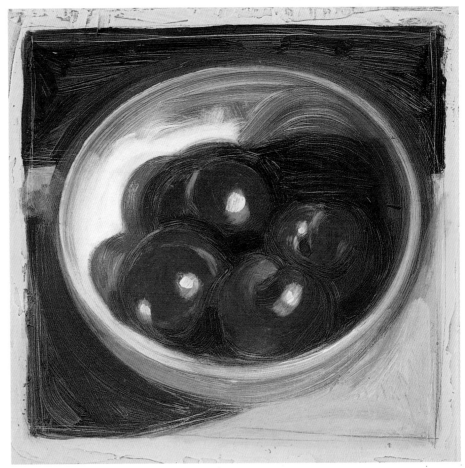

395

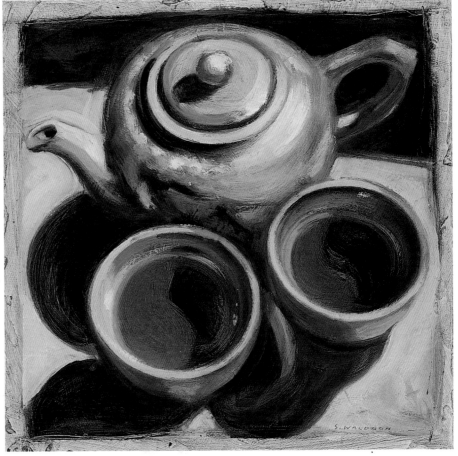

396

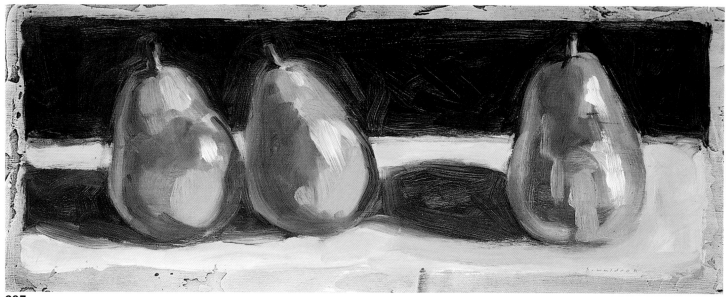

397

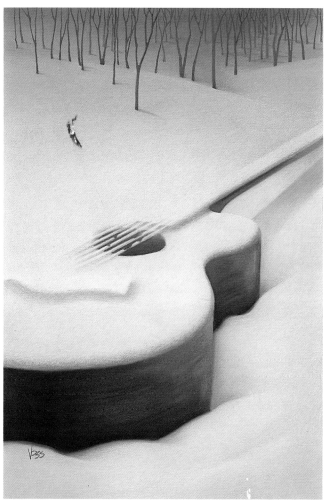

398

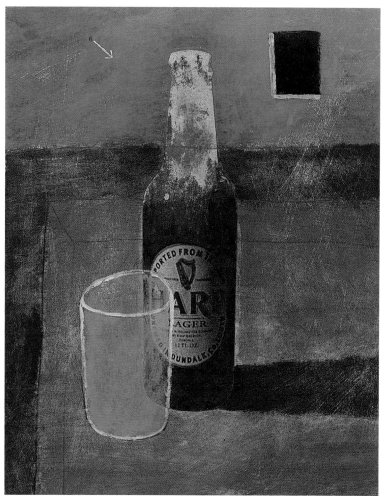

399

400

Artist: **Steven Rydberg**

Client: Loring Cafe

Medium: Oil, acrylic on masonite

Size: 31" x 20"

401

Artist: **Bob Russo**

Client: MAX Federal Credit Union

Medium: Acrylic on canvas

Size: 48" x 36"

402

Artist: **William Low**

Art Director: Robert Barber

Medium: Digital

Size: 36" x 24"

403

Artist: **Peter M. Sylvada**

Medium: Oil on board

Size: 20" x 16"

404

Artist: **Peter M. Sylvada**

Medium: Oil on board

Size: 20" x 16"

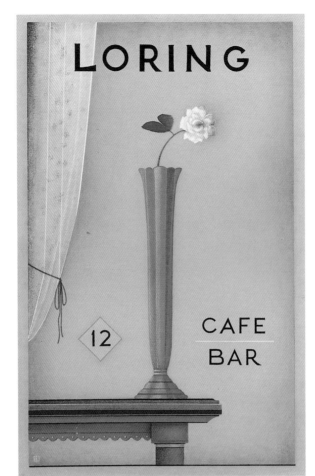

400

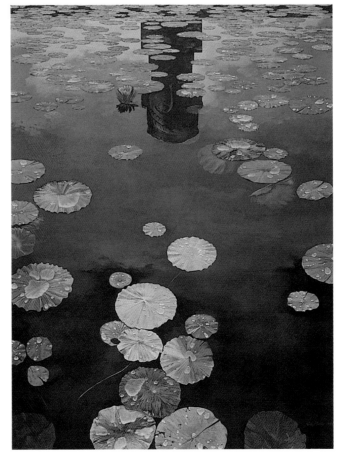

401

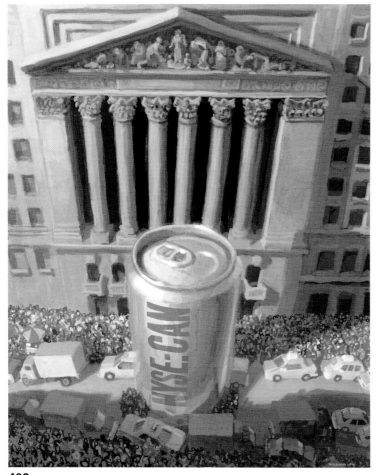

402

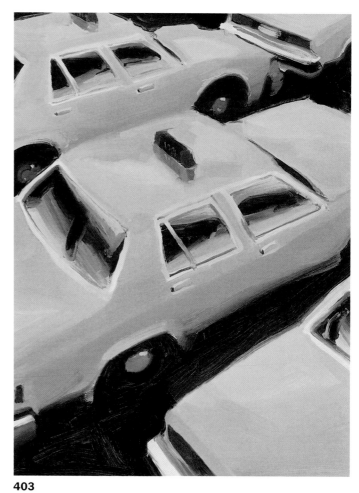

403

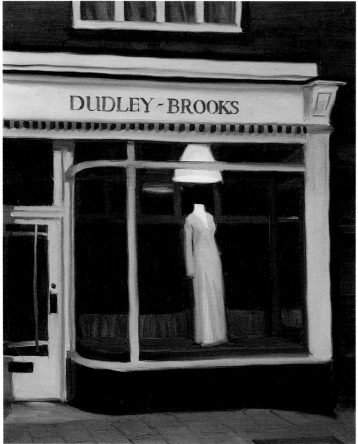

404

405

Artist: **Michael McNamara**

Client: Color Forms Inc.

Medium: Oil on canvas

Size: 22" x 28"

406

Artist: **Francis Livingston**

Medium: Oil on masonite

Size: 15" x 24"

407

Artist: **Mark J. Tocchet**

Client: University of the Arts
Illustration Department

Medium: Digital

Size: 7" x 5"

408

Artist: **Nanette Biers**

Art Director: Michael Braley

Client: M.H. de Young Memorial Museum,
San Francisco

Medium: Oil on canvas

Size: 22" x 28"

409

Artist: **Michael Bramman**

Art Director: Sue Atkins

Client: La Galerie Du Don

Medium: Acrylic on canvas

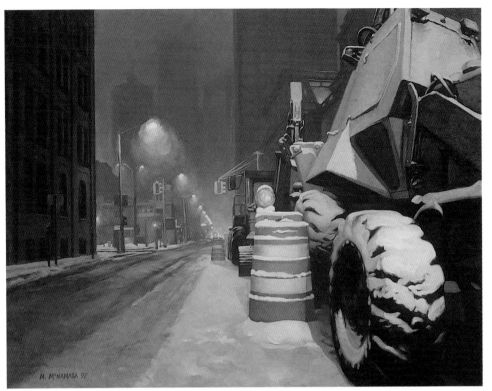

405

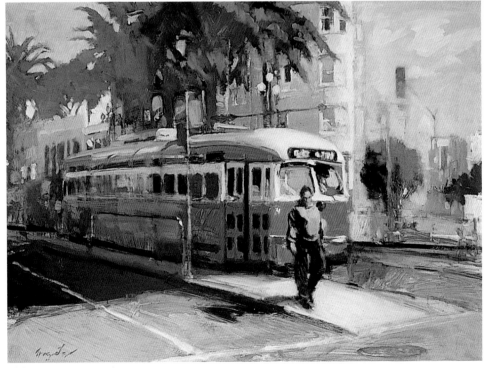

406

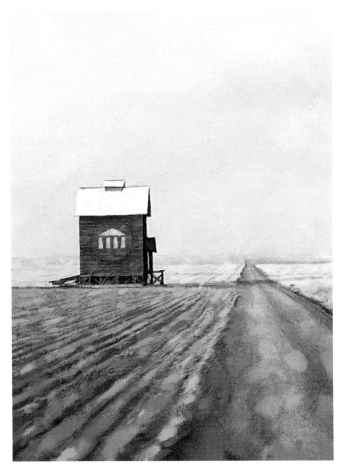

407

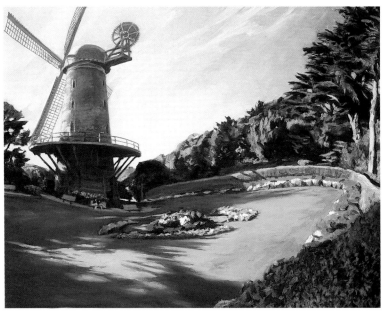

408

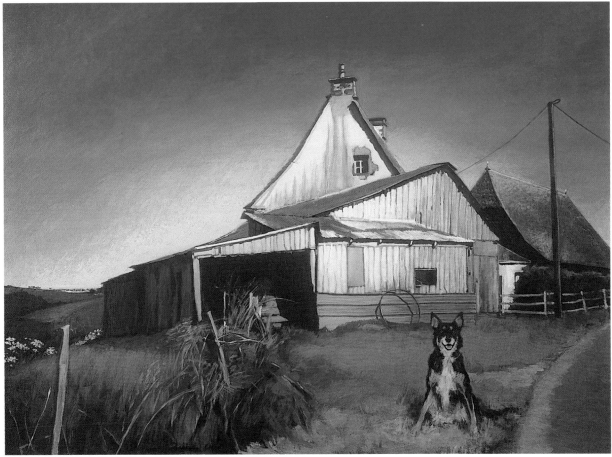

409

410

Artist: **Michael Bramman**

Art Directors: Sue Atkins
Nigel Atkins

Client: La Galerie Du Don

Medium: Acrylic on board

411

Artist: **Michael Bramman**

Art Director: Sue Atkins

Client: La Galerie Du Don

Medium: Acrylic on board

412

Artist: **Attila Hejja**

Art Director: Robert Schulman

Client: NASA

Medium: Oil on panel

Size: 35" x 72"

413

Artist: **Greg Newbold**

Art Directors: Dawn Astram
Scott Usher

Client: The Greenwich Workshop

Medium: Acrylic on masonite

Size: 15" x 32"

414

Artist: **David F. Henderson**

Client: Boonton Area Committee
For The Arts

Medium: Oil on board

Size: 22" x 31"

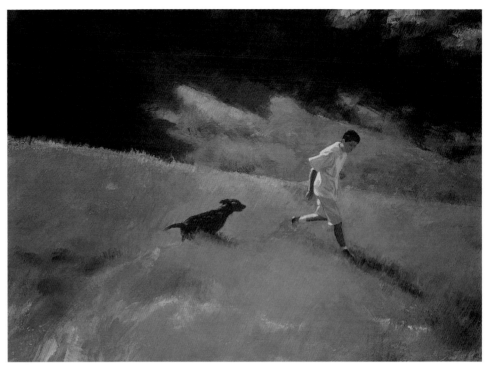

410

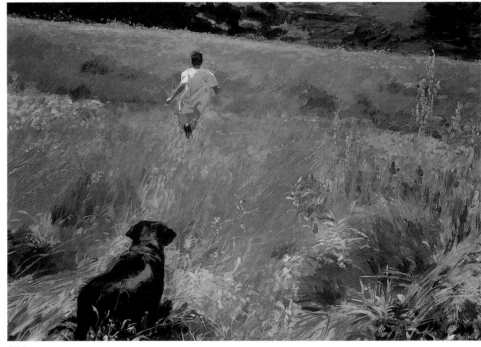

411

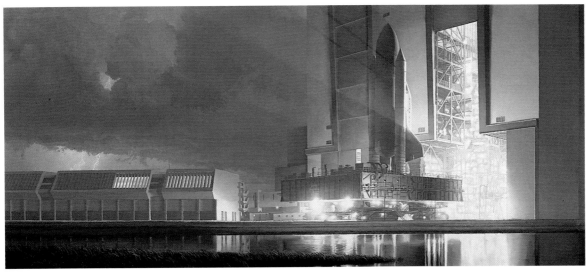

412

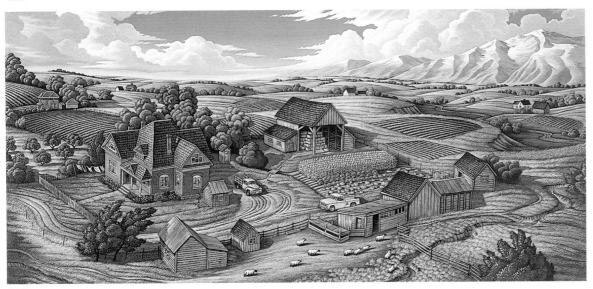

413

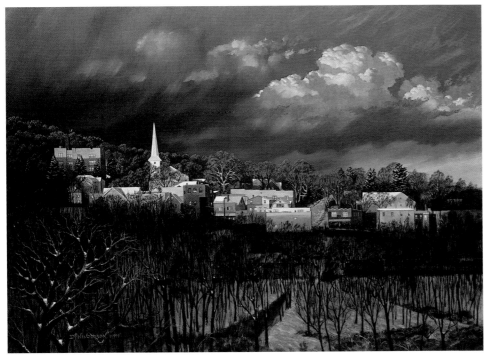

414

415

Artist: **Milton Glaser**

Client: Watershed Agricultural Council

Medium: Mixed

416

Artist: **Amy L. Young**

Medium: Gouache on paper

Size: 5" x 5"

417

Artist: **Russell Farrell**

Art Director: Barbara Binzen

Client: Wildlife Conservation Society

Medium: Acrylic on watercolor board

Size: 9" x 19"

418

Artist: **John D. Dawson**

Art Director: Ethel Kessler

Client: U.S. Postal Service

Medium: Acrylic on board

Size: 18" x 24"

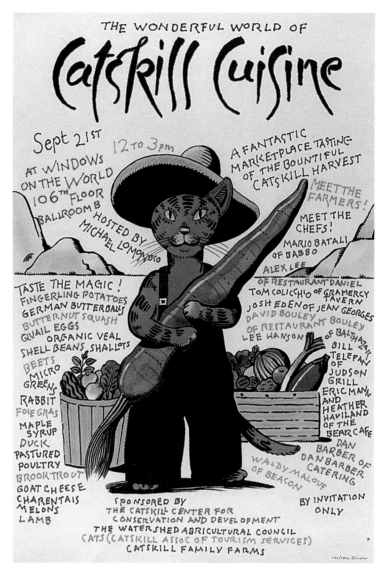

415

416

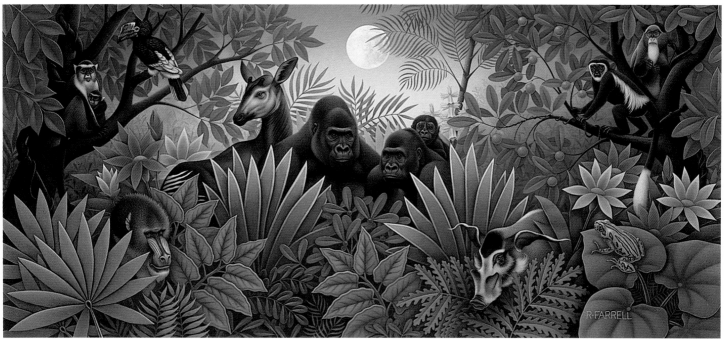

417

SONORAN DESERT

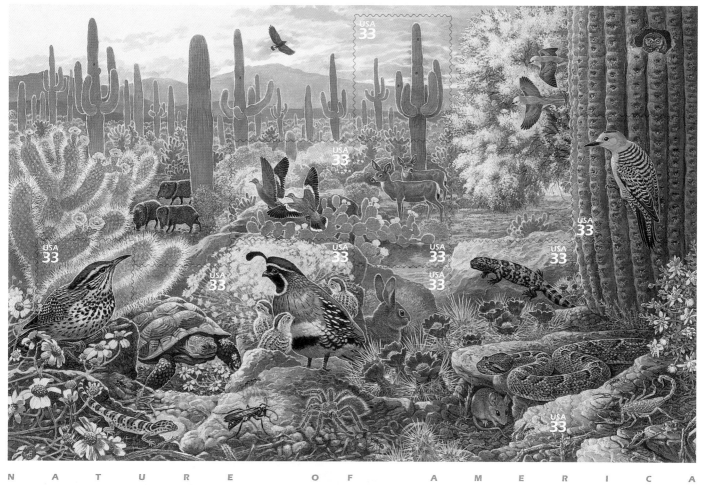

N A T U R E O F A M E R I C A

419

Artist: **Steve Buchanan**

Art Director: Carl Herrman

Client: U.S. Postal Service

Medium: Digital

Size: 16" x 12"

420

Artist: **Susan Reagan**

Art Director: Rasa Valaitis

Client: American Greetings

Medium: Watercolor on watercolor paper

Size: 12" x 12"

421

Artist: **Todd Zalewski**

Art Director: Barbara McGrath

Client: Riverbanks Zoo

Medium: Gouache on Bristol

Size: 12" x 15"

422

Artists: **Cheryl Griesbach**
 Stanley Martucci

Client: Bernstein & Andriulli

Medium: Oil on masonite

Size: 14" x 18"

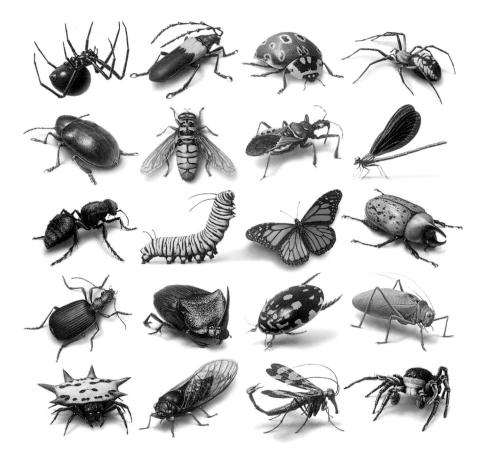

419

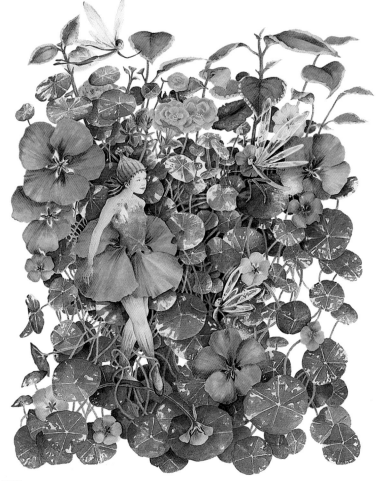

420

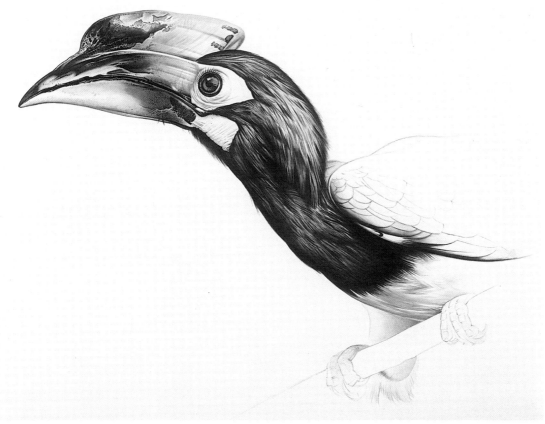

421

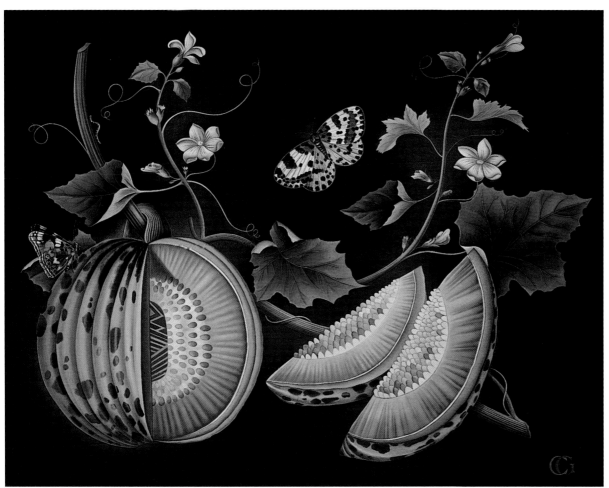

422

423

Artist: **Steve Buchanan**

Art Director: Carl Herrman

Client: U.S. Postal Service

Medium: Digital

Size: 8" x 12"

424

Artist: **Yvonne Buchanan**

Client: Buchanan Illustration

Medium: Pen & ink, watercolor on paper

Size: 15" x 20"

425

Artist: **Jack Unruh**

Art Director: Sharon Kramer Lowe

Client: Wildlife Conservation Society

Medium: Ink, watercolor on board

Size: 19" x 37"

426

Artist: **Jack A. Molloy**

Art Directors: Sharon Werner
Karen Geiger

Client: Joanie Bernstein Artist
Representative

Medium: Pencil, watercolor

Size: 17" x 11"

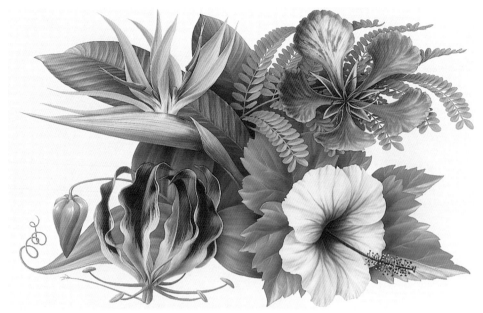

423

424

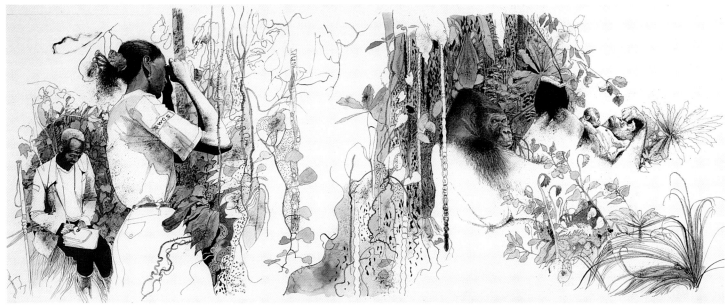

425

426

427

Artist: **Bart Forbes**

Art Director: Jim Burke

Client: Dellas Graphics

Medium: Oil on board

Size: 19" x 14"

428

Artist: **Murray Tinkelman**

Art Director: Joe Glisson

Client: Dellas Graphics

Medium: Pen & ink on Bristol

Size: 14" x 9"

429

Artist: **Murray Tinkelman**

Art Director: Jim Burke

Client: Dellas Graphics

Medium: Pen & ink on Bristol

Size: 14" x 9"

430

Artist: **Theo Rudnak**

Client: Disney/Cullman Ventures

Medium: Acrylic, gouache on canvas

Size: 16" x 16"

431

Artist: **Mike Hodges**

Medium: Lithographic crayon on
 gessoed paper

Size: 8" x 8"

427

428

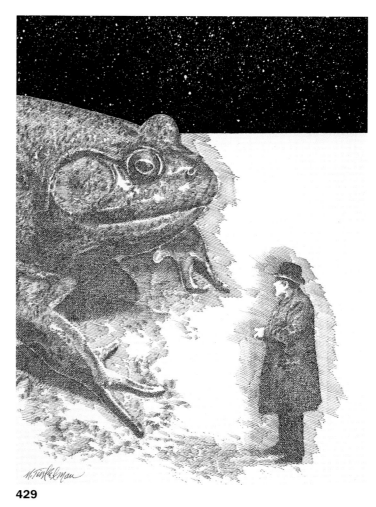

429

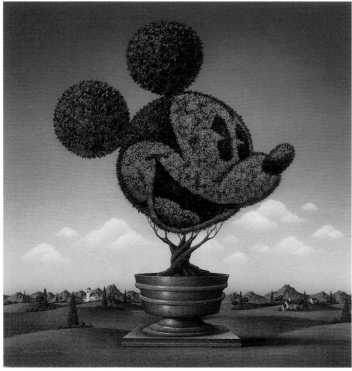

430

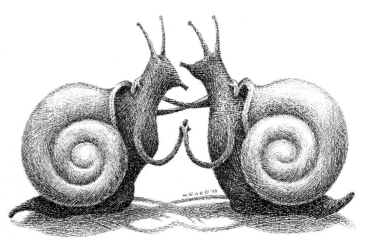

431

432

Artist: **Michael Schwab**

Art Director: Jami Spittler

Client: Golden Gate National Parks

Medium: Pen & ink, digital

Size: 29" x 22"

433

Artist: **Gary Cooley**

Medium: Digital

434

Artist: **Roger DeMuth**

Medium: Cel Vinyl on acetate

Size: 12" x 30"

435

Artist: **Kunio Sato**

Art Director: Juriko Saito

Client: Spoon Co., Ltd.

Medium: Mixed

Size: 70 cm x 71 cm

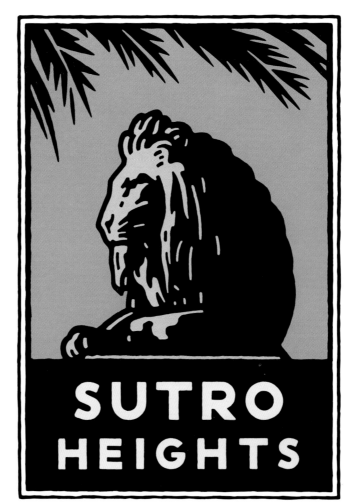

432

433

434

435

436

Artist: **Rafael Lopez**

Medium: Acrylic on canvas

Size: 17" x 14"

437

Artist: **Rafael Lopez**

Client: Hann-Ross Gallery, Santa Fe

Medium: Mixed on wood

438

Artist: **Bill Mayer**

Art Director: Mark Hanger

Client: Denver Zoo

Medium: Gouache on hot press Strathmore

Size: 15" x 20"

439

Artist: **Jerry LoFaro**

Art Director: Dave Higgins

Client: National Geographic/Galoob Toys

Medium: Acrylic, airbrush on
Letra Max board

Size: 16" x 12"

440

Artist: **Bill Mayer**

Art Director: Debbie Reynolds

Client: Netware Magazine

Medium: Gouache on hot press Strathmore

Size: 20" x 15"

436

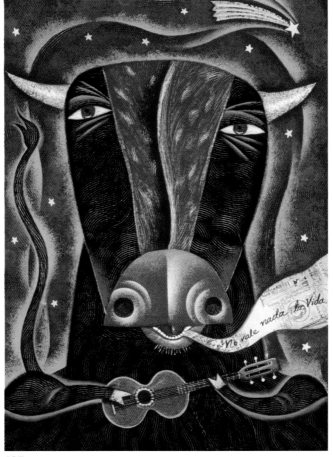

437

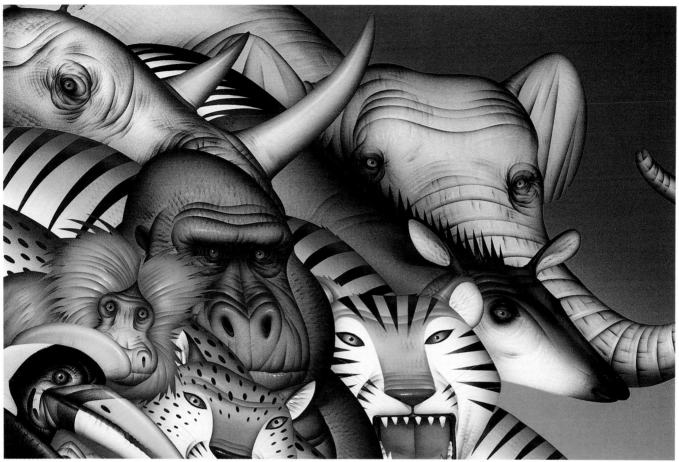

438

439

440

441

Artist: **Fian Arroyo**

Art Director: Tammy Hines

Client: North Castle Design

Medium: Digital

Size: 12" x 9"

442

Artist: **Terry Kovalcik**

Art Director: Collette Carter

Client: Portal Publications

Medium: Airbrush on Strathmore
Plate Bristol

443

Artist: **Greg Newbold**

Art Director: Deborah Michel

Client: Michel Publishing

Medium: Acrylic on Bristol

Size: 10" x 10"

441

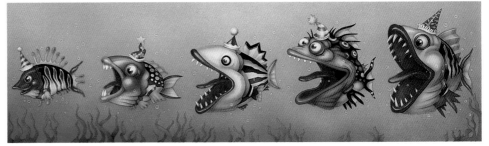

442

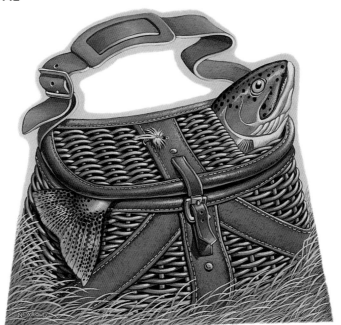

443

uncommissioned/ unpublished

Yvonne Buchanan, Chair
Illustrator

Ray-Mel Cornelius
Illustrator

Etienne Delessert
Illustrator

John English
Illustrator

Rudy Gutierrez
Illustrator

Mirko Ilić
*Illustrator/Designer,
Mirko Ilić Corp.*

Gene Mydlowski
Ballantine Books

Dan Smith
Art Director, National Wildlife
Magazine, *National Wildlife
Federation*

Michael Whelan
Artist/Illustrator

Jury

444 Gold Medal

Artist: **John F. Martin**

Medium: Oil on canvas

Size: 20" x 30"

"The markings on this Fifth Avenue intersection caught my interest while I was searching for ground reflections after it had rained. Some years ago I had covered extensive ground in Manhattan as a foot messenger and the activity there has always been spellbinding to me. I've been illustrating New York City landscapes ever since. This award came as a complete surprise and I am grateful to the Society of Illustrators, as well as for the help I received early on at the Junior College of Albany and Syracuse University."

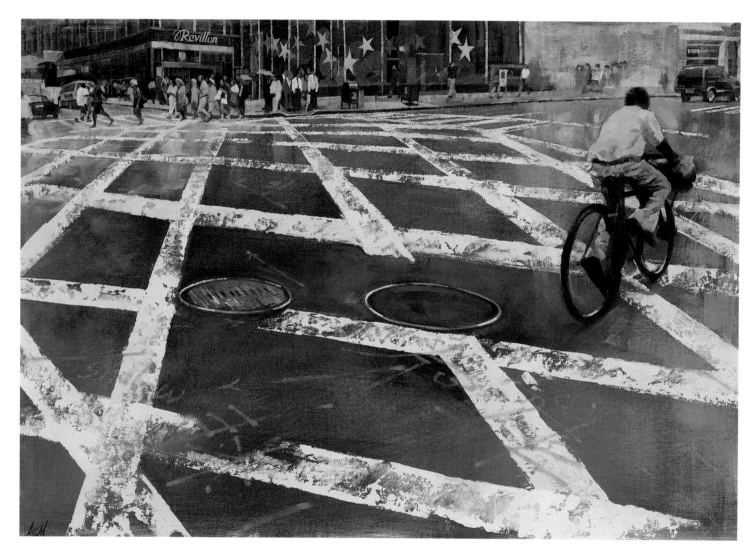

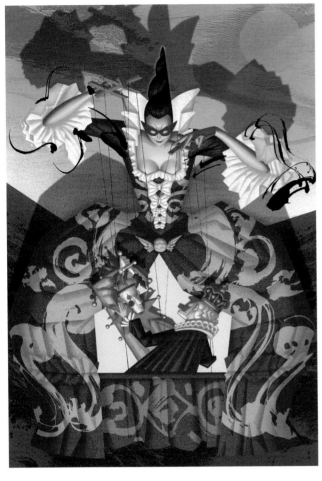

445 Silver Medal

Artist: **Hiro Kimura**

Medium: Digital

Size: 15" x 10"

"My first love in art was brush lines. I could hardly walk when I began messing with my grandfather's treasured calligraphy brushes and sumi ink, much to his annoyance. As I learned more about painting, a marriage of painting and calligraphic lines began to take shape in my mind. I'm elated that one such attempt was recognized."

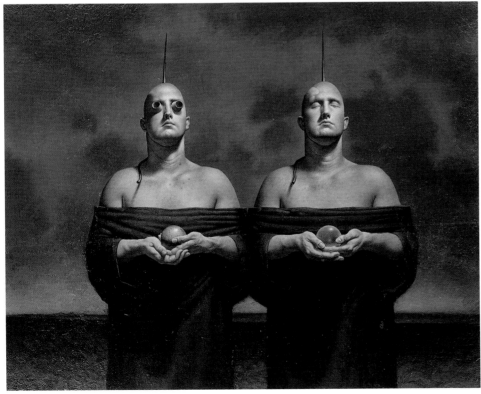

446 Silver Medal

Artist: **John Jude Palencar**

Medium: Acrylic on panel

Size: 27" x 33"

"This painting is one of several in a body of my personal work which explores the theme of faith. I worked from photographs, plaster casts and life. 'Storm Worship' examines an interpretation and expression of faith—particularly the misguided and inane. Here, twins—having attached lightning rods to their shaved heads—wait in hopes of communion with an approaching storm. One reverently cups a stone sphere and the other a glass insulator—elemental symbols of earth and air. Faith is a powerful and mystical force, infusing intensely personal beliefs with sometimes misguided actions. One need only remember the Heaven's Gate cult to see the parallel."

447

Artist: **David Ho**

Medium: Digital

Size: 40" x 29"

448

Artist: **Nick Rotondo**

Medium: Digital

449

Artist: **Will Wilson**

Medium: Oil on canvas

Size: 24" x 24"

450

Artist: **Greg Spalenka**

Medium: Digital, mixed

Size: 14" x 11"

451

Artist: **John Rush**

Medium: Oil, acrylic on canvas

Size: 26" x 18"

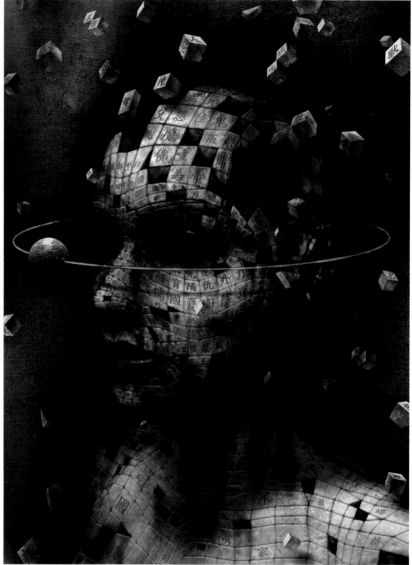

447

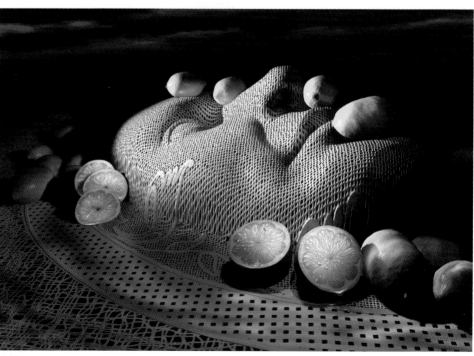

448

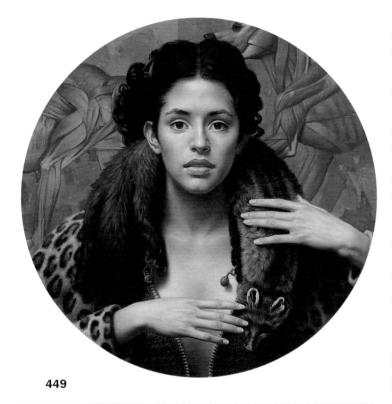

449

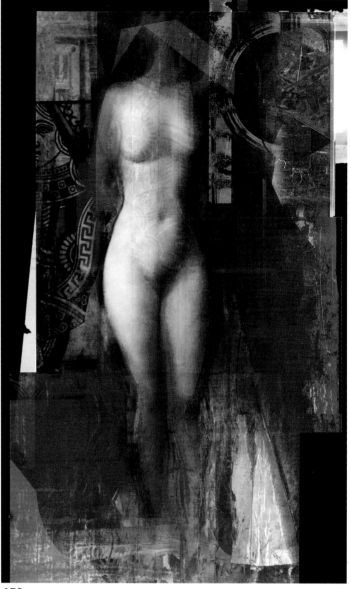

450

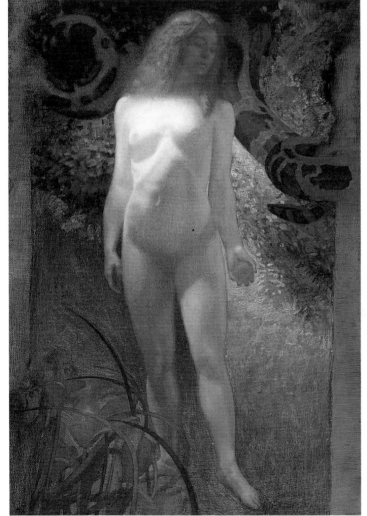

451

452

Artist: **Ned Gannon**

Medium: Oil on linen on board

Size: 24" x 30"

453

Artist: **Tracy Villa Carrera**

Medium: Oil on linen canvas

454

Artist: **Yvonne Buchanan**

Medium: Pen & ink, watercolor on paper

Size: 10" x 7"

455

Artists: **Megan Berkheiser**
Michael Liddy

Art Director: Rose Cali

Client: Yogi Berra Museum

Medium: Mixed on wood

Size: 42" x 60"

456

Artist: **Mike Bryce**

Medium: Oil on canvas

Size: 36" x 26"

457

Artist: **Glenn Harrington**

Medium: Oil on linen

Size: 10" x 10"

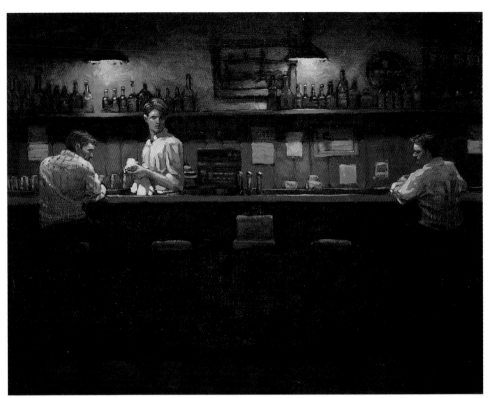

452

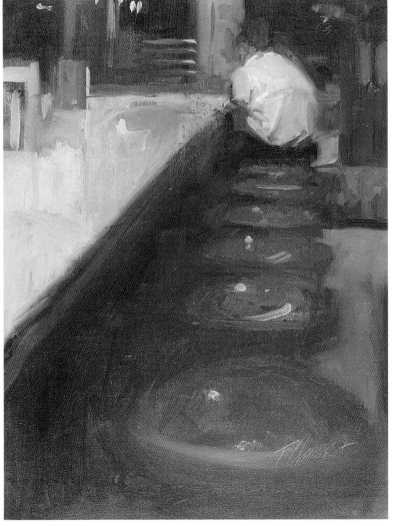

453

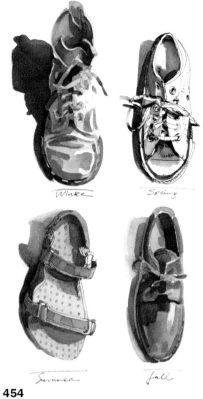

454

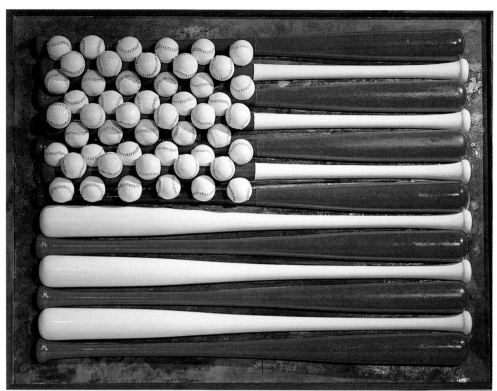

455

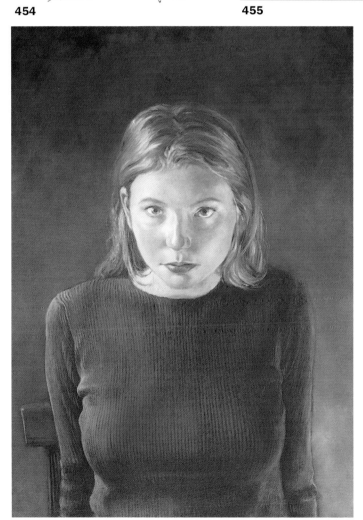

456

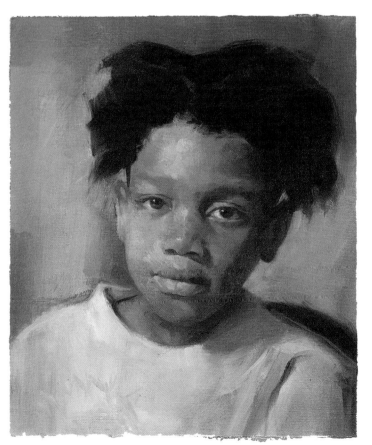

457

458

Artist: **Renato Alarcao**

Medium: Watercolor on paper

459

Artist: **Bill Thomson**

Medium: Acrylic

Size: 14" x 9"

460

Artist: **Jim Burke**

Medium: Oil on board

Size: 12" X 8"

461

Artist: **Michael Whelan**

Medium: Acrylic on board

Size: 36" x 36"

462

Artist: **Robert Hunt**

Medium: Oil on linen

Size: 20" x 16"

463

Artist: **Steven Adler**

Medium: Oil on masonite

Size: 29" x 16"

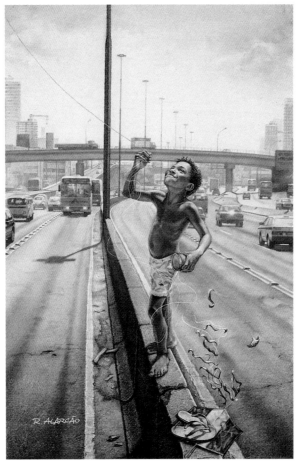

458

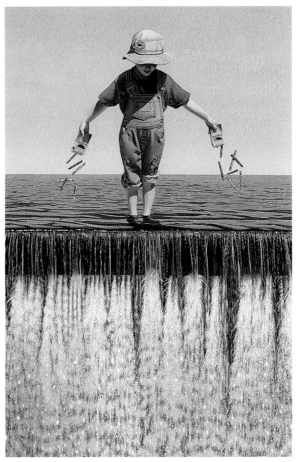

459

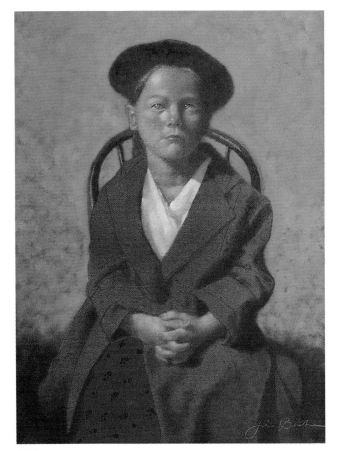

460

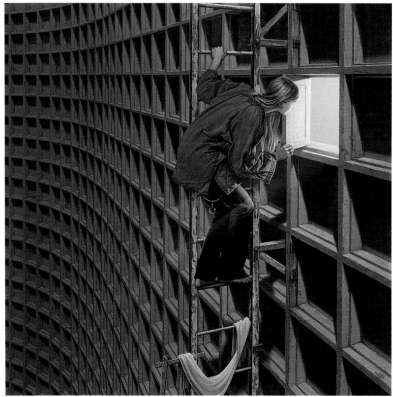

461

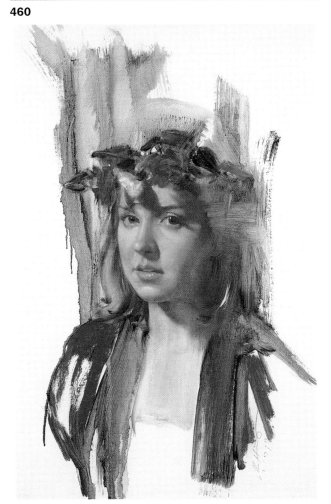

462

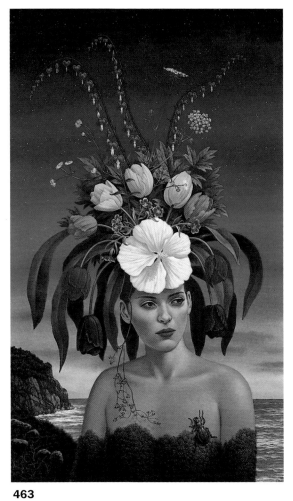

463

464

Artist: **Dick Krepel**

Medium: Ink, collage on watercolor paper

Size: 20" x 12"

465

Artist: **James Bennett**

Medium: Oil on board

Size: 11" x 15"

466

Artist: **Joe Ciardiello**

Medium: Pen & ink on paper

Size: 15" x 10"

467

Artist: **Eric Strenger**

Medium: Acrylic on board

Size: 9" x 12"

468

Artist: **Paul Zwolak**

Medium: Mixed

469

Artist: **Larry Kresek**

Medium: Oil on gessoed masonite

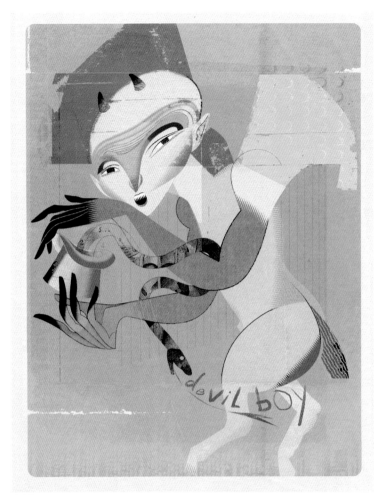

464

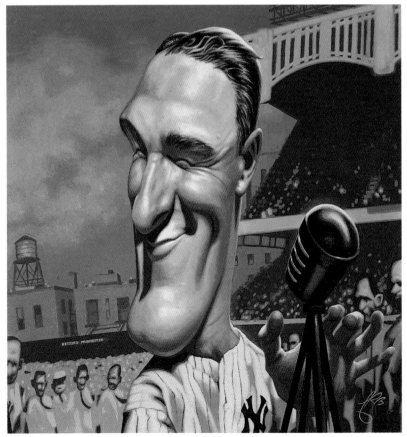

465

466

467

468

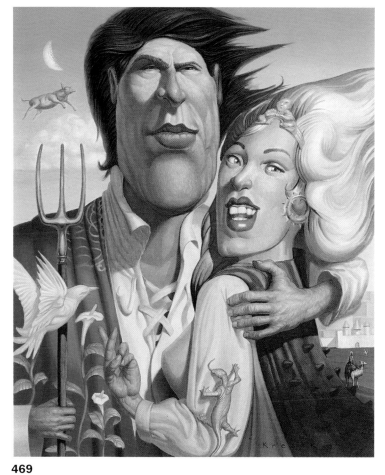

469

470

Artist: **Eric Strenge**

Medium: Acrylic, colored pencil on board

Size: 8" x 5"

471

Artist: **Dale Stephanos**

Medium: Mixed on wood

Size: 20" x 15"

472

Artist: **Liz Lomax**

Medium: Mixed

Size: 18" x 10"

473

Artist: **Jon Marro**

Medium: Marker, colored pencil,
gouache on Bristol

Size: 8" x 10"

474

Artist: **Lawrence Carroll**

Medium: Mixed on paper

Size: 30" x 24"

475

Artist: **Ken Laager**

Medium: Oil on canvas

Size: 40" x 32"

473

Artist: **Abby Merrill**

Medium: Gouache, pencil on Arches
cold press

Size: 20" x 15"

477

Artist: **Kaleb Wyman**

Medium: Colored pencil on Strathmore
cold press paper

Size: 18" x 14"

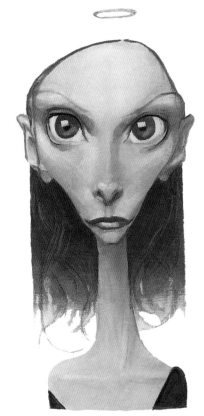

470

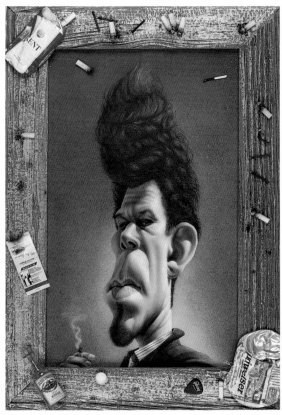

471

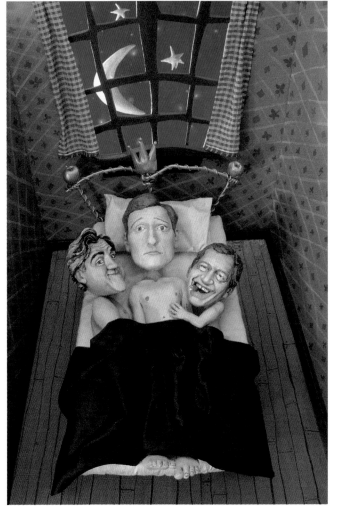

472

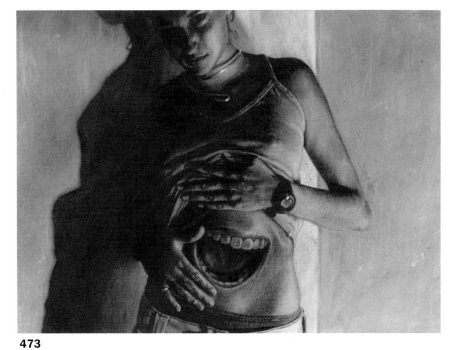

473

474

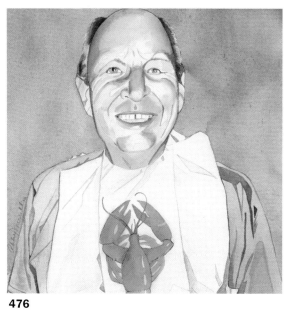

476

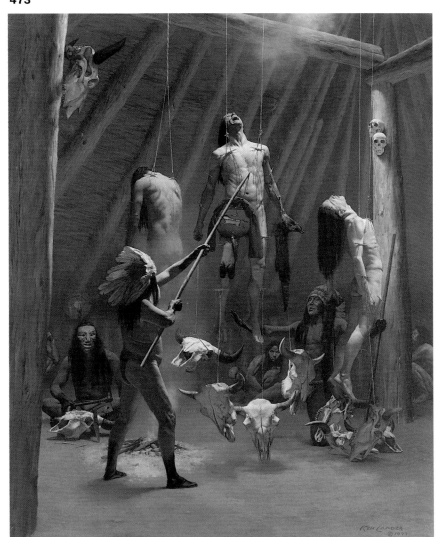

475

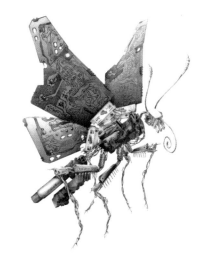

477

478

Artist: **Gene Mollica**

Medium: Oil on canvas

Size: 60" x 96"

479

Artist: **Francis Livingston**

Medium: Oil on masonite

Size: 18" x 14"

480

Artist: **Max Grafe**

Medium: Monoprint on paper

Size: 16" x 12"

481

Artist: **Adam Niklewicz**

Medium: Acrylic on board

Size: 15" x 9"

482

Artist: **John Michael Yanson**

Medium: Digital

Size: 6" x 4"

483

Artist: **Marc Burckhardt**

Medium: Acrylic on cold press board

Size: 14" x 11"

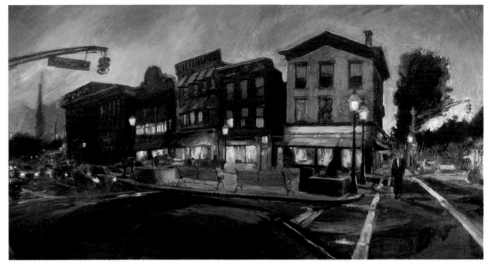

478

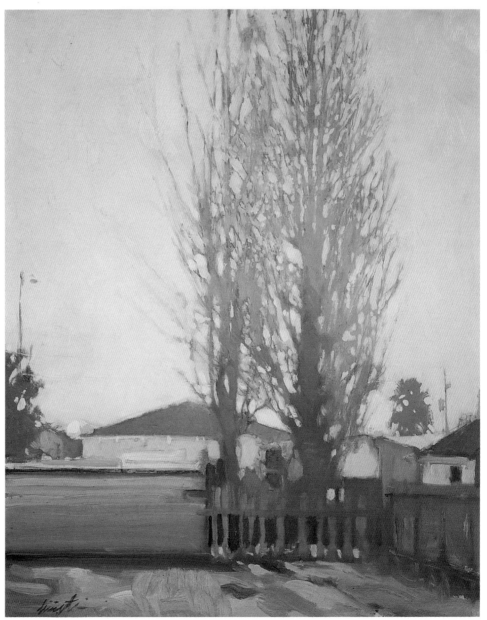

479

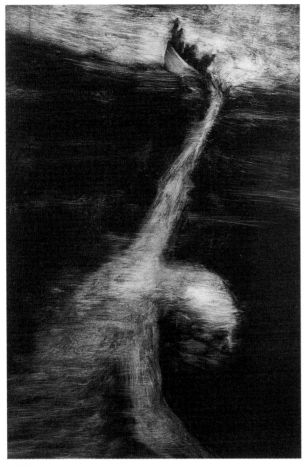

480

481

482

483

484

Artist: **Steven Adler**

Medium: Oil on masonite

Size: 30" x 20"

485

Artist: **Daniel Page Schallau**

Medium: Pen & ink, colored pencil on
watercolor paper

Size: 10" x 14"

486

Artist: **Krista Brauckmann-Towns**

Medium: Acrylic on board

Size: 18" x 19"

484

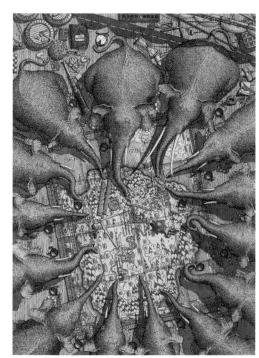

485

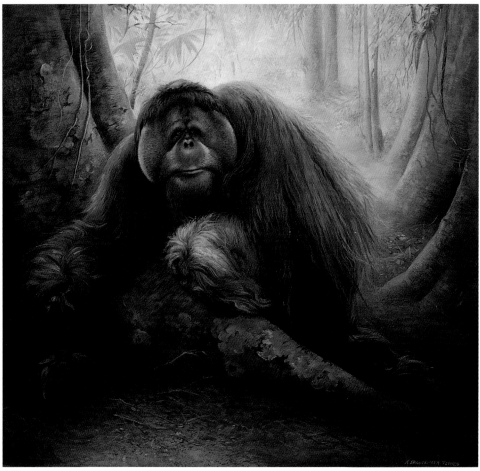

486

student scholarship competition

The Society of Illustrators fulfills its education mission through its museum exhibitions, library, archives, permanent collection and, most proudly, through the Student Scholarship Competition.

The following pages present a sampling of the 193 works selected from over 4,100 entries submitted by college level students nationwide. The selections were made by a prestigious jury of professional illustrators.

Tim O'Brien chairs this program and major financial support is given by Hallmark Corporation Foundation of Kansas City, Missouri. Along with donations from corporations, bequests and an annual auction of member-donated works, the Society awards over $80,000 to the students and their institutions.

This year, Marshall Arisman and Philip Hays were selected as Distinguished Educators in the Arts, an honor now recognized by all as affirmation of an influential career in the classroom.

As you will see, the talent is there. If it is coupled with determination, these students will move ahead in this annual to join the selected professionals. Let's see.

Hallmark Corporate Foundation

The Hallmark Corporate Foundation of Kansas City, Missouri, is again this year supplying full matching grants for all of the awards in the Society's Student Scholarship Competition. Grants, restricted to the Illustration Departments, are awarded to the following institutions:

13,500	School of Visual Arts
6,500	Academy of Art College
4,500	Maryland Institute, College of Art
4,000	Fashion Institute of Technology
3,000	Savannah College of Art and Design
2,500	California State University-Long Beach
2,000	Pratt Institute
1,500	Art Center College of Design
1,500	Brigham Young University
1,500	Columbus College of Art & Design
1,500	Paier College of Art
1,000	Kendall College of Art & Design
1,000	Montserrat College of Art
1,000	Syracuse University

MARSHALL ARISMAN

I've known Marshall Arisman for more than 30 years. We met when I began teaching a book illustration class at the School of Visual Arts in 1968. Marshall had just become Chair of Illustration and Cartooning. At the time the department was combined with Graphic Design and Advertising and it was called the Media Department. The school was a lot smaller then. In 1984, Marshall created the Masters Program in Illustration and I took on the duties of the Chair of Undergraduate Illustration and Cartooning. Due to our similar philosophies concerning education, illustration, picture making, etc., the transition was so smooth most people not directly involved were not aware of the change until after it had taken place. We've worked closely together for many years and a strong friendship grew out of our working experience. We've had endless discussions about the process of educating illustrators. There are many reasons why Marshall is the consummate educator: he is an accomplished artist whose work is celebrated all over the world; he loves the process of making pictures; he is verbal, intelligent, and he cares. He teaches to the individual. Each picture he criticizes becomes new territory to explore and understand with the person who created the picture, and he approaches it all with a freshness and enthusiasm that belies the amount of time he's been doing it. I think that's because he's as good at learning as he is at teaching. Marshall believes that the learning process never stops, so he's as good a student as he is an instructor. That's why he's so good at what he does. There's a simple rule for teaching people how to make pictures or anything else. You tell a person his or her picture is good or bad and then you tell that person why. Marshall has been doing that, unerringly, for as long as I've known him. I know he brings as much creativity and vision into his classroom as he does to his studio. Marshall's teaching skills transcend time. He's what good education is about.

Jack Endewelt

PHILIP HAYS

In September of 1957 Phil Hays taught his first illustration class at the School of Visual Arts in New York. It was my good fortune to be a student in that class. Phil was not much older than his students were but he was already one of the top illustrators in America. His work appeared regularly in *Seventeen*, *Cosmopolitan*, *Redbook*, *McCall's*, *Esquire*, on record covers and in advertising. My classmates and I were thrilled to learn from such a successful and glamorous artist. He created great setups in the classroom with models and props. He introduced us to the best modern writers and sent us to plays, films and the picture collection at the library. He enlarged our world in every way. The pictures that Phil was making in those days were vivid and memorable. There were two SVA posters in particular. One was a tightrope walker and the other was a parachutist. Images of risk and daring.

Phil was soon named chair of the illustration department at SVA. He developed a strong department while continuing to teach and to create great illustrations. In 1978 he went to California to chair the illustration program at the Art Center College in Pasadena and in New York we missed him as a friend and as an artist.

Phil's favorite expression is "Why not?" He welcomes experimentation and innovation. He opens doors for his students in their work and in the real world, with lists of art directors to call on. Phil takes pride in his students' accomplishments and in their individuality. There is no formula. A wide and varied circle of successful illustrators were taught, encouraged and inspired by Phil. Many of them have gone on to teach and inspire others.

Phil is a wonderful choice for this award. I studied with the very best teachers I could have wished for at SVA and the best of them all was Phil Hays.

Paul Davis

This annual award is selected by the Board of Directors upon recommendation of the Education Committee.
Past recipients:
Alvin J. Pimsler 1997, Alan E. Cober 1998, Murray Tinkelman 1999

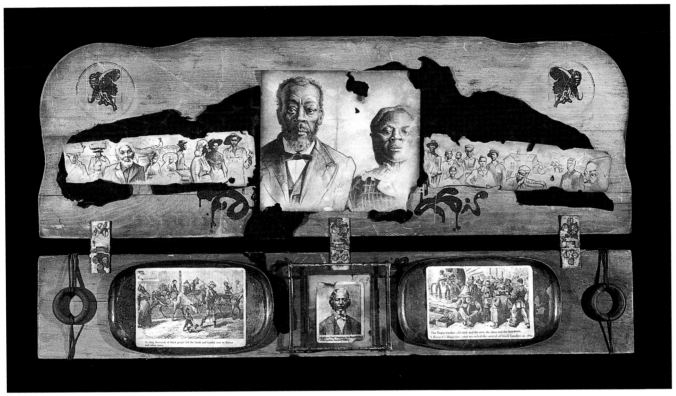

Jules R. Arthur
Joo Chung, Instructor
School of Visual Arts
Mixed
$4,000 Robert H. Blattner Award

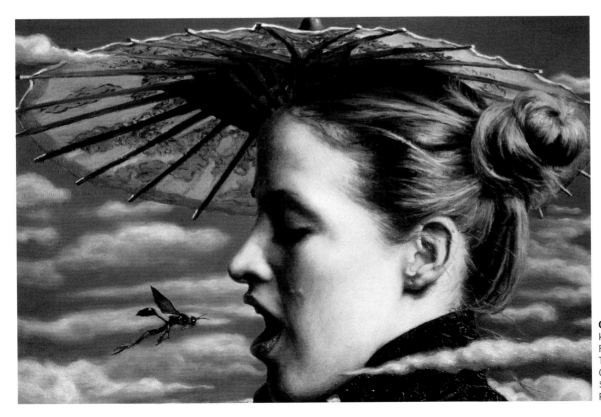

Qi Z. Wang
Kam Mak, Instructor
Fashion Institute of
Technology
Oil
$4,000 Jellybean
Photographics Award

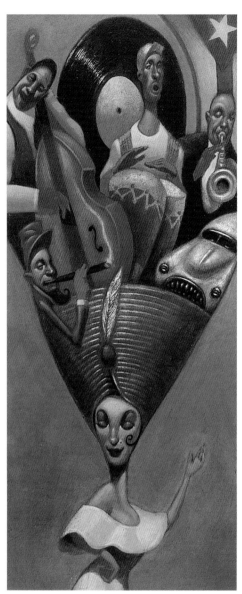

Moby Francke
Tim Racer, Instructor
Academy of Art College
Mixed
$2,000 Award in Memory of
Helen Wohlberg Lambert
RSVP Publication Award

Mario Sequeira
Warren Linn, Instructor
Maryland Institute, College of Art
Charcoal
$2,500 The Starr Foundation Award

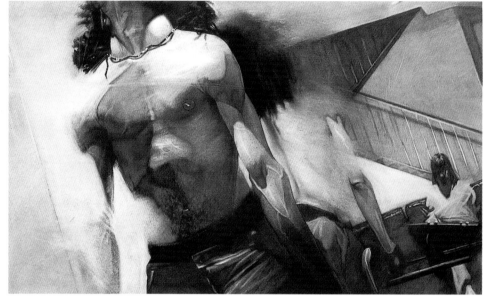

Richard Park
George Zebot, Instructor
California State University - Long Beach
Oil
$2,500 The Starr Foundation Award

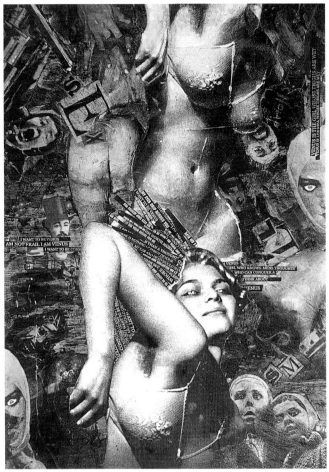

Greg Zadrozny
Dave Passalacqua, Instructor
Pratt Institute
Mixed
$2,000 The Greenwich Workshop Award

Catarina Fernandes
Vladimir Shpitalnik, Instructor
Paier College of Art
Mixed
$1,500 Dick Blick
Art Materials Award

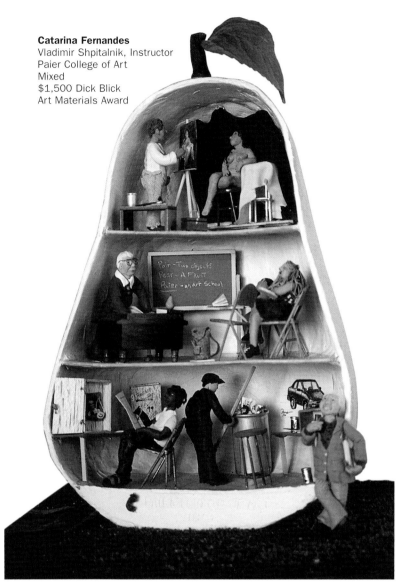

Joel Dugan
James Wu, Instructor
Academy of Art College
Mixed
$1,500 The Norman Rockwell
Museum at Stockbridge Award

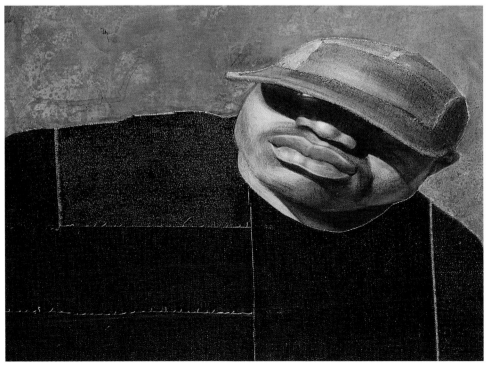

Derek Blanks
Warren Linn, Instructor
Maryland Institute, College of Art
Oil on panel
$2,000 Kirchoff/Wohlberg Award

Victoria Stein
Durwin Talon, Instructor
Savannah College of Art and Design
Digital
$2,000 Award in Memory of
Meg Wohlberg

Daniel Dos Santos
Sal Catalano, Instructor
School of Visual Arts
Oil on board
$2,000 Jellybean Photographics Award
2001 "Call For Entries" Poster Award

Brian O. B. Solinsky
Peter Fiore, Instructor
School of Visual Arts
Pencil
$1,500 The Norman Rockwell Museum
at Stockbridge Award

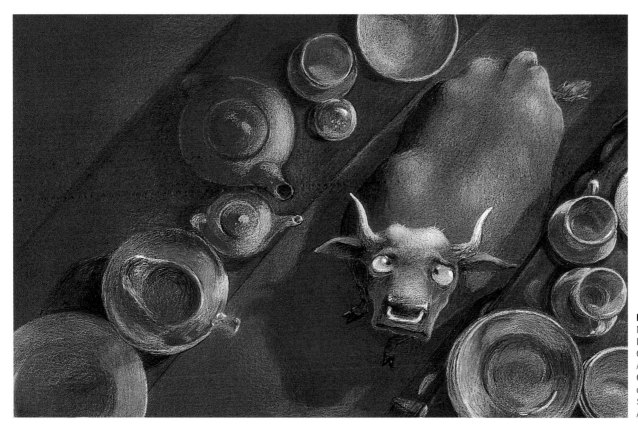

Elizabeth Hornbeck
Mark Hazelrig,
Instructor
Columbus College of
Art & Design
Colored pencil on
colored ground
$1,500
Albert Dorne Award

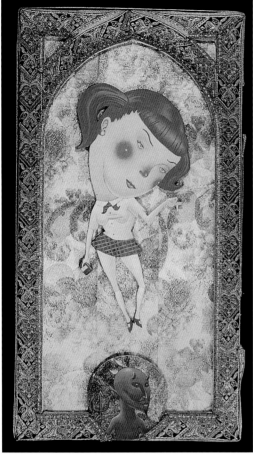

Benjamin Marra
Marty Blake, Instructor
Syracuse University
Oil on board, collage
$1,000 Friends of the
Institute of Commercial Art Award

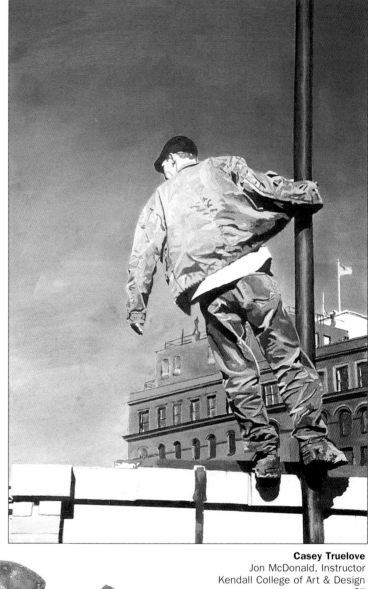

Casey Truelove
Jon McDonald, Instructor
Kendall College of Art & Design
Oil
$1,000 Norma and Alvin
Pimsler Award

Erick Thomas
Elisa Della-Piana, Instructor
Montserrat College of Art
Mixed
$1,000 John T. Klammer
Dimensional Award

Brian Main
Mohamed Danawi,
Instructor
Savannah College of Art
and Design
$1,000
Kirchoff/Wohlberg Award
in Memory of
Frances Means

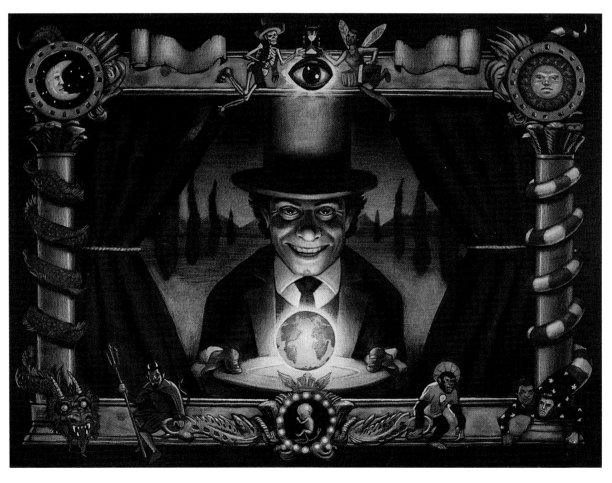

Reuben Negrón
Alan Reingold, Instructor
Maryland Institute, College of Art

Grant Barnhart
C.F. Payne, Instructor
Columbus College of Art & Design

artists index

Adel, Daniel, 25
56 West 22nd St. 8th Fl.
New York, NY 10010
(212) 989-6114
Danieladel.com
danieladel@mindspring.com

Adler, Steven, 463, 484
3557 Slate Mills Rd.
Sperryville, VA 22740
(540) 547-3971
(800) 789-9389

Alarcao, Renato, 4
31 Andrew Ave.
Oakland, NJ 07436
(201) 337-7285
renatoalarcao@hotmail.com
Rep: (201) 337-7285

Arisman, Marshall, 64
314 West 100th St.
New York, NY 10025
(212) 967-4983

Arroyo, Fian, 441
901 Surfside Blvd.
Surfside, FL 33154
(305) 866-6370
fianarroyo@aol.com
www.fian.com

Backlund, John, 203
6013 Creek Dr.
Blackhawk, SD 57718
(605) 787-5847

Ballard, Lee, 374
514 Galland St.
Petaluma, CA 94952
(707) 775-4723
leeballardnillo@earthlink.net
nillo@earthlink.net

Barkat, Jonathan, 60, 68
240 Ripka St.
Philadelphia, PA 19127
(215) 508-4522

Barnard, Bryn, 112
417 Point Caution Dr.
Friday Harbor, WA 98250-9222
(360) 378-6355

Bennett, James, 15, 19, 22, 465
5821 Durham Rd.
Pipersville, PA 18947
(215) 766-2134 PH/FAX
Rep: Richard Solomon
(212) 223-9545

Benny, Mike, 125, 386
3421 Reims Ct.
Austin, TX 78733
(512) 263-5490

Berkheiser , Megan, 455
Berkheiser/Liddy Studio
30 Charles St. #42
New York, NY 10014-7302
(212) 255-5539
(212) 514-8746

Biers, Nanette, 278, 408
123 Willow Ave.
Corte Madera, CA 94925
(415) 927-1531
Rep: (212) 475-0440

Billout, Guy, 110
225 Lafayette St. #1008
New York, NY 10012
(212) 431-6350
(212) 941-0787 FAX

Blechman, Laurel, 140
7853 Mammoth Ave.
Panorama City, CA 91402
(818) 785-7904

Bleck, Cathie, 283
2270 Chatfield Dr.
Cleveland Heights, OH 44106
(216) 932-4910
cb@catiebleck.com
www.cathiebleck.com

Blondon, Hervé, 1
c/o Wanda Nowak
231 East 76th St. #5D
New York, NY 10021
(212) 535-0438
(212) 535-1624 FAX
www.wandanow.com

Bohbot, Michel, 371
3823 Harrison St.
Oakland, CA 94611
(510) 547-0667
michelb@jps.net

Borda, Juliette, 92
17 Little West 12th St. #310
New York, NY 10014
(212) 414-2404

Borge, Richard, 243
459 West 49th St. #4W
New York, NY 10019
(212) 262-9823
www.richborge.com

Borgert, Tim, 71
45 South Ludlow St.
Dayton, OH 45402
(937) 225-2386

Bowers, David, 182, 370
206 Arrowhead Lane
Eighty-four, PA 15330
(724) 942-3274
(724) 942-3276 FAX

Bowman, Eric, 380
7405 SW 154th Pl.
Beaverton, OR 97007
(503) 644-1016

Bramman, Michael, 409, 410, 411
104 Dudley Court/Upper Berkeley St.
London, England W1H 7PJ
(0)-20-7723-3564

Brauckmann-Towns, Krista , 486
6 N. 777 Palomino Dr.
St. Charles, IL 60175
(630) 513-9525

Brodner, Steve, 13, 20
711 West 190th St. #5F
New York, NY 10040
(212) 942-7139

Bryce, Mike, 456
P.O. Box 2317
Providence, RI 02906
(401) 578-7304

Buchanan, Steve, 419, 423
317 Colebrook Rd.
Winsted, CT 06098-2225
(860) 379-5668
steve@stevebuchanan.com

Buchanan, Yvonne, 424, 454
18 Lincoln Pl.
Brooklyn, NY 11217
(718) 783-6682
www.yvonnebuchanan.com

Buehner, Mark, 200, 201
2646 South Alden St.
Salt Lake City, UT 84106
(801) 467-1565

Burckhardt, Marc, 483
112 West 41st St.
Austin, TX 78751
(512) 458-1690

Burke, Jim, 290, 460
647 Walnut St. Ext.
Manchester, NH 03104
(603) 668-0103

Cabry, Cyril, 356
14 Rue Pasteur
Asnieres Sur Seine
France 92600
011-331-4733-0803
Rep: Marlena Agency
(609) 959-9405

Cannoy, Lynne, 124
755 Brookline Blvd. #1
Pittsburgh, PA 15226
Rep: Shannon Associates
(212) 333-2551

Carrera, Tracy Villa, 453
Working Class Illustration
1280 Olive Dr. #256
Davis, CA 95616
(503) 758-9883
tvcarrera@hotmail.com

Carroll, Lawrence, 474
447 North Stanley
Los Angeles, CA 90036
(323) 655-5160

Carver, Morgan, 39, 381
Simone Represents
2420 North Valencia Ave.
Santa Ana, CA 92706
(714) 541-5957
mismot@mns.com

Christiana, David, 152
13990 North Sutherland Tr.
Tucson, AZ 85739
(520) 825-4043

Chwast, Seymour, 355
The Pushpin Group, Inc.
18 East 16th St. 7th Fl.
New York, NY 10003
(212) 255-6456
www.pushpininc.com

Ciardiello, Joe, 30, 316,
317, 318, 466
2182 Clove Rd.
Staten Island, NY 10305
(718) 727-4757
(718) 442-3760 FAX

Cigliano, Bill , 8
1525 West Glenlake Ave.
Chicago, IL 60660
(773) 973-0062

Cilluffo, Laurent, 257
East 8st St. #3G
New York, NY 10028
(212) 472-0833
cilluffo@earthlink.net
Rep: Wanda Nowak
(212) 535-0438

Clement, Gary, 90
c/o Marlena Agency
145 Witherspoon St.
Princeton, NJ 08542
(609) 252-9405

Collier, John, 296, 300
c/o Richard Solomon Artists Rep.
305 East 50th St. #1
New York, NY 10022
(212) 223-9545
(212) 223-9633 FAX

Colón, Raul, 136
43-C Heritage Dr.
New City, NY 10956
(914) 639-1505

Cooley, Gary, 314, 433
Indigo Studios
644 Antone
Atlanta, GA 30318
(404) 872-0110
gary@indigostudios.com

Couch, Greg, 151, 153
47 2nd Ave.
Nyack, NY 10960
(914) 358-9353
Rep: Joanne Palulian
(203) 866-3734

Cournoyer, Jacques, 343
170 Jean-Talon Ouest #410
Montreal, Quebec, Canada H2R 2X4
(514) 490-1412
Rep: Marlena Agency
(609) 252-9405

Cousineau, Normand, 351
c/o Marlena Agency
145 Witherspoon St.
Princeton, NJ 08542
(609) 252-9405

Craft, Kinuko Y., 2, 368
83 Litchfield Rd.
Norfolk, CT 06058
(860) 542-5018
(860) 542-6029 FAX

Craig, Daniel, 181, 199, 268, 282
Oasis Studio
118 East 26th St.
Minneapolis, MN 55404
(612) 871-4539
Rep: Bernstein & Andriulli
(212) 682-1490

Crawford, Robert, 158
123 Minortown Rd.
Woodbury, CT 06798
(203) 266-0059

Curry, Tom, 57, 234
Prickly Pear Studio
901 West Sul Ross
Alpine, TX 79830
(915) 837-2311
curry@brooksdata.net

Cutler, Dave, 81, 82
730 Nerita St.
Sanibel, FL 33957
(941) 472-1538

Daily, Don, 205, 206, 207
57 Academy Rd.
Bala Cynwyd, PA 19004
(610) 664-5729

Dancey, Mark, 240
2231 Holbrook
Detroit, MI 48212
(313) 871-8419
motorb@motorbooty.com

Dawson, John D., 418
P.O. Box 1323
Hilo, HI 96721-1323
(808) 959-2008

Day, Rob, 42
6095 Ralston Ave.
Indianapolis, IN 46220
(317) 253-9000
r@robday.com

de Sève, Peter, 35, 37, 111, 139
25 Park Pl.
Brooklyn, NY 11217
(718) 398-8099

Deas, Michael J., 138, 280
914 Governor Nicholls St.
New Orleans, LA 70116
(504) 524-3957

Delessert, Etienne, 62, 63, 155,
224, 269, 291, 292, 367
Delessert & Marshall
P.O. Box 1689
Lakeville, CT 06039
(860) 435-0061
(860) 435-9997 FAX

DeMuth, Roger, 434
59 Chenango St.
Cazenovia, NY 13035
(315) 655-8599
www.demuthdesign.com

DePalma, Mary Newell, 339
45 Bradfield Ave.
Boston, MA 02131
(617) 327-6241

Dillon, Leo, Diane & Lee, 183
221 Kane St.
Brooklyn, NY 11231
(718) 624-0023
(718) 624-1772 FAX

Donato, 213, 214, 215
397 Pacific St.
Brooklyn, NY 11217
(718) 797-2438

Douglas, Allen, 373
309 6th St. #3
Brooklyn, NY 11215
(718) 499-4101 PH/FAX

Dubois, Gerard, 56, 61
17 Du Soleil Pl. #302
Verdun I.D.S., Quebec
Canada H3E 1P7
(514) 762-5043
dubois@netaxis.ca
Rep: Marlena Agency
(609) 252-9405

Dugin, Andrej, 164
Weser Strabe 34
Stuttgart, Germany 70376
011-0711-59-1158

Dunnick, Regan Todd, 338
7663 Penninsular Dr.
Sarasota, FL 34231
(941) 923-4751

Duvivier, Jean-Manuel , 159
c/o Daniele Cullignon
200 West 15th St.
New York, NY 10011
(212) 243-4209
(212) 463-0634 FAX

Elesh, Edem, 244
6554 Homewood Ave.
Hollywood, CA 90028
(323) 461-5664

Elwell, Tristan, 179
41 Main St.
Dobbs Ferry, NY 10522
(914) 674-9235

English, Mark, 145, 146, 147, 227
539 Ridgeway
Liberty, MO 64068
(816) 781-0056
(816) 781-7304 FAX

Eslinger, Kevin, 307
c/o Gail Thurm Represents
232 Madison Ave. Suite 512
New York,, NY 10016
(212) 889-8777
(212) 447-1474 FAX

Fabian, Limbert, 326, 327
229 South Osprey Ave. #102
Sarasota, FL 34236
(941) 350-3497
limbertf@hotmail.com

Fancher, Lou, 208, 210, 211
Johnson & Fancher Inc.
440 Sheridan Ave. South
Minneapolis, MN 55405
(612) 377-8728

Farrell, Russell, 417
136 Mercer Ave.
Woodbury Heights, NJ 08097
(856) 848-9236

Fast, Ingo, 91
25 Broadway
Brooklyn, NY 11211
(718) 387-9570
www.ingofast.com

Fiedler, Joseph Daniel, 80
154 Vista Del Valle
Ranchos De Taos, NM 87557
(505) 737-5498

Fiore, Patrick, 297
4845 Winchester Dr.
Sarasota, FL 34234
(941) 355-2096

Fluharty, Thomas L., 392
2704 180th St. East
Prior Lake, MN 55372
(952) 226-2646
(952) 226-2647 FAX

Forbes, Bart, 217, 394, 427
5510 Nakoma Dr.
Dallas, TX 75209
(214) 357-8077
(214) 358-3396 FAX

Foster, Jon, 216
Buzzworks Studio
231 Nayatt Rd.
Barrington, RI 02806
(401) 245-8438

Frazier, Craig, 83, 293, 328,
329, 330
90 Throckmorton Ave. #28
Mill Valley, CA 94941
(415) 389-1475
Rep: Jan Collier Representive Inc.
(415) 383-9026

French, Martin, 180, 325
69425 Deer Ridge Rd.
Sisters, OR 97759
(541) 549-4969

Fuchs, Bernie, 135
3 Tanglewood Lane
Westport, CT 06880
(203) 227-4644

Galifianakis, Nick, 36
3427 Barger Dr.
Falls Church, VA 22044
(703) 916-9350

Gall, Chris, 175
Gallagher, S. Saelig, 150, 196
3624 Amaryllis Dr.
San Diego, CA 92106
(619) 222-3892
saelig@cts.com

Gannon, Ned, 452
388 Richmond Terrace #6L
Staten Island, NY 10301
(718) 447-9836

Gast, Josef, 54
527 Wellington Ave.
Seattle, WA 98122
(206) 720-1033
Rep: (740) 369-9702

George, Jane, 247
10 Westminster Pl.
Lafayette, CA 94549
(925) 274-9973
janegeorge@earthlink.net
www.janegeorge.com

Giusti, Robert, 281
340 Long Mountain Rd.
New Milford, CT 06776
(860) 354-6539

Glaser, Milton, 245, 246, 415
207 East 32nd St.
New York, NY 10016
(212) 889-3161

Goldstrom, Robert, 364
181 St. James Pl.
Brooklyn, NY 11238
(718) 398-9533

Gore, Leonid, 148, 149
1429 Dahill Rd. Apt. A
Brooklyn, NY 11204
(718) 627-4952
Rep: HK Portfolio, Inc.
(212) 675-5719

Grafe, Max, 480
99 Sutton St. #302
Brooklyn, NY 11222
(718) 609-0340

GrandPré, Mary, 233
597 Pascal St. South
St. Paul, MN 55116
(651) 699-0424

Granner, Courtney, 340, 352
San Jose, CA 95125
(408) 294-8691
grannerc@earthlink.net

Greenblatt, Mitch, 77
65 Atlantic Ave. #13
Brooklyn, NY 11201
(718) 624-6361
mitchismo.com

Griesbach, Cheryl, 422
One By Two Studio
34 Twinlight Terrace
Highlands, NJ 07732
(732) 291-5945

Guarnaccia, Steven, 163, 353,
354, 358
31 Fairfield St.
Montclair, NJ 07042
(973) 746-9785
squarnaccia@hotmail.com

Han, Oki, 156
Hong Jae Han Yang #13
109 Dong #101
Hong Jae 2 Dong
Sae Dai Moon-gu , Seoul, Korea
011-822-722-8733
okihanhitel.net

Harrington, Glenn, 229, 457
54 Twin Lear Rd.
Pipersville, PA 18947
(610) 294-8104 PH/FAX

Harris, Jack, 311
722 Yorklyn Rd. #150
Hockessin, DE 19707
(302) 234-5707
jack.harris@jackharris.com
Rep: Lisa Harris
(302) 234-5707 ext. 21

Hart, Richard, 310, 344, 361
Disturbance Design
15A Hammersmith Rd.
Durban, South Africa 4000
011-31-207-6100
011-31-208-1495 FAX

Hashimoto, Yoshinori, 165
2-3-11 Bellhouse Turigane-cho
Chuo-ku Osaka, Japan
011-81-06-6943-1166

Hejja, Attila, 412
15 Foster Pl.
Sea Cliff, NY 11579
(516) 671-2630 PH/FAX

Helton, Linda, 346
7000 Meadow Lake
Dallas, TX 75214
(214) 319-7877
Rep: Marlena Agency
(609) 252-9405

Henderson, David F., 414
21 James Rd.
Boonton Township, NJ 07005
(973) 402-1461
Rep: (212) 986-5680

Hewgill, Jody, 118, 126,
230, 231, 382
260 Brunswick Ave.
Toronto, Ontario, Canada M5S 2M7
(416) 924-4200
Rep: Salley Heflin
(212) 366-1895

Ho, David, 45, 218, 447
3586 Dickenson Common
Fremont, CA 94538
(510) 656-2468

Hodges, Mike, 93, 431
734 Indian Beach Circle
Sarasota, FL 34234
(941) 351-2226

Holland, Brad, 69, 70, 225, 262,
271, 272,
96 Greene St.
New York, NY 10012
(212) 226-3675
(212) 941-5520 FAX

Hollenbach, David, 66
5816 43rd Ave. BA
Woodside, NY 11377
(718) 553-0944
Rep: (740) 369-9702

Hollingsworth, M. Kyle, 232
6554 Homewood Ave.
Hollywood, CA 90028
(323) 461-5664

McKean, Dave, 129, 236
c/o Allen Spiegel Fine Arts
221 Lobos Avenue
Pacific Grove, CA 93950
(831) 372-4672 PH/FAX
asfa@redshift.com

McKowen, Scott, 253, 254, 255
Punch & Judy Inc.
428 Downie St.
Stratford, Ontario, Canada N5A 1X7
(519) 271-3049

McLean, Wilson, 41, 236, 303,
145 East 35th St. #5FE
New York, NY 10016
(212) 685-3470

McMahon, Franklin, 38
The Gallery McMahon
289 East Deerpath Rd.
Lake Forest, IL 60045
(847) 615-1787
corbis.com
Search Franklin McMahon

McMullan, James, 98, 99, 323
207 East 32nd St.
New York, NY 10016
(212) 689-5527
(212) 689-4522 FAX

McNamara, Michael, 405
Color Forms Inc.
24200 Woodward Ave.
Pleasant Ridge, MI 48069
(248) 399-0060
(248) 399-4390 FAX

Merrill, Abby, 476
850 Park Ave.
New York, NY 10021
(212) 772-6853

Minkin, Yishai, 74
210 7th St. #2
Jersey City, NJ 07302
(201) 795-5341

Minor, Wendell, 274
15 Old North Rd. P.O. Box 1135
Washington, CT 06793
(860) 868-9101
(860) 868-9512 FAX
wendell@minorart.com
www.minorart.com

Mollica, Gene, 478
1269 Prospect Ave.
Brooklyn, NY 11218
(718) 686-6764

Molloy, Jack A., 420
c/o Joanie Bernstein
750 8th Ave. South
Naples, FL 34102
(941) 403-4393

Moore, Larry, 259, 260
1315 Edgewater Dr.
Orlando, FL 32804
(407) 648-0832
Rep: Scott Hull & Associates
(937) 433-8383

Muth, Jon J., 194
c/o Allen Spiegel Fine Arts
221 Lobos Ave.
Pacific Grove, CA 93950
(831) 372-4672 PH/FAX
asfa@redshift.com

Myers, Robert, 220
2632 2nd St. #4
Santa Monica, CA 90405
(310) 396-7303

Nakamura, Joel, 350
72 Bobcat Tr.
Santa Fe, NM 87505
(505) 989-1404

Nascimbene, Yan, 172, 173, 286,
287, 288
235 7th St.
Davis, CA 95616
(530) 756-7076
(530) 758-9604 FAX
Rep: (212) 397-7330

Nelson, Bill, 301
P.O. Box 579
Manteo, NC 27954
Rep: Richard Solomon
(212) 223-9545

Nemoto, Yenpitsu, 289
1-33-12-A202 Hamadayama
Suginami-ku
Tokyo, JAPAN 168
011-81-03-3290-6250

Newbold, Greg, 413, 443
1231 East 6600 South
Salt Lake City, UT 84121
(801) 268-2209

Nicklin, Maria, 348
Furyworks
148A Winchester St.
Warrenton, VA 20186
(540) 341-2821

Niklewicz, Adam, 481
44 Great Quarter Rd.
Sandy Hook, CT 06482
(203) 270-8424

Ning, Amy, 86, 87
3966 Gaviota Ave.
Long Beach, CA 90807
(562) 989-9509
Rep: (949) 485-3664

Northeast, Christian, 58
336 Rusholme Rd. Upper Fl.
Toronto, Ontario, Canada M6H 2Z5
(416) 538-0400

O'Brien, Tim, 132, 178
310 Marlborough Rd.
Brooklyn, NY 11226
(718) 282-2821

O'Keefe, David, 21
3520 Buckboard Lane
Brandon, FL 33511
(813) 684-4099
okeefe4art@aol.com

Olbinski, Rafal, 222, 258, 362,
363, 372,
142 East 35th St.
New York, NY 10016
(212) 532-4328
(212) 532-4348 FAX

Orbik, Glen, 140
7853 Mammoth Ave.
Panorama City, CA 91402
(818) 785-7904

Palencar, John Jude, 3, 46, 134,
184, 219, 265, 446
6763 Middlebrook Blvd.
Middleburg Heights, OH 44074
(216) 676-8839

Parada, Roberto, 16, 17, 28,
c/o Levy Creative Management
300 East 46th St. #4G
New York, NY 10017
(212) 687-6463
www.levycreative.com

Parker, Curtis, 85, 241, 345
1946 East Palomino Dr.
Tempe, AZ 85284
(480) 820-6015

Parnell, Jay, 333, 360
912 Edgewood Pl.
Indianapolis, IN 46205
(317) 924-4643

Patrick, John, 276
2353 Park Ave. #2
Cincinnati, OH 45206

Payne, C.F., 5, 10, 11, 267
3600 Sherbrooke Dr.
Cincinnati, OH 45241
(513) 769-1172
(513) 769-1173 FAX
Rep: Richard Solomon
(212) 223-9545

Phillips, Stephen John, 187
3 Hardy Ct.
Towson, MD 21204
(410) 583-6880

Pinkney, Jerry, 190, 197
41 Furnace Dock Rd.
Croton-on-Hudson, NY 10520
(914) 271-5238

Preiss, Leah Palmer, 114
2709 Vanderbilt Ave.
Raleigh, NC 27607
(919) 834-7426

Pugh, Lorena, 379
Purebred Editions
323 Harrison St.
North Kingstown, RI 02852
(401) 885-9438
www.purebrededitions.com/ l pugh

Pyle, Charles S., 104
24 Western Ave.
Petaluma, CA 94952
(707) 782-9376

Ransome, James, 143, 144, 302
71 Hooker Ave.
Poughkeepsie, NY 12601
(914) 473-8221 PH/FAX

Reagan, Susan, 420
1675 Lincoln Ave.
Lakewood, OH 44107
(216) 228-5711

Roberts, Victoria, 321
c/o Riley Illustration
155 West 15th St. #4C
New York, NY 10011
(212) 989-8770
(212) 989-7892 FAX
www.rileyillustration.com

Rodriguez, Edel, 106
16 Ridgewood Ave. Box 102
Mount Tabor, NJ 07878
(973) 983-7776

Rotondo, Nick, 448
Deborah Wolfe Ltd.
731 North 24th St.
Philadelphia, PA 19130
(215) 232-6666

Roux, Christian, 336
60 Boulevard De Clichy
Paris, France 75018
011-331-42-239-744
Rep: Marlena Agency
(609) 252-9405

Rudnak, Theo, 109, 430
549-6 Amsterdam Ave. NE
Atlanta, GA 30306
(404) 876-4058
(404) 875-9866 FAX

Rush, John, 226, 375, 376, 451
123 Kedzie St.
Evanston, IL 60202
(847) 869-2078

Russo, Bob, 401
6332 North Hampton Dr. NE
Atlanta, GA 30328
(404) 252-6394

Ruzzier, Sergio, 334
c/o Wanda Nowak
231 East 76th St. #5D
New York, NY 10021
(212) 535-0438
www.wandanow.com

Rydberg, Steven, 400
611 West Ridgewood Ave. #311
Minneapolis, MN 55403
(612) 870-7675

Sagona, Marina, 331
c/o Riley Illustration
155 West 15th St. #4C
New York, NY 10011
(212) 989-8770
(212) 989-7892 FAX
www.rileyillustration.com

Salina, Joseph, 34
39 Parliament #310
Toronto, Ontario, Canada M5A 4R2
(416) 367-8421 PH/FAX
jozas@interlos.com

Sano, Kazuhiko, 116, 117, 133,
195, 369
105 Stadium Ave.
Mill Valley, CA 94941
(415) 381-6377
(415) 381-3847 FAX

Santore, Charles, 189
138 South 20th St
Philadelphia, PA 19103
(215) 563-0430

Sato, Kunio, 435
Spoon Co., Ltd.
Bellhouse 2 2 17 Toungane-cho
Chuo-ku Osaka, Japan T540-0035
011-81-6-6943-1100
011-81-6-6943-1165 FAX

Savage, Stephen, 275
444 Sackett St.
Brooklyn, NY 11231
(718) 624-5435

Scanlan, Peter, 142
6 Cedar Lane
Closter, NJ 07624
(201) 750-0732

Schallau, Daniel Page, 485
2215 NW Irving St. #36
Portland, OR 97210
(503) 220-1960

professional statements

Kirchoff/Wohlberg
Artists Representatives

Illustration © 2000 Lois Ehlert FROM *Market Day*

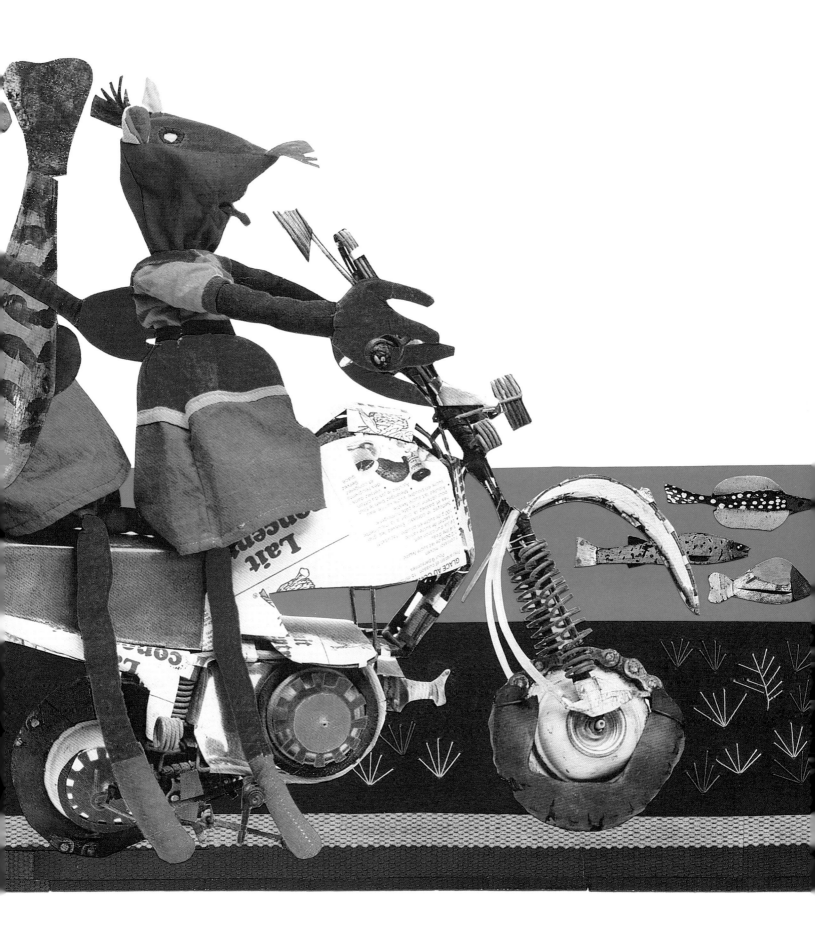

866 United Nations Plaza New York, NY 10017
Phone: 212-644-2020 Fax: 212-223-4387 www.kirchoffwohlberg.com

Great illustrators represent Gerald & Cullen Rapp

 Philip Anderson
 N. Ascencios
 Stuart Briers
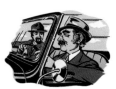 Lon Busch
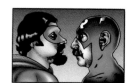 Jonathan Carlson

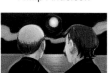 Michelle Chang
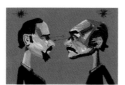 R. Gregory Christie
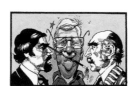 Jack Davis
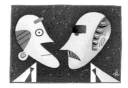 Robert de Michiell
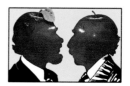 The Dynamic Duo

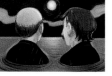 Randall Enos
 Leo Espinosa
 Phil Foster
 Mark Fredrickson
 Mark Gagnon

 Eliza Gran
 Gene Greif
 Pieter Horjus
 Peter Horvath
 Celia Johnson

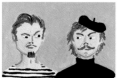 Douglas Jones
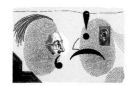 James Kaczman
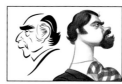 John Kascht
 Steve Keller
 J.D. King

 Laszlo Kubinyi
 Scott Laumann
 PJ Loughran
 Bernard Maisner
 Hal Mayforth

 David McLimans
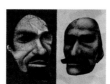 James O'Brien
 John Pirman
 Jean-Francois Podevin
 Marc Rosenthal

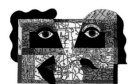 Alison Seiffer
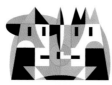 Seth
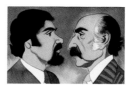 Whitney Sherman
 Jeffrey Smith
 James Steinberg

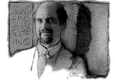 Drew S.
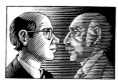 Elizabeth Traynor
 Michael Witte
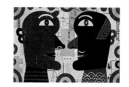 Noah Woods
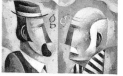 Brad Yeo

And **Gerald & Cullen Rapp** has represented great illustrators since 1944

108 East 35th Street, New York, NY 10016 | Phone 212 889 3337 | Fax 212 889 3341 | www.theispot.com/rep/rapp

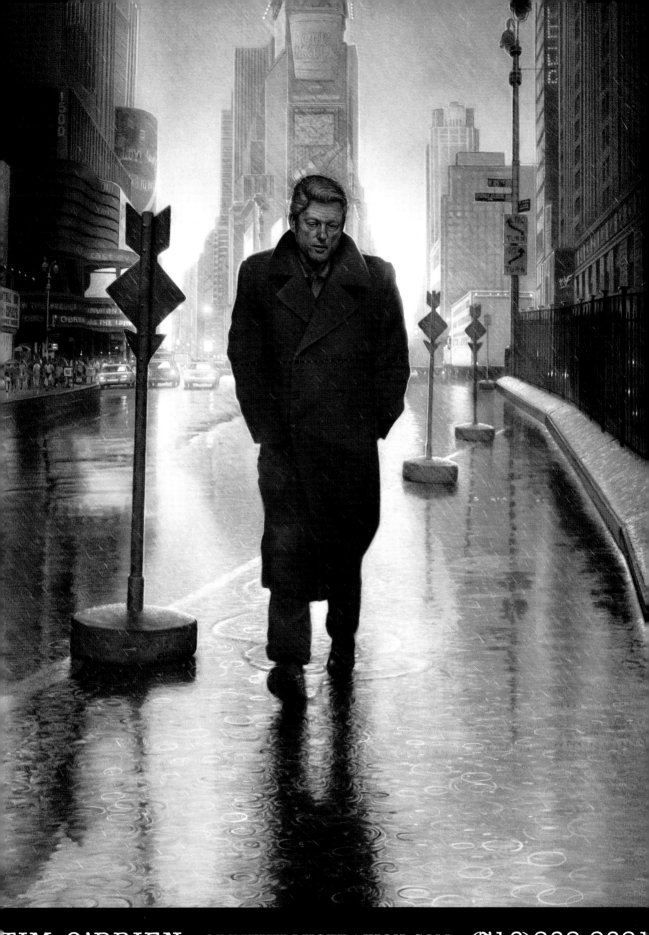

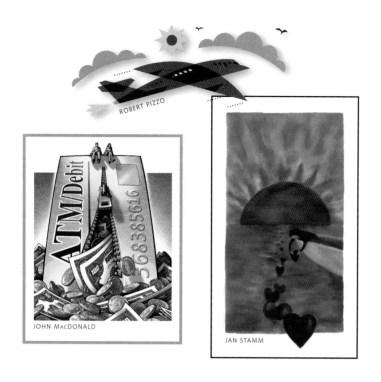

ROBERT PIZZO

JOHN MacDONALD

JAN STAMM

BRIAN JENSEN

BARRY FITZGERALD

MARIA RENDON

GET DISCOVERED
365 days a year

Advertise in the Directory of Illustration.

"For the past nine years, I have been able to count on the **Directory of Illustration** to help me build a national reputation. When I ask art directors, *'Where did you see my work?'* the answer I always get is, '**In the Directory.**'"
ROBERT PIZZO — ADVERTISER SINCE 1992
(203)938-0663

"Over the past ten years, I've bought pages in most of the major illustration directories. Of them all, the **Directory of Illustration** has consistently brought in the most assignments — it gives me the *best* exposure to the market. If forced to choose one directory, the **Directory of Illustration** wins hands down."
JOHN MACDONALD — ADVERTISER SINCE 1993
(413)458-0056

"I reach clients in ways that would have been impossible on my own. The **Directory of Illustration** is distributed to the editorial art directors and book publishers I am seeking. The combination of personal help, the quality of the book, the website, and the national distribution has helped my business tremendously."
JAN STAMM — ADVERTISER SINCE 1996
(619)280-6205

DIRECTORY OF ILLUSTRATION 17

Published by:
SERBIN COMMUNICATIONS, INC.
511 OLIVE STREET
SANTA BARBARA, CA 93101

"Advertising in the **Directory of Illustration** has enabled me to expand beyond the local market and get work from a national client base. The marketing plan has introduced my work to publishers, advertising agencies and corporations who are interested in my ideas and style. Consistent advertising in the **Directory of Illustration** builds my credibility."
BRIAN JENSEN — ADVERTISER SINCE 1995
(612)339-7055

"The **Directory of Illustration** works for me. It gets my work in front of the right people. Every year it has proven to be a cost effective way to market my work and land new clients in editorial, advertising and corporate markets."
BARRY FITZGERALD — ADVERTISER SINCE 1994
(785)841-2983

"For the past five years, **the Directory of Illustration** has been the most effective way for me to reach potential clients. Art directors looking for a fresh approach have discovered my work through the Directory."
MARIA RENDON — ADVERTISER SINCE 1995
(626)794-5195

Call 800-876-6425 for our 16-page brochure.

ART BUYERS CAN QUALIFY FOR A COMPLIMENTARY edition of the Directory of Illustration by visiting our web site at directoryofillustration.com or calling 800-876-6425.

MIDTOWN MANHATTTAN • FROM METROPOLIS

THE ALBERT LORENZ STUDIO

49 Pine Avenue • Floral Park, New York 11001 • (516) 354-5530 • Fax: (516) 328-8864
www.lorenzstudio.com • Email: MLorenzART@aol.com
Metropolis, published in 1996 by Harry N. Abrams, Incorporated, New York

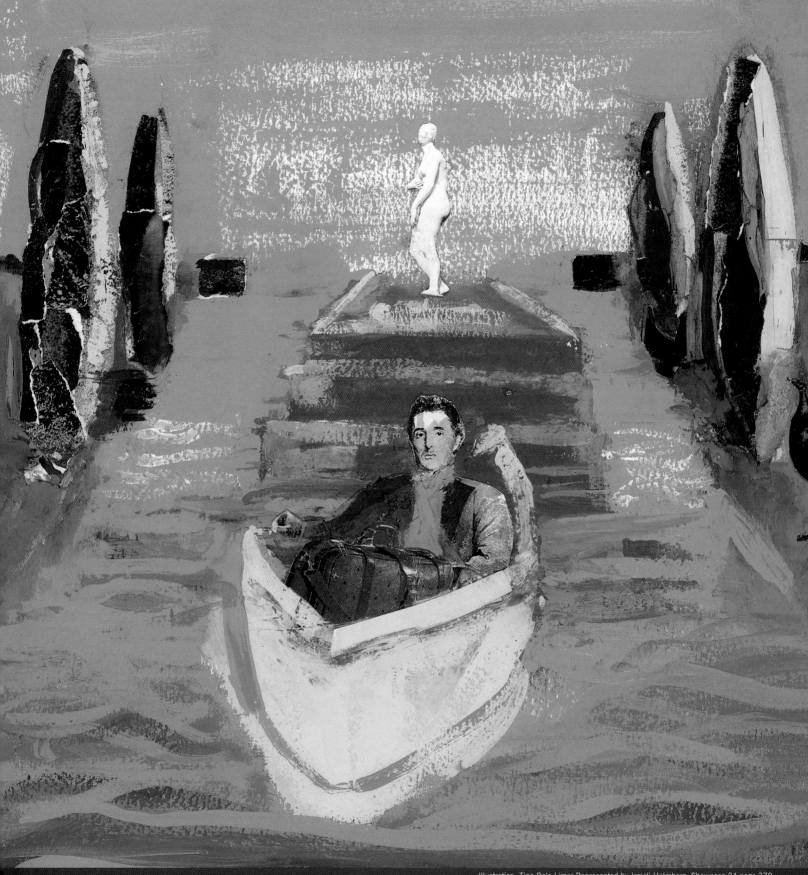

Illustration: Tina Bela Limer Represented by Irmeli Holmberg, Showcase 24 page 370

YOUR SHIP HAS COME IN!

To all of you who sail the mighty sea of talent - we salute you.

To receive a copy of Showcase Illustration or for information, call 212.673.6600 or 800.894.7469

american **showcase**

"THANKS TO THE SOCIETY OF ILLUSTRATORS,
ON THE EVE OF ITS 100TH ANNIVERSARY, FOR HAVING
PRESENTED AND REPRESENTED ILLUSTRATION AND ILLUSTRATORS
WITH DIGNITY, INTEGRITY AND STYLE."

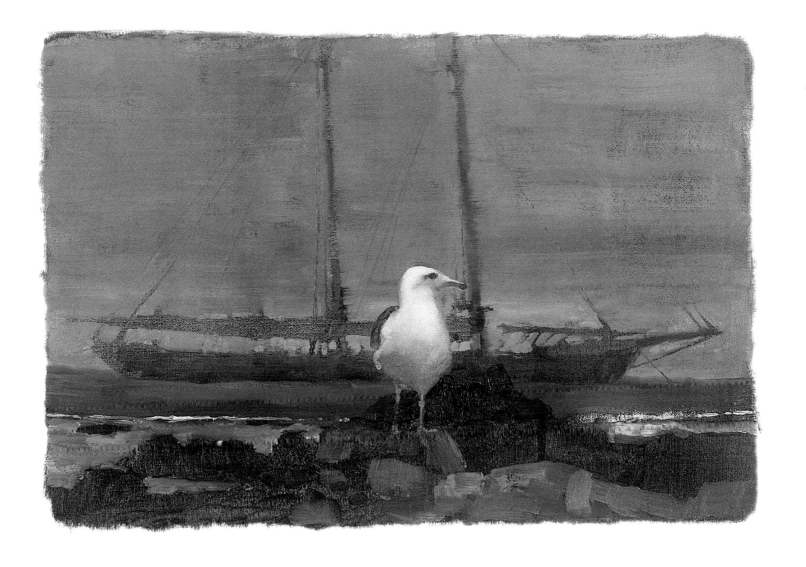

— BERNIE FUCHS, MEMBER SINCE 1959

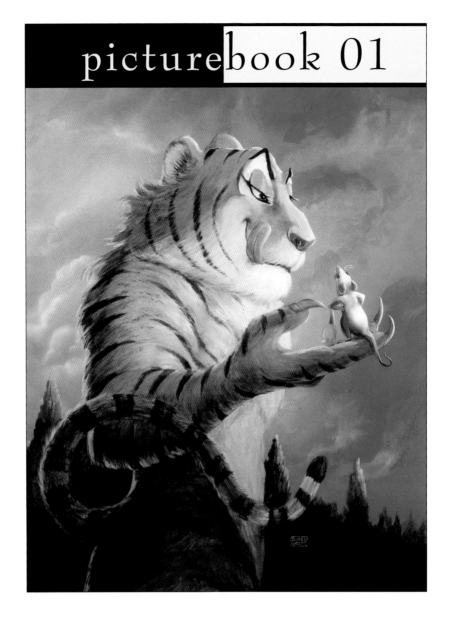

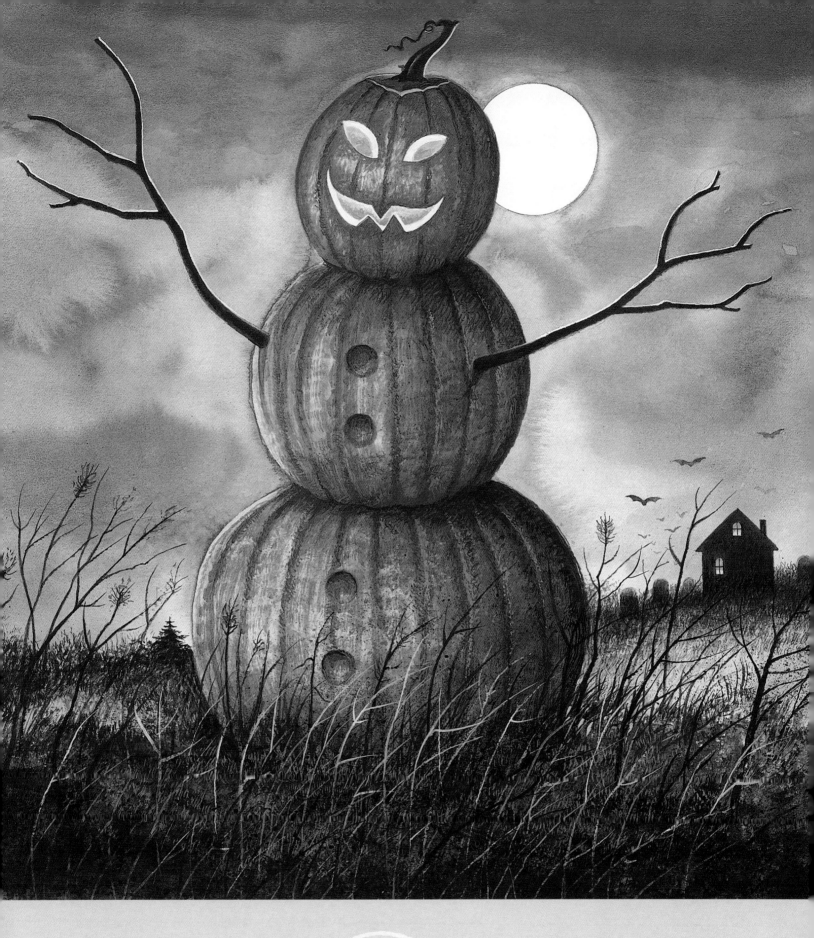

This visually stunning book is sure to be a favorite autumn read-aloud. —School Library Journal

PUMPKIN HEADS! Written and Illustrated by Wendell Minor

Visit Wendell Minor on the web at **minorart.com**

Scholastic/The Blue Sky Press, artwork copyright 2000 by Wendell Minor

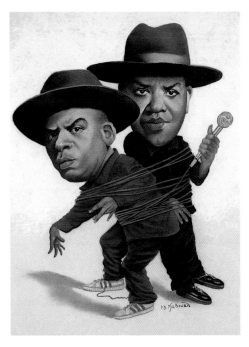
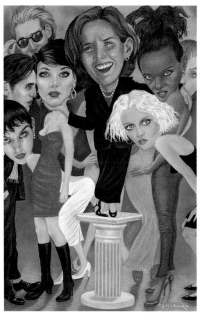
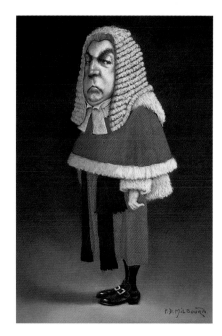
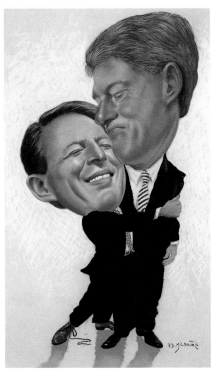
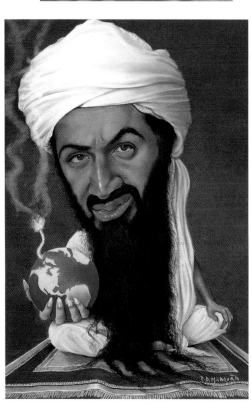
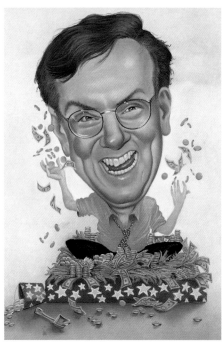
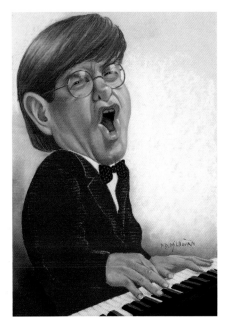
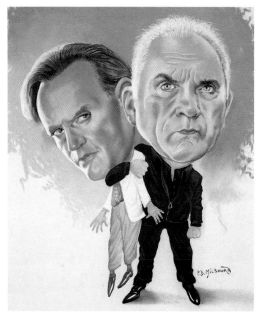
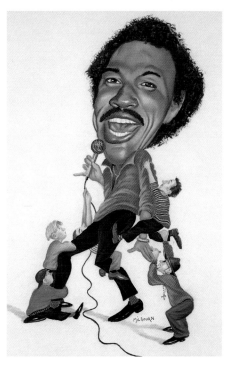

PATRICK MILBOURN • **327 West 22nd Street** • **New York, NY 10011** • **212-989-4594**

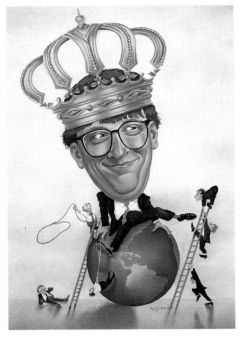
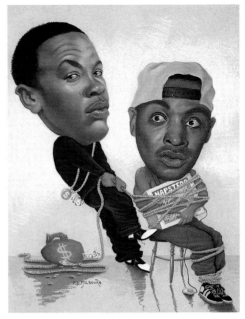

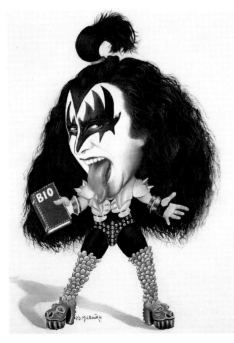
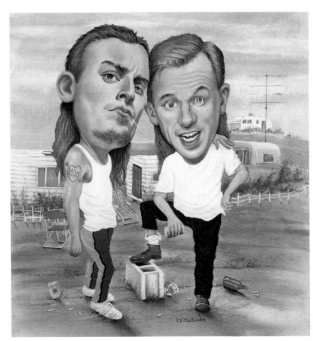
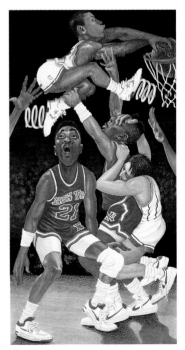

PATRICK MILBOURN • **327 West 22nd Street** • **New York, NY 10011** • **212-989-4594**

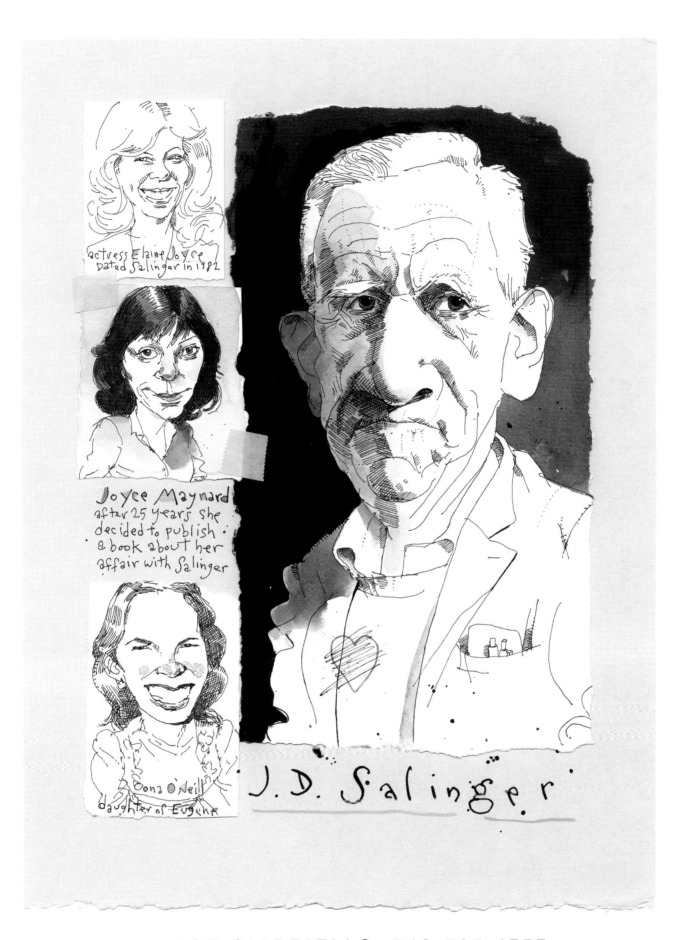

actress Elaine Joyce
Dated Salinger in 1982

Joyce Maynard
after 25 years she
decided to publish
a book about her
affair with Salinger

Oona O'Neill
daughter of Eugene

J. D. Salinger

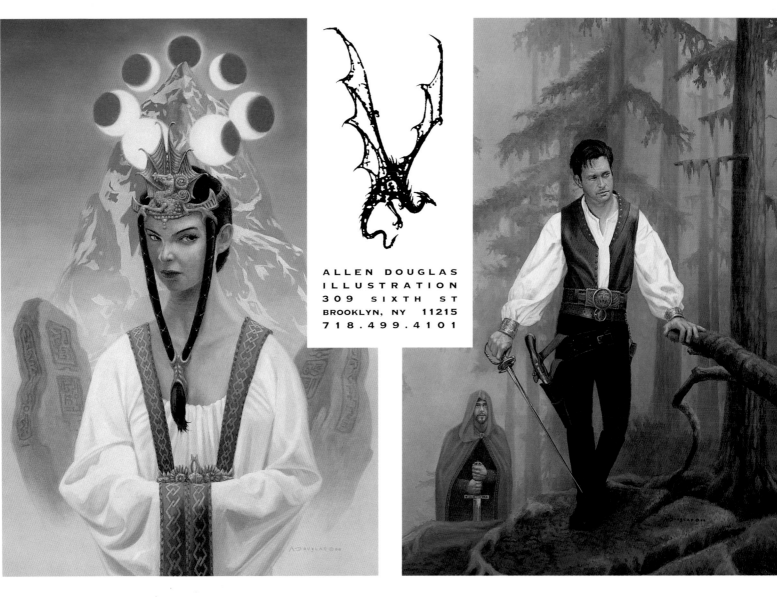

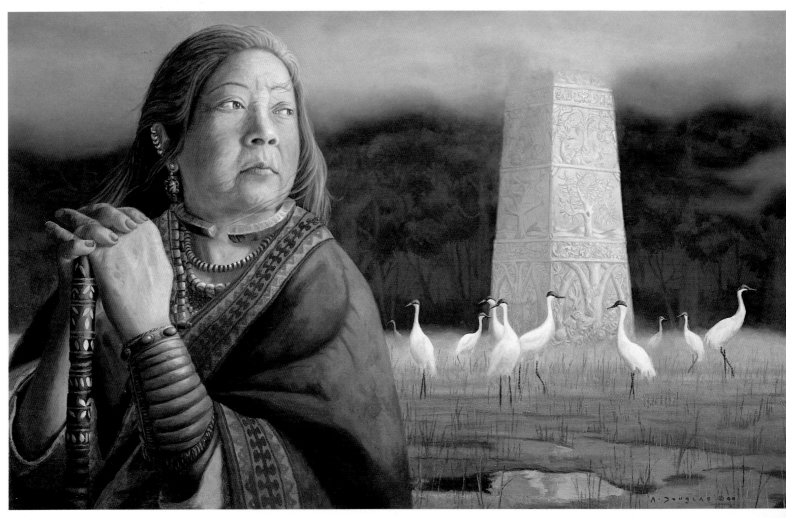

ALLEN DOUGLAS
ILLUSTRATION
309 SIXTH ST
BROOKLYN, NY 11215
718.499.4101

society
activities

THE DAVID P. USHER/GREENWICH WORKSHOP
MEMORIAL AWARD
☘
PETER SYLVADA

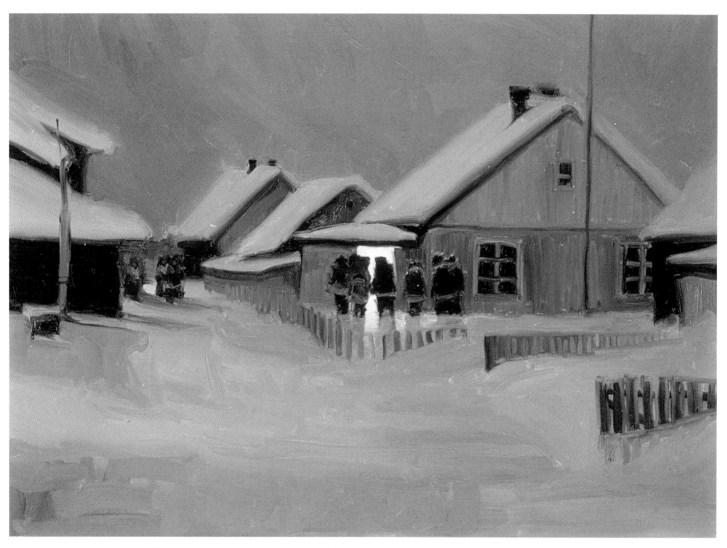

From the book "A Symphony of Whales" ◆ Harcourt Brace and Company

The selection was made from all of the works exhibited in the 42nd Annual. The jury included:
Past Medalists Guy Billout and Teresa Fasolino; Exhibition Chair and Assistant Chair,
Martha Vaughan and Nancy Stahl and
representing The Greenwich Workshop, Peter Landa.
A cash prize and subsequent print edition accompanies this award.

**THE GREENWICH
WORKSHOP**
Since 1972

THE SOCIETY OF ILLUSTRATORS
MEMBERS ELEVENTH ANNUAL
OPEN EXHIBITION

our own show

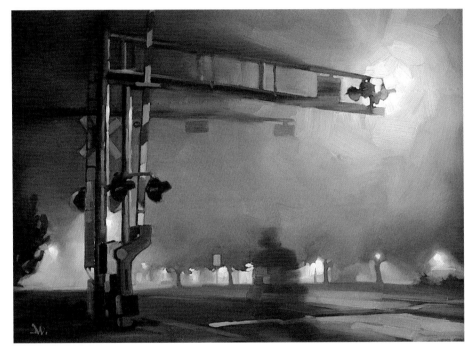

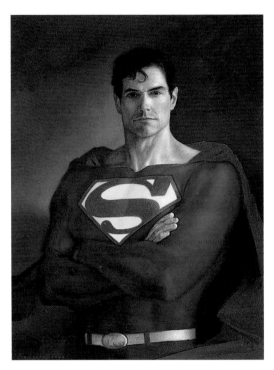

AWARD OF MERIT
Donato Giancola

STEVAN DOHANOS
AWARD
Gregory Manchess

"Our Own Show"
presents annually
the
Stevan Dohanos
Award
as the
Best in Show
in this open,
unjuried
exhibition.

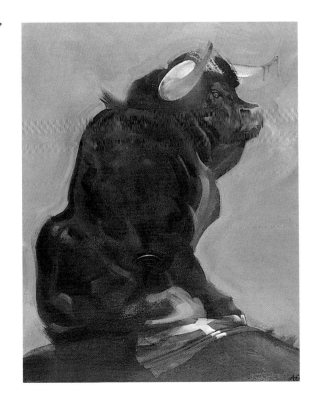

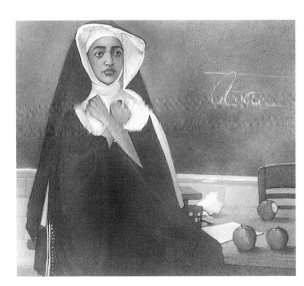

AWARD OF MERIT
K. Wendy Popp

AWARD OF MERIT
Abe Echevarria

THE ORIGINAL ART 2000

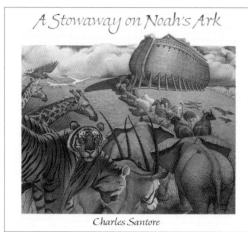

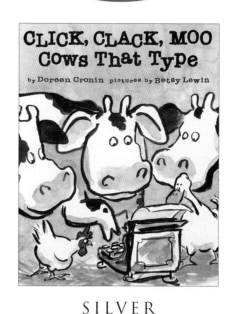

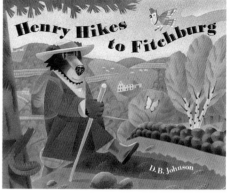

GOLD
Illustrator: *Charles Santore*
Book: A Stowaway On Noah's Ark
Editor: Heidi Kilgras
Publisher: Random House
Children's Books

SILVER
Illustrator: *Betsy Lewin*
Book: Click, Clack, Moo Cows That Type
Art Director: Anahid Hamparian
Editor: Rebecca Davis
Publisher: Simon & Schuster Books For
Young Readers

SILVER
Illustrator: *D.B. Johnson*
Book: Henry Hikes To Fitchburg
Art Director: Bob Kosturko
Editor: Margaret Raymo
Publisher: Houghton Mifflin
Company

Founded in 1980 to "Celebrate the Fine Art of Children's Book Illustration," this exhibition has been sponsored by the Society of Illustrators for the past ten years.

The selection process was by a jury of outstanding illustrators, art directors and editors in the field of children's book publishing.

JURY
Christopher Canyon, Michael Dooling, Daniel Kirk, Emily Arnold McCully, Chris Soentpiet, Simms Taback and Paul Zakris

Ted Lewin CHAIR,"The Original Art 2000" ◆ Dilys Evans FOUNDER, "The Original Art"

The Society of Illustrators recognizes the underwriting support of The Picture Book

SOCIETY OF ILLUSTRATORS MUSEUM SHOP

Founded on February 1, 1901, the Society of Illustrators has been the center for the study of illustration for the past 100 years. *The Centennial Year* brings to the Museum Shop several special items (page 4). ILLUSTRATORS 42 can be purchased with *The Centennial Image* by Bernie Fuchs. There are also new large format books, T-shirts and gift items.

This year's highlight is the reissue of the book "The Illustrator in America". 458 pages spanning 1860 - 2000.

The Musum Shop is an extension of the Society's role as the center for illustration in America today. For further information or quantity discounts, contact the Society at
•TEL: (212) 838-2560 • FAX: (212) 838-2561
•E-MAIL: si1901@aol.com

ILLUSTRATORS ANNUAL BOOKS

These catalogs are based on our annual juried exhibitions, divided into four major categories in American Illustration: Editorial, Book, Advertising, and Institutional. Some are available in a limited supply only.

In addition, a limited number of out-of-print collector's editions of the Illustrators Annuals that are not listed below (1959 to Illustrators 32) are available as is.

Contact the Society for details...

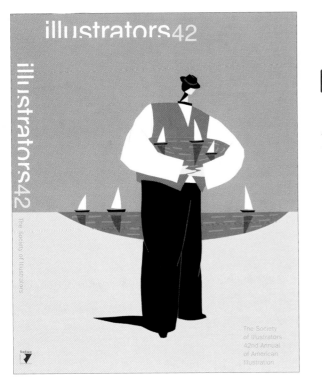

ILLUSTRATORS 42
270 pp.
Cover by Craig Frazier.
Contains 480 works of art.
Included are Hall of Fame biographies
and the Hamilton King interview.
Our most recent annual, the most contemporary illustration.
$49.95

NEW!

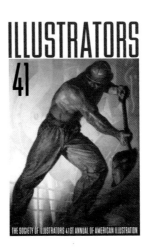

ILLUSTRATORS 41
$40.00

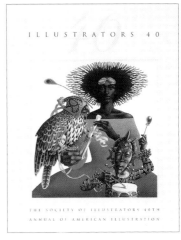

ILLUSTRATORS 40
$35.00

ILLUSTRATORS 38
$30.00

ILLUSTRATORS 37
$25.00

ILLUSTRATORS 36
$20.00

ILLUSTRATORS 33
$20.00

SOCIETY OF ILLUSTRATORS • 128 East 63rd Street • New York, NY 10021-7303
www.societyillustrators.org EMail: society@societyillustrators.org

THE ILLUSTRATOR IN AMERICA
1860 - 2000

NEW EXPANDED EDITION!

BY WALT REED
EDITED BY ROGER REED

First published in 1964, this is the third edition of *The Illustrator in America.* It now goes back in time to the Civil War when artist reporters made on-the-spot pictures of the military action for publication by newspapers and periodicals of the day.

Following the improvements in printing and the attractions of better reproductions, the turn of the century brought a "Golden Age of Illustration" spearheaded by Howard Pyle, Edwin Austin Abbey, A.B. Frost and others, who brought it to a high art. Illustrators were celebrities along with the authors whose works they pictured.

This history of 140 years of illustration is brought up to the millennium year of 2000 when the new computer-generated techniques and digital printing are creating another revolution in this evolving, dynamic art form.

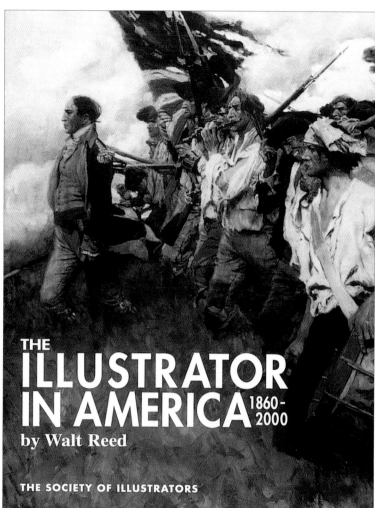

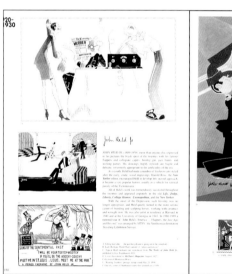

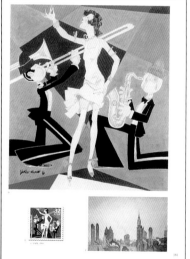

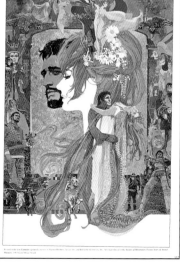

As before, the pictures and biographies of the outstanding artists of each decade are presented along with the historical context of each ten-year period. A time-line chart presents the various influences of styles, schools, and "isms" within this diverse and vital field that has made such an important contribution to America's art.

Included are the works of over 650 artists, their biographies, examples of their signatures and their best works. Among the artists are Winslow Homer, Thomas Moran, Charles Dana Gibson, Frederic Remington, William Glackens, Maxfield Parrish, N.C. Wyeth, James Montgomery Flagg, J.C. and F.X. Leyendecker, Jessie Wilcox Smith, John Held Jr., Norman Rockwell, Dean Cornwell, John Falter, Harold von Schmidt, Stevan Dohanos, Robert Fawcett, Austin Briggs, Al Parker, Bernie Fuchs, Bob Peak, Brad Holland, Milton Glaser, Richard Amsel, Gary Kelley, Leo and Diane Dillon, and Chris Van Allsberg.

COVER ILLUSTRATION:
"The Nation Makers" by Howard Pyle
Collection of the Brandywine River Museum

458 PAGES, FULL COLOR, HARDBOUND.
$49.95

PRO-ILLUSTRATION

by Jill Bossert

A How-to Series

$24.00 EACH. SET OF THREE $60.00

Charles Santore

VOLUME ONE
EDITORIAL ILLUSTRATION

The Society of Illustrators has simulated an editorial assignment for a Sunday magazine supplement surveying the topic of "Love." Topics assigned to the illustrators include: Erotic Love, First Love, Weddings, Sensual Love, Computer Love, Adultery and Divorce. The stages of execution. from initial sketch to finish, are shown in a series of photographs and accompanying text. It's a unique, behind-the-scenes look at each illustrator's studio and the secrets of their individual styles. Professional techniques demonstrated include oil, acrylic, collage, computer, etching, trompe l'oeil, dyes and airbrush.

EDITORIAL
Marshall Arisman, Guy Billout, Alan E. Cober, Elaine Duillo, Joan Hall, Wilson McLean, Barbara Nessim, Tim O'Brien, Mel Odom

VOLUME TWO
ADVERTISING ILLUSTRATION

This is an advertising campaign for a fictitious manufacturer of timepieces. The overall concept is "Time" and nine of the very best illustrators put their talents to solving the problem. The stages of execution, from initial phone call to finish, are described in photographs and text. You'll understand the demonstration of the techniques used to create a final piece of art. Professional techniques demonstrated include oil, acrylic, mixed media collage, computer, three-dimension and airbrush.

ADVERTISING
N. Ascencios, Mark Borow, Robert M. Cunningham, Teresa Fasolino, Mark Hess, Hiro Kimura, Rafal Olbinski, Fred Otnes, Chris Spollen

VOLUME THREE
CHILDREN'S BOOKS

In photographs and text, each of the nine artists describe the stages of execution from initial idea--if they are the author, too--or manuscript proposed by an editor, to the completion of a piece of art. They discuss the special challenges of creating children's books, among them: consistency of character and tone, attention to pace and visual flow, and the task of serving narrative as well as aesthetics.

CHILDREN'S BOOKS
Steve Byram, Raul Colòn, Laura Cornell, Steve Kroninger, Emily McCully, James McMullan, Jerry Pinkney, Charles Santore, Dan Yaccarino

FAMOUS AMERICAN ILLUSTRATORS

by Arpi Ermoyan

THE HALL OF FAME

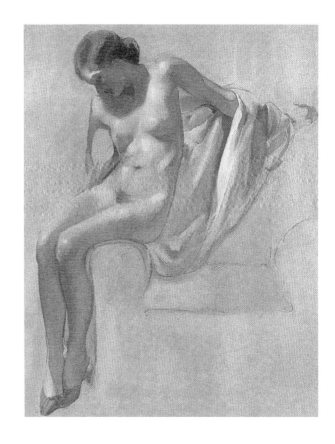

Every year since the inception of the Hall of Fame in 1958, the Society of Illustrators bestows its highest honor upon those artists recognized for their distinguished achievement in the art of illustration. The 87 recipients of the Hall of Fame Award represented in this book are the foremost illustrators of the last two centuries.

FAMOUS AMERICAN ILLUSTRATORS, a full-color, 224 page volume, is a veritable "Who's Who" of American illustration. The artists are presented in the order in which they were elected to the Hall of Fame. Included are short biographical sketches and major examples of each artist's work. Their range of styles is all-encompassing, their viewpoints varied, their palettes imaginative. The changing patterns of life in America are vividly recorded as seen through the eyes of these men and women—the greatest illustrators of the 19th and 20th Centuries. **11 1-2 x 12 inches. $34.95**

THE CENTENNIAL BOOKSTORE

THE
SOCIETY of
ILLUSTRATORS

Our Centennial Year

THE CENTENNIAL YEAR -
SPECIAL GIFT ITEMS
Founded in 1901, the Society of Illustrators is celebrating its 100th anniversary with many new gift items. Many feature *The Centennial Logo* by Karl Steinbrenner.

SPECIAL EDITION - ILLUSTRATORS 42
featuring *The Centennial Image* by Bernie Fuchs Created for Arizona Highways Magazine, Bernie's image of a canyon at sunset is the Society's *Centennial Image*. A limited number (300) signed by the artist are being tipped in the latest annual and presented in a slipcase.
Suitable for framing.
$125.00

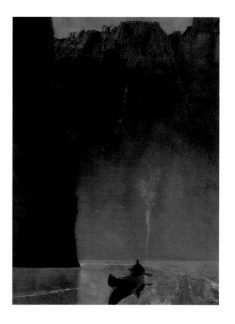

THE CENTENNIAL CALENDAR
This 13 month limited edition calendar features works from the Permanent Collection. 24" x 13". January 2001 - January 2002.
$12.00

CERAMIC TILES
These 6" x 6" fired ceramic tiles feature Bradbury Thompson's famous design of the SI. They can be installed in kitchens and baths or be used as paperweights or other decoration. Weather resistant.
$30.00 EACH

MENS AND LADIES WATCHES
Battery powered, quartz movement, water resistant, heavy gold plate case, stainless steel back, genuine leather band.
$29.95 EACH

POKER CHIPS
Custom clay casino quality poker chips with edgespots and the SI logo.
$120.00 PER 100

THE BUSINESS OF ILLUSTRATION
Steve Heller's effective text on the nuts and bolts and whys of illustration. Commentary by leading pros and agents as well as hints on pricing and self-promotion. Great for students and young professionals. Recommended highly.
144 pages, softbound, color **$27.50**

GOING DIGITAL
AN ARTIST'S GUIDE TO COMPUTER ILLUSTRATION
At last, an easy-to-read guide to illustrating on your computer. Author and illustrator, John Ennis, offers an under- the-hood look at how it's done and how to start up your digital studio.
144 pages, softbound, color. **$29.95**

HEALTH HAZARDS MANUAL
A comprehensive review of materials and supplies, from fixatives to pigments, airbrushes to solvents.
132 pages, softbound. **$9.95**

THE BUSINESS LIBRARY

Each of these volumes is a valuable asset to the professional artist whether established or just starting out.
Together they form a solid base for your business.

THE EDUCATION OF AN ILLUSTRATOR
Steve Heller and Marshall Arisman have assembled 20 top educators in essay and interview as to how graphic design/illustration is taught and learned. Eight sample curricula are included. New for 2001.288 pages, softcover, color. **$18.95**

THE LEGAL GUIDE FOR THE VISUAL ARTIST
1999 EDITION.
Tad Crawford's text explains basic copyrights, moral rights, the sale of rights, taxation, business accounting and the legal support groups available to artists.
256 pages, softbound. **$19.95**

GRAPHIC ARTISTS GUILD HANDBOOK PRICING AND ETHICAL GUIDELINES - VOL. 9
Includes an outline of ethical standards and business practices, as well as price ranges for hundreds of uses and sample contracts.
312 page, softbound. **$24.95**

THE RED ROSE GIRLS
Jessie Willcox Smith, Elizabeth Shippen Green and Violet Oakley left Howard Pyle's school to become illustrators at the beginning of the last Century. They also lived together in "The Red Rose Inn" outside Philadelphia. Bunny Carter authored this edition. Cover by Violet Oakley.
216 pages, hardbound, color. **$39.95**

THE THEATER POSTERS OF JAMES MCMULLAN
A celebration of his memorable posters, most commissioned by New York's Lincoln Center Theater. Includes reproductions of preliminary sketches and photo reference, as well as the finished art.
128 pages, color, hardbound. **$35.95**

SIGHT & INSIGHT - THE ART OF BURTON SILVERMAN
From the exhibition held at the Butler Institute of American Art in Youngstown, Ohio and the Brigham Young Museum in Provo, UT, 1999. This book is a collection of the past 25 years of work by this universally respected painter, illustrator and teacher.
157 pages, color, hardbound. **$35.95**

BOOKS & CATALOGS

THE ART OF NATIONAL GEOGRAPHIC - A CENTURY OF ILLUSTRATION
175 images by 75 artists from the vast archives of the Geographic are presented by author, Bunny Carter, in six chapters: Anthropology, Discovery, Natural History, Conflict, The Universe and Cultures. Bios of the artists and a forward by Stephen Gould are included. Cover by N.C. Wyeth.
240 pages, hardbound, color. **$50.00**

ROLLING STONE: THE ILLUSTRATED PORTRAITS
93 illustrators and 173 illustrated portraits from this magazine's over 35 years of covering the music scene have been assembled by current Art Director, Fred Woodward. Julian Allen to Janet Woolley. Muhammad Ali to Frank Zappa. Cover by Mark Ryden.218 pages, hardbound, color. **$40.00**

JOHN LA GATTA - AN ARTIST'S LIFE
Hall of Fame illustrator John La Gatta lived a life as glamorous as the elegant men and gorgeous women he depicted during the twenties and thirties for magazines and advertisers. A biography and lavish portfolio of his work reveals one of the Golden Age's most famous artists.
168 pages, hardbound, color. **$39.95**

STILL AVAILABLE

WENDELL MINOR: ART FOR THE WRITTEN WORD

$30.00

EDWARD SOREL: UNAUTHORIZED PORTRAITS

$30.00

THE J.C. LEYENDECKER COLLECTION

$16.00

COBY WHITMORE

$16.00

APPAREL

SI CAPS
Blue or Red with SI logo and name embroidered in white. Adjustable, one size fits all **$15.**

White shirt with the Society logo.
L, XL, XXL **$15.**

39TH ANNUAL EXHIBITION "CALL" T-SHIRT
Image of the tattooed face by Anita Kunz. 100% cotton. Heavyweight pocket T.
L, XL, XXL **$15.**

38TH ANNUAL EXHIBITION "CALL" T-SHIRT
Image of a frog on a palette by Jack Unruh. Frog on front pocket. 100% cotton. Heavyweight pocket T.
L, XL, XXL **$15.**

NAVY BLUE MICROFIBER NYLON CAP
SI logo and name embroidered in white. Floppy style cap. Feels broken in before its even worn. Adjustable, one size fits all.
$20.

SWEATSHIRTS
Blue with white lettering of multiple logos or grey with large red SI.
L, XL, XXL **$20.**

40TH ANNUAL EXHIBITION "CALL" T-SHIRT
Image of "The Messenger" by Leo and Diane Dillon. 100% cotton. Heavyweight pocket T.
L, XL, XXL **$15.**

GIFT ITEMS

SI LAPEL PINS
Actual Size
$6.00

The Society's famous Red and Black logo, designed by Bradbury Thompson, is featured on many items.

SI TOTE BAGS
Heavyweight, white canvas bags are 14" high with the two-color logo **$15.00**

SI PATCH
White with blue lettering and piping - 4" wide
$4.00

SI CERAMIC COFFEE MUGS
Heavyweight 14 oz. mugs feature the Society's logo or original illustrations from the Permanent Collection.
1. John Held, Jr.'s "Flapper";
2. Norman Rockwell's "Dover Coach";
3. J. C. Leyendecker's "Easter";
4. Charles Dana Gibson's "Gibson Girl"
5. SI Logo
$6.00 each

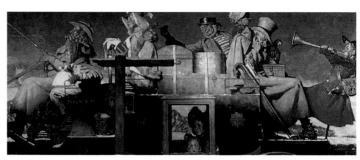

SI NOTE CARDS
Norman Rockwell greeting cards, 3-7/8" x 8-5/8", inside blank, great for all occasions. Includes 100% rag envelopes

10 CARDS -	**$10.00**
20 CARDS -	**$18.00**
50 CARDS -	**$35.00**
100 CARDS -	**$60.00**

ORDER FORM

Mail: The Museum Shop, Society of Illustrators, 128 East 63rd Street, New York, NY 10021-7303
Phone: 1-800-SI-MUSEUM (1-800-746-8738) Fax: 1-212-838-2561 EMail: society@societyillustrators.org

42

NAME _____

COMPANY _____

STREET _____
(No P.O. Box numbers please)

CITY _____

STATE _____ ZIP _____

PHONE () _____

Enclosed is my check for $ _____
Make checks payable to SOCIETY OF ILLUSTRATORS

Please charge my credit card:
☐ **American Express** ☐ **Master Card** ☐ **Visa**

CARD NUMBER _____

SIGNATURE _____ EXPIRATION DATE _____
*please note if name appearing on the card is different than the mailing name.

Ship via FEDEX Economy and charge my account _____

QTY	DESCRIPTION	SIZE	COLOR	PRICE	TOTAL

# of items ordered	**Total price of item(s) ordered**	
	TAX (NYS Residents add 8 1/4%)	
	UPS Shipping per order	6.00
	or	
	Foreign Shipping via Surface per order	15.00
	or	
	Foreign Shipping via Air per order	CONTACT OFFICE
		FX
	TOTAL DUE	